Museum and Gallery Education

Eilean Hooper-Greenhill

Leicester University Press
Leicester, London and New York

© Eilean Hooper-Greenhill, 1991, 1994

First published in Great Britain in 1991 by Leicester University Press
(a division of Pinter Publishers Ltd)
25 Floral Street, London WC2E 9DS

This paperback edition first published in 1994

British Library Cataloguing in Publication Data
A CIP catalogue record for this book is available
from the British Library
ISBN 0-7185-1306-1
ISBN 0-7185-1761-X (pbk)

Library of Congress Cataloging-in-Publication Data
CIP applied for

Typeset by Koinonia Ltd, Bury, Lancashire
Printed and bound in Great Britain by
Biddles Ltd, Guildford and King's Lynn

Contents

This book is dedicated to all those who care
about museum and gallery education

General preface to series

Museums are an international growth area. The number of museums in the world is now very large, embracing some 13,500 in Europe, of which 2,300 are in the United Kingdom; some 7,000 in North America; 2,000 in Australia and Asia; and perhaps 2,000 in the rest of the world. The range of museum orientation is correspondingly varied, and covers all aspects of the natural and human heritage. Paralleling the growth in numbers comes a major development in the opportunities open to museums to play an important part in shaping cultural perceptions within their communities, as people everywhere become more aware of themselves and their surroundings.

Accordingly, museums are now reviewing and rethinking their role as the storehouses of knowledge and as the presenters to people of their relationship to their own environment and past, and to those of others. Traditional concepts of what a museum is, and how it should operate, are confronted by contemporary intellectual, social and political concerns which deal with questions like the validity of value judgements, bias in collecting and display, the de-mystifying of specialist knowledge, the protection of the environment, and the nature of our place in history.

These are all large and important areas, and the debate is an international one. The series *Leicester Museum Studies* is designed to make a significant contribution to the development of new theory and practice across the broad range of the museum operation. Individual volumes in the series will consider in depth particular museum areas, defined either by disciplinary field or by function. Many strands of opinion will be represented, but the series as a whole will present a body of discussion and ideas which should help to redress both the present poverty of theory and the absences of a reference collection of substantial published material, which curators everywhere currently see as a fundamental lack. The community, quite rightly, is now asking more of its museums. More must be given, and to achieve this, new directions and new perspectives must be generated. In this project, *Leicester Museum Studies* is designed to play its part.

SUSAN M. PEARCE
Department of Museum Studies
University of Leicester

Preface

Museum and Gallery Education has been written for all those who believe that museums and galleries are a unique source of knowledge, inspiration, enjoyment and information, and who want to enable others to discover this too. The book traces the development of the educational role of museums from the beginning of the nineteenth century up to the present and into the future, offers strategies for managing this aspect of museum work, outlines appropriate methods of working, and describes examples of good practice.

The belief in the power of museums to move the spirit and develop the mind was a founding principle for many institutions, although the last two centuries have not seen a straightforward development of the educational potential of museums. Many obstacles have stood in the way of those who wished to make museums and galleries as available as possible for as many people as possible. Perhaps one of the greatest has been the definition of 'museum education' itself. During the last two centuries, this has shifted dramatically. Originally encompassing the entire museum operation, by the 1930s the educational role of museums was largely confined to work with primary school children. Since then, educational functions have developed and enlarged until, at the present time, many museums can be seen to be embracing their publics enthusiastically, and opportunities for knowledge, inspiration, enjoyment and information are being opened up. Even today, however, there are battles being fought over how deep the educational functions of museums should be allowed to penetrate into the centre of museums, or whether the educational function of museums is, in fact, their centre.

This book focuses on those activities in museums and galleries that are designed to enhance and complement the displays and the collections. It places these activities, which might appropriately be carried out by a museum or gallery education section, in the context of the broad educational remit of museums, and shows how the two interrelate. A more detailed analysis of this broad educational remit will be covered in other books.

Museum and gallery education will prove useful to museum studies students, in particular those studying museum education; to curators in museums and galleries who want to study this aspect of museum work; and to teachers and teacher-trainers wanting to develop methods of using museums and their collections.

Acknowledgements

I am indebted to all those colleagues who freely and generously gave information, shared ideas, and offered help during the process of completing this book. One of the most warming characteristics of museum and gallery education is its supportive and collaborative nature, and my book would be very much the poorer if this were not the case.

Many people have made specific and vital contributions to the project, too many to describe in detail, but I record my grateful thanks. However, I should like to thank in particular the four people who read the complete draft and made very helpful suggestions for improvements: Hazel Moffat, HMI; Gail Durbin, Education Officer for English Heritage (South East Area), and Chair of the Group for Education in Museums; Timothy Ambrose, Director, Scottish Museums Council; and Rachel Mason, Head of Centre for Postgraduate Teacher Education, Leicester Polytechnic.

Special thanks should go to Jan Anderson, Adrienne Avery-Grey, Maria Barreto, Mary Bryden, Adrian Budge, John Carter, Peter Clarke and his colleagues, Liz Hunter, Toby Jackson, Sunjay Jain, Mary Mellors and her colleagues, Julia Nicholson, John Reeve, Nicola Scadding, Katrina Siliprandi, Diana Smith, David Sorrell, Tony Stevens, Rachel Sullivan, Vicki Woollard, and Sylvia van Zyl and her colleagues. I would also like to acknowledge ICOM/CECA who, in 1985, gave me the opportunity of reading and reviewing an extensive survey of museum and gallery education activities from across the world. It was a privilege to have access to the material, which remains unpublished. I have drawn on this material for the book, and the specific articles referred to in the text are listed in the Appendix.

The Research Board of the University of Leicester has given me several grants to travel to research the material for this book, and I am grateful for this. I also acknowledge the opportunity to complete the book during my study leave in the Summer Term 1990.

My colleagues in the Department of Museum Studies, University of Leicester, have been supportive throughout, and in particular I would like to thank Gaynor Kavanagh for advice on the historical section of the book, and Jim Roberts for drawing the figures.

Any errors of fact or judgement must, of course, be claimed as my own.

EILEAN HOOPER-GREENHILL
Leicester 1991

List of abbreviations

AAM	American Association of Museums
AMMSEE	Area Museum Service for South Eastern England
CECA	Committee for Education and Cultural Action
CMA	Canadian Museums Association
CPVE	Certificate of Pre-vocational Education
CUKT	Carnegie United Kingdom Trust
DES	Department of Education and Science
GCSE	General Certificate of Secondary Education
GEM	Group for Education in Museums
HMI	Her Majesty's Inspectorate
ICOM	International Council of Museums
LMS	Local Management of Schools
MAGDA	Museums and Art Galleries Disability Association
OAL	Office of Arts and Libraries
RNIB	Royal National Institute for the Blind
ROM	Royal Ontario Museum
SAMA	Southern African Museums Association
TVEI	Technical Vocational Educational Initiative

1. An introduction to education in museums and galleries

What do we mean by 'museum and gallery education'?

How can we understand the expression 'museum and gallery education'? In using the words, an immediate conflict of meaning is exposed between, on the one hand, the museum understood as an educational institution in its own right, and on the other hand, activities specially planned and organized with clearly defined teaching objectives. For some people, all the activities that museums and galleries undertake have an educational purpose. Included in this would be the collection of material (paintings, geological specimens, historical artefacts and so on), the planning and production of exhibitions, and the arrangement of special events and teaching sessions. However, other people would understand 'museum and gallery education' to refer only to teaching sessions and events for adults and children.

In reviewing the development of museums over the last two hundred years to discover how 'museum education' has been interpreted, it has gradually become clear that meanings have shifted considerably during this period. At the beginning of the nineteenth century, museums and galleries were, in themselves, understood as educational establishments. They were set up to enable people to educate themselves, and were often built in conjunction with libraries, lecture rooms and even laboratories. Museums were one opportunity among many of acquiring knowledge.

Museums and galleries often fulfilled other symbolic functions, too. The larger national museums were expressions of nationhood and of advanced culture, and the local town museum often carried messages about important local individuals and civic pride.

During the First World War museums played important roles in the provision of schooling for children, and in the communication of important ideas, through exhibitions, for the general public. Exhibitions on infant care and other matters of health and hygiene were put on by museums and were visited enthusiastically by crowds of people anxious to understand how to improve their lives. When schools were unable to continue their work due to teachers being called up and buildings being requisitioned, it was often

the museums that stepped in to help.

At the end of the war, educational agencies were anxious to extend these functions of museums, and several proposals were made to restructure museums in order to make explicit funding and organizational links with education authorities. But, at this point, museums withdrew. Curators after the First World War were not anxious to make closer links with education authorities, or to work more closely with educational providers for adults or children.

However, the calls for access to museums for educational opportunities intensified, especially from teachers. Soon, arrangements were made for special teachers to work with schoolchildren, and far less attention was paid to the needs of adults. Little attention was paid at this time, too, to making displays easily accessible to non-specialist visitors. By the 1960s, museum and gallery education was understood to mean work with schools.

Since that time, museum and gallery education has become a profession, even though a very small one. It is now recognized as an area of specialized work, requiring specific training in addition to the general educational training that either teachers or museum curators require. Museum education straddles the world of museums and the world of education. Over the last twenty years, as the confidence and experience of museum educators has grown, it has become clear that it is not very efficient to organize well-designed teaching sessions while the museum displays remain confused in their objectives and difficult to work with. As soon as museum educators began to realize that they were likely to be providing a remedial service for poorly designed displays, it became clear that a more coherent approach was needed on the part of the whole museum. Concepts began to be developed that articulated ideas about the whole educational or communicative approach of the museum.

At the same time, many curators became aware that although in the past it had been necessary to spend time rationalizing the often confused and badly documented collections that they had inherited, it was now time to look more carefully at how these collections could be used. It is clear that the documentation and storage procedures need to be in place before objects can be used for educational purposes, but, this being the case, many curators are now very active indeed in making opportunities for the public at all levels to relate to the collections.

So we find ourselves at the end of the twentieth century in a situation that is new to us, but perhaps not so very different from the original intentions of the founders of museums. The emphasis today, from all sides, is on the active use of collections, and on making available as many different forms of learning and enjoyment as possible with the resources available. A great deal of thought is currently being given to the development of methods of making museums both more accessible to and more enjoyable for their visitors, and more relevant to their potential visitors.

The many different communicative aspects of museums are being scrutinized and developed. These include, for example, new ways of approaching exhibition planning, with curators actively seeking the opinions and collaboration of their target audiences; and new ways of using museum ward-

ers, with less of an emphasis on their role as guards, and more on their potential as interpreters.

This book concentrates more on the organized and planned provision of learning opportunities for museum audiences than on the other aspects of museum communication. There will be, for example, material on how to establish a museum education service rather than on how to set up a museum exhibition. This is not to deny the broad educational remit of museums and galleries, which will be referred to frequently in general terms. But all books must have a particular focus and this one will approach museum education as a specific professional activity, often undertaken by museum or gallery education officers, but equally undertaken by curators. Other aspects of museum communication must be left to other books.

As far as possible this book will take a general approach to museum and gallery education and will offer concepts and methodologies that are felt to be relevant to workers in many different types of institution. It is possible, but not very fruitful, to concentrate on the differences between teaching in an art gallery and a museum, or between working in a historic house or an environmental site. Of course much of the subject matter will be very specific in each of these cases. But many of the educational methods and many of the policy and management issues will be the same.

Where possible, references to experiences and events will be drawn from the international scene. Much of the theory and methodology of museum education has an international relevance. It is fair to say that there is an active international community of museum and gallery educators, and people, ideas and activities are exchanged in a sometimes surprising way. A group of museum educators and teachers in Yorkshire, for example, has operated an exchange programme with a similar group from Sweden for several years now, with enormous mutual benefit for professional development. A second example is the exchange between Brazilian and Portuguese children as part of a museum education project that explored the experiences of Portuguese settlers in Brazil in the sixteenth century. The project grew out of a training course organized by English Heritage and the Department of Education and Science (DES), with English drama experts involved in both Brazil and Portugal.

Basic educational philosophies

International co-operation and collaboration is possible in museum and gallery education because there is a fairly clearly defined basic philosophy. Teaching in museums and galleries has as one of its first objectives the making of a relationship between the collections of the museum and the needs and interests of the particular museum visitor. Ideally, this relationship needs to be as active as possible, dynamic and flexible. It is recognized that each group and each individual will have a different set of needs and interests, and that the presentation of any part of the collection cannot therefore be the same for all. A museum or gallery teacher working with the same six objects throughout the day, but with three very different groups of

people (for example, a group of 7-year olds, a GCSE (General Certificate of Secondary Education) history group, and a group of senior citizens) will re-orient the objects in a different way for each group.

Different aspects of the six objects will be of relevance to people with different knowledge levels and at different stages of their lives. With a group of sixteenth-century portraits, for example, the 7-year olds might write stories about one of the sitters to develop their writing and language skills, the GCSE group might be studying the sixteenth century in depth and might want to look at what the portraits revealed about court society, while the senior citizens might be part of a needlework class and might find the costumes and the fabrics of interest. Although the same objects might be used, the approach taken and the aspects focussed on would be very different in each case. Selection of the particular aspects of the objects that will be of interest to specific groups is one of the skills that must be developed for successful museum teaching.

The exploration of the collections, whether these are of a thousand thumbscrews, of three hundred classic cars, or of twenty-five Impressionist paintings, is a fundamental premise of museum and gallery education. For a museum teacher, the task is to find ways of making the collections interest-ing, relevant and exciting for people. This leads to a focus on the artefacts, which in turn demands two things: a selection of a small number of relevant objects, and the discovery of a theme that links the objects. A selection of objects is necessary because most museums, galleries, historic houses or sites are an enormous reservoir of material, and useful work cannot be accomplished unless limits are drawn. A theme that links the objects is important because this can be used to develop ideas and to focus thinking and investigation. The choice of themes and artefacts must be made in relation to the needs of the group and in collaboration with the group leader and his or her objectives for the visit to the museum. Again, this calls for specific skills in the selection of helpful and accessible material, and demands knowledge both of the museum collections and of the learning styles and capacities of different age and ability groups. The selection of objects and themes is a dialectical process, with either the themes dictating the objects to be used, or the objects suggesting the themes to be devel-oped, or a combination of both. Very often the objectives of the museum visit will need to be developed and clarified as part of the process of deciding on the objects and the themes. The museum teacher here per-forms an advisory function for the teacher or group leader.

Once the selection of artefacts has been made and the themes to be addressed have been selected, then the teaching approach can be designed. Museum educators use an enormous variety of methods to develop a dy-namic relationship between the collections and the audience, and later chapters will discuss some of them. On the whole, and limited only by resources (although these limits can be severe), the most active methods are favoured. Thus handling objects, using role-play, working around a site or a building, being involved in theatre-in-education, making a large-scale collage, building a group sculpture, making deductions from first-hand evidence, watching a demonstration, and using tape or video-recorders are

all standard ways of working. Most museum educators do not want to reproduce a traditional classroom atmosphere for either children or adults on the grounds that learning in museums should be a different kind of experience, and should enable a first-hand encounter with both the collections of the museum and the site in which the collections are held.

Museum and gallery education works with some of the basic ideas of life-long learning. It is recognized that learning continues throughout life, and that it is not limited to studies in a formal educational institution. Museums and galleries indeed celebrate the fact that they are not such institutions. Museums and galleries have two primary remits: to collect and to enable people to relate to the collections. There is no prescribed syllabus and no curriculum. It is the nature of the collections and the policies of the museum that determine the way in which the relationships between the museums and people are made. This offers museum and gallery educators enormous scope for imaginative and exciting work, for innovation and for exploration.

At the same time, of course, in making links outside the museum, it is important to understand the concerns and objectives of those with whom links are made. Thus teachers' concerns with the National Curriculum, and adult educators' concerns for the personal achievements of their groups must be drawn into the planning of educational provision. None the less, the museum educator is able to adopt many of the learner-centred, facilitative methods that underpin lifelong learning (Hooper-Greenhill 1988d:41).

Museum education is concerned as much with the activities and practices of the museum, gallery or historic site as it is with the contents of these institutions. Thus, for instance, the processes involved in putting up an exhibition are studied through making an exhibition itself. At Stevenage Museum, for example, GCSE students were invited to research and mount an exhibition as an introduction to the local museum and its activities. In Sweden, an adult education group which had worked to produce an art exhibition of local paintings understood the medium itself in a new way:

> We have had our eyes opened. I should never have driven to town to see what is now being shown if I had not seen what was shown here, but now I am curious to see how it functions and how it was mounted. We have got into the process, as it were, we know how it works. [Riksutstallningar 1976:119]

Museum and gallery education is not limited to the confines of the particular building. Much work is carried out away from the museum itself. The Tate Gallery in Liverpool has a Media Van that travels to different parts of Liverpool, carrying staff who run practical art and media workshops in conjunction with local community groups, including Park Lane high security prison (Meewezen1989). These workshops operate to introduce the gallery, its staff and activities to people who would not normally be interested in museums or galleries. Many are run as a series, one of which is held with the same staff and participants at the Tate Gallery itself. Some museum education staff visit museums with boxes of objects, some will visit schools to run training courses for the whole staff to attend.

Outreach work is appropriate where distances are great and many people are unable to reach museums. The Mobile Museum Education Service of the National Museum of Botswana sends a truck 'The Zebra on Wheels' loaded with artefacts and films to the most remote parts of the country (Metz n.d.:6, Unesco survey). Similarly, at Moto Moto Museum in Mbala, Zambia, fieldwork involving both research staff and education staff is carried out in various parts of the country, with the aim of both documenting the past and its artefacts, and informing the people about them. 'Is not the origin of knowledge in the social sciences, the 'people'? And is not the ultimate recipient of the results, the same 'people'?' (Juel n.d.:7, Unesco survey).

There is no shortage of either creative ideas or of energetic individuals willing to be involved in museum education. There are often, however, considerable shortages of resources of all sorts and this can and must influence the type of educational provision that may be offered. Where, for example, there are upwards of eight hundred children visiting per day and a staff of three museum teachers to work with them, as happens at the Tower of London, it is clearly not feasible for each child to have individual attention. Various responses to this situation have been developed by museum staff, most of which are designed to help group leaders maximize their visits without the presence of an education officer. These include museum publications available in the museum shop or through mail order, the preparation of teachers' information packs, introductory videos or slide packs that can be bought or loaned to groups, and the provision of courses in the museum that enable teachers and other group leaders to manage their own visit. Sometimes worksheets are prepared by the museum staff and these can be acquired (or must sometimes be bought) by teachers either for use as they are or for adaptation. All of these methods are also useful in the not uncommon situation where the museum has no specialist education staff, and curators have to do the best possible on their own.

Each museum or gallery's educational provision is unique. No two museums, galleries, or sites will provide the same educational service. There are several reasons for this, which include the tradition within the institution, the amount of help given through the Local Education Authority, the number and expertise of specialist staff employed (if any), the type of museum, the range of the collections and the educational policies of the museum or gallery.

The choices open to each museum in deciding what kind of educational provision to develop are enormous and are limited only by the resources available. Even this is not always a finite limitation, as resources can often follow from determined policies and objectives.

In Britain today, the educational roles of museums and galleries are being emphasized at government level, where Richard Luce, as Arts Minister, identified this area of museum work in 1989 as a priority for development during the next decade. Within the museums profession, the Museums and Galleries Commission is turning its attention to museum education as an area for encouragement, in response to the new widespread professional awareness of the importance of the relationship of museums to their publics.

Part one. *Historical perspectives*

2. Museums for a civilized public

Over the last two hundred years the educational role of museums has undergone a remarkable shift in emphasis. At the beginning of the nineteenth century one of the founding objectives for museums was to educate and inform. Objects from the natural world and from the past were accumulated in order for people to have the opportunity to learn about the world in which they lived. Museums were fundamentally understood as educational institutions, open to those who had not had the benefit of extended education, so that they might teach themselves. Objects and pictures were seen as particularly useful in the teaching of those who were not skilled in learning. Museums were also given the task of unifying society: they were seen as suitable places where all classes of people might meet on common ground. Thus museums were seen as ideal institutions; institutions that offered radical potential for social equality, achieved through learning.

By the 1920s the educational role of museums was not upheld so firmly, and the radical potential of museums was no longer articulated so clearly. New interests came to the fore. Collecting was seen much more as an end in itself, and the completion and care of collections became a major professional concern for curators. Where previously education and curation had been practiced as two parts of the same task, now they became two discrete work areas. Specialist education staff were appointed with remits to develop services for schools and for adult visitors. The organization of loan services and school visits became the province of the museum teacher in provincial museums, while the guide-lecturer provided gallery tours for adults in the national museums. Curators largely withdrew from relationships with the public, relying on exhibitions as their main form of communication.

However, it was not until the late 1960s that display methods became the focus of research and development. Up until then, many museums were content to fill cases with objects with very little thought given as to how these objects would be understood by visitors. But at the beginning of the 1990s there is once more a strong emphasis on the educational role of museums, as attention shifts from the accumulation of objects to the use of existing collections. The educational role of museums is expanding on all fronts. New approaches to display techniques based on new technology are explored; interactive exhibits are used to involve visitors in active participation in exhibitions; special events are organized using theatre or drama;

educational programmes are designed to suit many different audiences. There is a lively interest now in visitor responses, and museums have become enormously popular.

At the beginning of the nineteenth century, the emphasis was on making opportunities available through museums and galleries for educational self-help. At the end of the twentieth century, one hundred years after the introduction of schooling for all, the philosphy of lifelong learning and the recognition that learning does not end with the completion of formal schooling, can provide a theoretical underpinning for new efforts to make museums both educational and entertaining for all.

The early nineteenth century: a variety of influences

Several disparate forces contributed to the emergence of museums as educational institutions at the beginning of the nineteenth century. These were a belief in educational self-help among both the working and middle classes; a concern on the part of radical reformers to provide leisure opportunities for the working classes in the form of 'rational recreation'; a conviction in the power of art to humanize and civilize; and a desire to provide neutral spaces where all sections of society could meet. Many of the institutional forms that emerged were driven by more than one of these forces and in addition, museums and galleries were perceived as significant in fields other than that of education. Art galleries and museums became the bearers of multiple and often contradictory meanings.

Events overseas were also influential. During the French Revolution, the Louvre had been transformed from the private gallery of the King and his Court into a public museum which was seen as an instrument of mass public education. It was administered by the education section of the new republican state (Hudson 1987:42) and as such, provided a completely new model of what a museum might be. The Louvre was free and open to all, with some days of the week set aside for the sole use of art students (Bazin 1959:51). Public events guided the curators in the choice of exhibitions. Cheap catalogues were produced for the people who flocked to the museum and were translated for the foreign visitors (Bazin 1959:51). Some teaching took place in some of the galleries (Seling 1967:109). The museum as an institution had moved from being the closed celebratory playground of the King to being an open school for all.

At the beginning of the nineteenth century in Britain, museums were few, but prior to the 1845 Museums Act approximately forty museums existed (Chadwick 1983:53). These included some museums that were established specifically for educational purposes; the Ashmolean, for example, was attached to the University of Oxford and was built in conjunction with libraries, a lecture room and a chemical laboratory. It opened in 1683 (Simcock 1984). Dulwich Picture Gallery was established in 1814, attached to Alleyne's School. The British Museum had been established by Act of Parliament in 1759, and the National Gallery had opened in 1824. These two latter museums were established for various reasons, and as a

result had different functions on national and international levels. However, many local museums were set up by societies mainly concerned with furthering opportunities for increasing knowledge.

Museums in Mechanics Institutes and Literary and Philosophical Societies

The museums that were established at around the turn of the century by both Mechanics Institutes and Literary and Philosophical Societies had specifically educational objectives. They were seen as one of the various forms of provision for adult education. During the last quarter of the eighteenth century and the first quarter of the nineteenth century, many new educational institutions emerged all over England. They included the learned societies which formed an 'intellectual club' for the middle classes and the Mechanics Institutes which catered mainly for the working classes (Stephens and Roderick 1983:16). Both types of institution set up museums as part of their resources for learning.

Mechanics Institutes were established specifically to further the opportunity of education for the working classes. The arguments that underpinned this development included the right of all citizens to education, a growing philanthropic and humanitarian attitude to the poor, and a more utilitarian belief in the need for a better educated workforce (Chadwick 1983:50). Many of these institutions created museums with collections that included mechanical and scientific models and machines, paintings, engravings and geological specimens.

Classes were based on the collections with lectures on science and scientific instruments. Temporary exhibitions were held, with at least fifty exhibitions held in Mechanics Institutes between 1830 and 1840 (Cunningham 1980:101). These were seen as a recreational form of scientific education and therefore more acceptable to working-class audiences than lectures, but exhibitions were also mounted for financial reasons. With an entry fee of 6d a day, crowds poured in. In May 1839 the Derby Mechanics Institute presented 'an exhibition of ... many of the newest and most ingenious productions of human talent and industry, and specimens of the natural productions of the various parts of the world'. Various types of machinery were exhibited, attended by workmen, and were demonstrated to visitors; experiments were performed. Inhabitants of the Poor House were admitted free, and children from the Sunday and Charity schools of Derby and other towns were admitted at 2d each (Chadwick 1983:52). The profits from these exhibitions were often designated for the provision of a public building erected in a style deliberately opposed to that of the pub or beer-hall, suitable for sensible leisure time.

Artefacts, probably from the collections, were displayed at the Christmas parties held in the Mechanics Institutes. These parties assumed considerable significance as part of the movement to create moments when all classes could come together in harmony and peace. The Christmas Party in Manchester 1848–9, for example, was an attempt to re-create a socially

harmonious medieval past. The Manchester Free Trade Hall was decorated to look like a baronial hall of Old England, complete with banners, flags, old armour, armorial blazonings, spears, swords, antlers, heads of buffalo and ibex, and including helmets, partizans and halberds lent by the police. The objects performed a symbolic function in the re-creation of a golden past.

Institutions designed for the middle classes also founded museums. The Liverpool Royal Institution, for example, founded in 1814, proposed to promote 'Literature, Science and the Arts' by erecting day schools, a school of design, a library, a museum, an art gallery and a laboratory for chemical and physical apparatus (Stephens and Roderick 1983 :17). The Gallery of Art and the Museum of Natural History were among the most successful of these ventures.

The Royal Institution of Cornwall established a lively and successful museum which by the 1830s 'offered numerous facilties for studying the natural history, mineralogy and geology of the county and comparing them with the products of other lands'. The post of curator was occupied by aspiring scholars, generally from working-class backgrounds, who gained opportunities through their work to pursue their studies. At least one of these curators gave extensive courses of lectures for adults (Stephens and Roderick 1983:22-3). In 1838 classes were provided for miners funded by a local benefactor.

The systematic museum established in Norwich in the early 1820s organized a series of lectures on geology and natural history for adults in 1824 and in 1827 the Committee of the museum agreed that if schools paid one guinea per year, teachers could bring up to twenty students to the museum, provided that they themselves remained with the group (Frostick 1985; Durbin 1984).

The museum set up by the Scarborough Philosphical Society was opened free of charge in 1846 to schools: 'some of our members endeavoured to extend its [the museum's] popularity by obtaining the consent of the council for the gratuitous admission of schools from a distance ... many hundreds have been admitted gratuitously' (Stephens and Roderick 1983:32).

Thus many museums were established for direct and explicit educational purposes, and museums took their place along with libraries and lecture halls as places to which to turn for instruction, information and knowledge.

Changes in the perception of leisure

Although museums were emerging rather slowly as specific and discrete institutions in Britain at this time, exhibitions, shows, panoramas, menageries and gardens were well-established forms of leisure provision (Altick 1978). However, during the eighteenth century leisure consumption had become increasingly class-related (Cunningham 1980:76). During this period various forms of enclosure had led to public spaces being appropriated and privatized, and as a consequence leisure consumption became increasingly delineated by social position. Formerly public areas had been set aside

for the leisure of the rich, and the lower classes who had previously had access were now excluded, as for example at Great Tower-Hill, 'where none but the aristocracy are permitted to come in' (Cunningham 1980:82). William Cooke-Taylor commented in 1841 that the commons were enclosed, policemen guarded the streets and kept the highways clear, high walls enclosed ornamental gardens and footpaths were closed. The zoological and botanical gardens, libraries and museums, Athenaeums and art galleries, which had become features of many towns in the eighteenth century were by this time almost exclusively private ventures run for profit, or were financed through subscriptions which working people could not afford.

Middle-class reformers saw a danger in these privatized and class-specific types of leisure and sought to create new leisure forms where all classes could mix in a controlled and public environment. As part of this impulse, during the first half of the nineteenth century an enormous amount of energy was put into the development of museums, public parks, and libraries in the belief that leisure time should be spent on self-improvement and 'rational recreation'. Rationality stood for order and control. The enemy of rational recreation was undisciplined and uncontrollable popular culture. Leisure was to be once more public and communal, and museums, libraries, public parks and botanic gardens were established to this end.

The use of museums and exhibitions for educational purposes acquired greater emphasis as the debate sharpened over the distinction between 'rational' and 'improving' matters, and those pastimes that were deemed to be frivolous and a waste of time. The notion of 'rational amusement' emerged as it became clear that the existing show-going and exhibition-visiting habits of the population could be harnessed in museums in the cause of moral and mental improvement (Altick 1978:227).

The power of art

A further strand must be identified in the analysis of the beginning of museums as educational institutions. This was the nineteenth-century conviction of the power of art to civilize and humanize. Martin Archer Shee, portrait painter and future President of the Royal Society articulated a number of themes in his 'Rhymes on Art' in 1805. The arts were celebrated as instruments of national glory and honour, and as having a civilizing, ennobling influence. The mechanization of labour was seen as threatening man's humanity, but exposure to the arts had the power to counterbalance this (Minihan 1977: ix). Time spent in museums would have a humanizing effect on the 'rough, drossy ore' of humanity (Minihan 1977:26), who, on becoming more discriminating consumers of art, would become more socially acceptable citizens.

During the 1830s and 1840s, a movement headed by the radical Members of Parliament Joseph Hume, William Ewart and Thomas Wyse, called on Parliament to open art monuments for the free viewing of the people. The 1841 Select Committee on National Monuments and Works of Art assembled evidence to show that museums were effective as 'a means of

moral and intellectual improvement for the People'. However their role was conceptualized, museums and art galleries were undoubtedly well-visited and this provided evidence of their efficacy. The National Gallery had over 10,000 visitors on certain holidays and the British Museum, open to the public during the Easter and Whit holidays only since the late 1830s, had 32,000 visitors on the WhitMonday of 1841. With such success in the museums in London, the radicals sought to achieve something similar in the provinces and the eventual outcome was the Museums Act 1845, which enabled municipal boroughs with a population of over 10,000 to erect and maintain buildings for museums of art and science, financed out of a rate not exceeding ½d in the pound and with admission charges not exceeding 1d per person (Cunninghan 1980:105).

Neutral spaces in a conflictual world

As museums and galleries were established, the question of funding was raised. Although the Mechanics Institutes had had high ambitions, and had intended that their museums and libraries should be long-term educational ventures, many of these had in fact not been sustained for long. The learned societies, too, were often impoverished and many of the museums that they began were taken over by city authorities. Funds were always in short supply, at both local and national levels. The vision and accompanying funding that was evidenced in France with the reorganization of the Louvre was not to be repeated in Britain.

Throughout the nineteenth century the provision of public funding for the arts was inseparable from debates about national values, the future of an industrialized society, and of democracy. Some saw the arts as the last bastion of embattled upper-class culture, some as a way of bridging the widening gulf between rich and poor. A more utilitarian argument held that museums, libraries and parks could reduce drunkenness, crime and trespass and were therefore a contribution to the national economy. There were great doubts over whether a rapidly growing industrial population could fit into the old class framework. Artistic culture and museums could teach the lower classes the aspirations of their betters. Art galleries and museums would inculcate the masses with 'taste'. It was implicitly believed that an improvement in taste resulted in a moral improvement.

Libraries, museums and public parks were also seen as places where the classes could meet harmoniously in public. Charles Kingsley in 1848 praised the British Museum 'because it is almost the only place which is free to English Citizens as such, where the poor and the rich may meet together... the British Museum is a truly equalising place; therefore I love it' (Cunningham 1980:106).

Slowly over the decades the government began to accept the notion that cultural institutions should be encouraged by public funds and institutions and that these institutions could have a variety of functions, but equally, would contribute significantly to the constitution of an educated and civilized population.

Thus at the beginning of the nineteenth century museums were per-ceived as rational solutions to the need to provide opportunities for educa-tional self-help, both for the middle classes and the working classes. Muse-ums and galleries were seen as neutral spaces where all classes of society might spend their leisure time in fruitful and educational leisure. Some institutions made specific opportunities for learning available to adults in the form of lectures and classes, and to schoolchildren in the form of school visits, but the establishment of a museum or art gallery was seen as an educational act in itself.

3. *Three nineteenth-century case-studies*

The educational function of museums

By the middle of the nineteenth century the age of the public museum had begun. As we have already seen, education, understood and interpreted on many different levels and in many different ways, was regarded by many as the primary function of museums.

It is important to remember the paucity of educational opportunity that lay beneath the exhortation that museums should take on such a substantial educational function. Educational systems for children and for adults were extremely limited. The idea of schooling for all was not introduced until the 1870s. Where schooling was a possibility attendance was often very erratic (Lawson and Silver 1973:278), the teaching rudimentary, and the content narrow. The Mechanics Institutes had lost their impetus by the middle of the century and in many cases the lecture courses for adults had become haphazard and the museums and collections dispersed. The growth of public libraries was slow, and by 1869 only thirty-five places had taken advantage of the two Public Libraries Acts in 1850 and 1855 to open local facilities (Lawson and Silver 1973:279).

With few other openings for self-help in education, museums were perceived as places where learning opportunities could be offered that would improve the individual learner and contribute to the social good. In the 1880s a list of 'Useful Rules to Keep in Mind on Visiting a Museum' was drawn up to help the visitor:

1. Avoid attempting to see too much.
2. Remember that one specimen or one article *well* seen is better than a score of specimens casually inspected.
3. Before entering a Museum ask yourself what it is you wish particularly to see, and confine your attention largely to those specimens. Consult the attendant as to what is specially interesting in each room.
4. Remember that the main object of the specimens is to instruct.
5. Have a note-book with you and record your impressions so that on a succeeding visit you may pick up your information where you left off in the previous visit.
6. Introduce in conversation your impression of what you see in Museums.
7. Consult frequently the technical literature on the special subject in

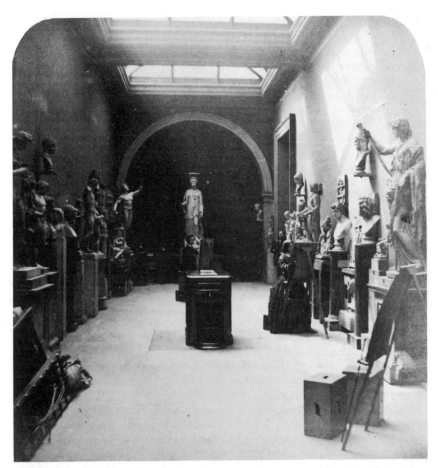

Plate 1 Museums and galleries have been a source for art education since their beginnings. Art students were often to be found sketching in the galleries in the British Museum at the end of the 19th century. Courtesy the Trustees of the British Museum.

which you are interested.

8. Visit the nearest Museum periodically, and let it be to you an advanced school of self instruction.
9. Remember there is something new to see every time you go.
10. Make a private collection of *something*. Remember that a collection of postage stamps has many uses.
11. Follow up some special subject of Museum study.
12. See slowly, observe closely, and think much upon what you see (Greenwood 1888:388).

Three case-studies demonstrate different ways in which the learning potential of museums was developed.

The South Kensington Museum

The first case-study shows how a large national institution prioritized the needs of visitors. In the 1850s Henry Cole was in charge of both the new Department of Practical Art (which was part of the Department of Trade and was later to become the Department of Science and Art), and the new Museum of South Kensington (to be later renamed the Victoria and Albert Museum). The new museum in South Kensington was the most visible of the Department's initiatives in relation to the use of museums for educational purposes, but the Department was also involved in attempts to establish local museums, galleries and art schools across the country (Minihan 1977:108). The establishment of museums was seen as a method of enabling all classes to investigate what was described as 'those common principles of taste which may be traced in the works of excellence of all ages'. The First Report of the Department of Practical Art spells it out:

> Indeed, a Museum presents probably the only effectual means of educating the adult, who cannot be expected to go to school like the youth, and the necessity for teaching the grown man is quite as great as that of training the child. By proper arrangements a Museum may be made in the highest degree instructional. If it be connected with lectures, and means are taken to point out its uses and applications, it becomes elevated from being a mere unintelligible lounge for idlers into an impressive schoolroom for everyone. [Minihan 1977:112]

Following the Great Exhibition of 1851 the South Kensington Museum was established. From the beginning the museum was explicitly destined to be used for educational purposes, and Prince Albert had at one time intended to use the large South Kensington site for a combination of teaching colleges and closely related illustrative collections that would have covered every interest represented at the Crystal Palace (Altick 1978:498). The first collections included those that had been acquired for the School of Design and the school and the museum were intimately connected (Physick 1982: Fig.16).

Henry Cole organized the museum with the needs of the public in mind. Admission was free for half the week, and 6d on the other days, and its hours of opening included evenings for the convenience of working people. The brightly lit evening interiors, at a time before the use of electricity, were exhibits in their own right. It was pointed out in 1883 that 30 per cent of all visitors to the museum had gone in the 12 hours per week of evening opening, as opposed to 70 per cent attending in the 42–48 hours of daytime opening (Hudson 1975:70). Inexpensive catalogues were available.

A refreshment room was provided, being the first to be sited in a museum. One of the ways in which Henry Cole saw the museum being of use to working people was as an alternative to the gin palace, and he demonstrated that it was in fact performing this role through analysing the sales of liquor in the cafe. The abstemiousness of the museum's visitors was, he suggested, sufficient to lay low the bogey of drunkenness that remained a reason frequently given for excluding the general public from museums (Altick 1978: 498–500).

The museum made its collections as available as possible. Local art schools were able to borrow material for up to two months, and were able to purchase duplicate articles for half their cost to the Department. By 1855 a circulating museum had been formed 'consisting of about 400 specimens and representing each section of the central museum'. Its purpose was 'to bring home the specimens of the London Museum to the provincial towns, with a view of improving the state of art manufactures in them'. By early 1856, over 55,000 people had seen the exhibits in Birmingham, Nottingham, Macclesfield, Norwich and Leeds (Minihan 1977:114).

In terms of administration, the museum was closely tied to the educational structures of the country from its inception: in 1956 the Department of Science and Art (the original administration) was transferred to the Committee of Council on Education. With the formation of a Board of Education for England and Wales in 1899, control of the museum passed to it, where it remained until 1944, when it passed first to the Department of Education and then to the Department of Education and Science (Smythe 1966:27). The museum now has independent trustee status.

The South Kensington Museum under the direction of Henry Cole demonstrates how an informed and enlightened approach can create procedures and processes that open up resources and possibilities. At the British Museum, at the same time, evening opening was resisted on grounds that the gas-lighting would harm the exhibits (Hudson 1975:70). Calls were heard in the National Gallery to exclude working people for at least part of the time because, on the one hand, the 'impure mass of animal and ammoniacal vapour' that the crowds exuded condensed on the surface of the paintings and damaged them, but also because such uneducated and unrefined people could not possibly appreciate the paintings and were in the way of those who could (Altick 1978:501). Henry Cole's solution to the conservation problem was to glaze the paintings.

Thomas Horsfall and his museum

The second case-study demonstrates how, in a small museum, the displays were organized to forge real links with the experience of the visitors. In 1884 Manchester's first art gallery opened in Queen's Park and an experiment in working-class education began. A local merchant and philanthropist, Thomas Horsfall (1841–1932), conceived the idea, first set out publicly in a letter to *The Manchester Guardian*, of an Art Museum and a school loans system.

Horsfall worked from a different perspective from that of Henry Cole in that his arrangement of the collections was aimed at the consumer of material goods rather than the producer or designer of such goods. Where the South Kensington Museum made available examples of gorgeous brocades and splendid goldsmiths' work for the benefit of the producer of artefacts (the student of art and design), the Art Museum was to exhibit ordinary everyday objects to interest the consumer of artefacts (ordinary working people). The objective was to improve the taste of the public and

to develop their standards of beauty so that people might thereby improve their own surroundings and become enabled to lead more worthwhile lives (MacDonald 1986:124). Horsfall believed that if the working classes could be taught, it would be through pictures and through objects. At the Art Museum this was to be achieved through a walk-round hands-on display.

William Morris designed and furnished two 'model rooms', designed to demonstrate to the working classes how houses might be furnished cheaply but in good taste (MacDonald 1986:123) Originally the room was to be that of a workman's cottage, but this had to be adapted to a small house as Morris objected that he could make nothing at the prices workmen could afford (MacDonald 1986:125). The room displays were such that visitors could walk through them, and the prices of the objects were included in the labels. The things themselves could be touched; as the archaeologist Flinders Petrie said: 'do let people *paw* things—it does them a deal of good' (MacDonald 1986:126).

The specific visitor that Horsfall had had in mind in designing his display was the working-class artisan earning 30 shillings a week. The original furnishing of the room by Morris had cost £73, which was far too expensive. The rooms failed and they were soon changed. Meanwhile the collections were moved in 1885 to Ancoats Hall in a notorious slum district of Manchester. With William Morris no longer involved, a new display permitted cheaper furniture to be used. Visitors were encouraged to make furniture, based on what they had seen, and classes in carpentry were advertised in the labels of the wood-carving exhibits. A simple dress was displayed in one of the rooms and a museum handbook announced that the Committee would supply paper patterns of the dress for twopence (2d). Lantern lectures were given, and also classes in clay-modelling and drawing (Chadwick 1983: 60). In 1902 a special teacher was appointed to work with children (Anon 1901–2:171).

The visitors to the museum were, apparently, 'just the kind that the museum was intended for, the hard-working artisan and his family' (MacDonald 1986:128). It is interesting now to see an example of a museum that had a specific target audience in mind and that designed its displays, including hands-on experience, based on research of the characteristics of this audience. It is also enlightening to see how the displays were used as the source for educational follow-up experiences that were offered either at the museum, elsewhere, or to be carried out at home. The educational opportunities are made very obvious to visitors by being mentioned in the labels and handbooks.

The educational museum at Haslemere

The third case-study shows how specific educational provision was made for children in a small museum. In 1888 Sir Jonathan Hutchinson built a small museum at Inval, and 1895 a second, larger museum at Haslemere. Hutchinson was a fervent educationalist and recommended the establishment of collections of objects in museums in 'all towns and large villages'.

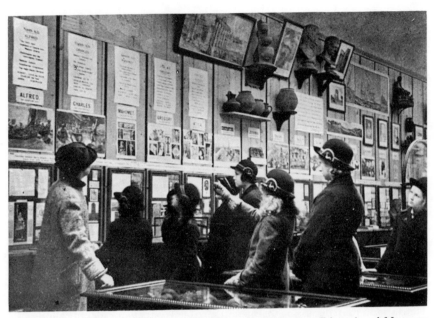

Plate 2 The displays in Jonathan Hutchinson's Haslemere Educational Museum were designed explicitly for teaching. The 'space-for-time' history gallery in 1939 shows how pictures, objects and related information are grouped to demonstrate chronological relationships. Courtesy Haslemere Educational Museum.

He thought that the objective of an educational museum should be to educate rather than to collect. A friend described him thus:

> He was a great believer in objective instruction and learning both by the eye and by cross-questioning....He would pick a flower and find in it lessons, terrestial and celestial, for all who had ears to hear or eyes to see. [Swanton 1947:5]

Hutchinson was a firm believer in the value of learning from objects and thought that museums with collections of educational objects should be established and made available to all:

> all objects should have detailed labels, and be helped in the best possible manner by photographs and drawings, the museum would thus become a richly illustrated book which those who would, might read. It would be a place to which teachers would take their pupils, not once a year as a holiday outing, but frequently, and as the best method of serious study. Never until something of this sort is accomplished will museums take their proper place, and never till they do will the natural sciences become attractive to the young, and a knowledge of them be easily got and well retained. [Swanton,1947:7]

Hutchinson's first museum was established in an adapted timber barn at his home. One space consisted of a 'space-for-time' gallery with the timber

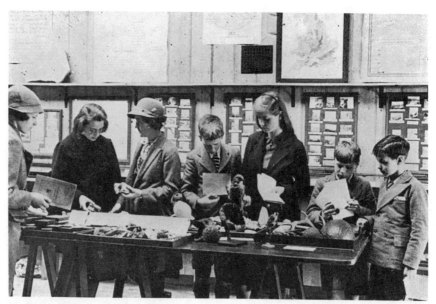

Plate 3 Children discussing objects and specimens put out for identification at the
'objective examination' at Haslemere Educational Museum in 1937.
Courtesy Haslemere Educational Museum.

walls painted with vertical stripes, each section representing a million years
of geological time. Shelves below the divisions held suitably arranged speci-
mens with labels, and related illustrative material was displayed on the walls.
The facing wall represented historic time, with similar divisions. Other
galleries held a variety of natural specimens with an emphasis on live
material, plants, fungi and amphibia (Swanton 1947:8). The labels were
printed by a young nephew who owned a printing press, and indeed each
member of the family looked after a part of the museum.

The second museum was rather larger, with a further 'space-for-time'
gallery, a book room and a picture and portrait room. Hutchinson pur-
chased the collections himself, but invited anyone who wanted to, to come
and help with the arrangement and the labelling of the collections, and to
add to the collections and particularly to temporary exhibitions, if they
wished. Friends and neighbours were exhorted to take part in Sunday
afternoon demonstrations or to give a short, fifteen-minute talk. An 'edu-
cational museum' should 'aim at supplying the means of obtaining knowl-
edge to thousands who will none of them ever themselves become collec-
tors or attempt any original work' (Swanton 1947:14).

In 1897 a curator, E.W. Swanton, was appointed, and soon made the
display of the collections more systematic, while retaining the 'space-for-
time' method, to the satisfaction of local teachers. In the spring of 1898
arrangements were made for the children from local schools to receive free
instruction in natural history. Large groups of seventy to a hundred arrived
at the museum and sat on cane-seated forms in the middle of the galleries

to listen to the curator. In the early days the teacher did not stay with the groups. Specimens and illustrations were passed round for the children to handle and observe. In 1904 a special classroom was built.

A popular feature of the museum as time went on was the development of the 'objective examination'. By 'objective' Hutchinson meant 'the inspection, identification and description of things', and he contended that no one could pass an objective examination unless the objects concerned had previously been studied and handled. In 1899 the first 'examination' took place. Ten sets of twenty questions were drawn up, published in pamphlet form and sold for 1d per booklet some time before the time for the examination itself. The age limit for candidates was 18. Candidates were allowed two months for preparation which involved not only work in the museum, but reading, asking parents and friends, and consulting encyclopedias. Only one set of twenty questions would be asked of each candidate during the examination, but which set was left to chance. In addition, selected objects (145 specimens and 75 portraits) had been on display in the museum during the preparation time and the candidate might also be asked about any of these. Ninety-two children took the first examination and forty-eight passed, receiving a book prize.

This examination was a highly structured and complex event and must have taken considerable organization. It was not held every year, and some curators of other museums pointed out that it was too time-consuming. In order to reduce the time in marking, the questions were made very factual and one-word answers were solicited. In the identification of the objects that were presented to the children, again short, one-word responses were expected. Certainly in some of the early questions, not all the answers depended on close observation of objects, although a question such as 'Which do you consider the three most beautiful birds in the Museum' was clearly designed to lead the children to the Bird Gallery.

Although Swanton (1947:39) points out some of the shortcomings of the questions, the system received from other museums considerable attention as an educational experiment and some museums also tried it. The system was still in operation in 1937 when it was described in an article in *The Times* accompanied by a photograph of the children examining the objects with the title 'Learning from Things' (Swanton 1947:44). Thus the Haslemere Museum introduced the idea that was so important in the Victorian schoolroom, that of object-teaching.

At Haslemere, we can also observe, possibly for the first time, the use of written materials to structure children's learning. Is this one of the origins of the much debated museum worksheet? It is easy to evaluate the objective examination as fragmented and over-mechanical from our post-Plowden position, but as a forty-year experiment in museum teaching methods that extended from the end of the nineteenth century to the beginning of the Second World War it has considerable significance.

These three case-studies show some of the ways in which museums were exploring the possibilities of making relationships with their visitors, both old and young. These explorations included the general atmosphere of the museum, and the facilities available to the public; the relevance of display

ideas and methods; and specific educational programmes for both chil-
dren and adults. At the end of the nineteenth century the educational
function of museums was accepted without question, and this educational
function extended right across the work of museums. Although not all
museums were able to achieve the highest standards, a comment in a
contemporary report on museums reveals the viewpoint of one of the major
policy-makers:

> The town museum should be the place to which all students and teachers of
> science in the district should naturally go for assistance. To bona fide students
> every facility and encouragement should be given, and loan collections should
> be prepared for teachers.... The practical value of museums in all adequate
> systems of education is not yet recognised by the general public. Too many of of
> these institutions have hitherto been but toys and hobbies, and require complete
> re-organisation. [British Association 1888:131]

4. Shifts and reversals

New perspectives

During the nineteenth century, education had been the prime function of the museum. The ideal museum was understood to be 'the advanced school of self-instruction', and the place where teachers should 'naturally go for assistance'. Although many museums and galleries were unable to achieve this ideal, this was a firmly held view. By the 1920s this conviction, held so strongly by nineteenth-century thinkers in so many areas of intellectual and political life, was under attack. A new generation of curators was less interested in the public use of museums, and more interested in the accumulation of collections. The professional emphasis was internal rather than external. Suggestions made after the First World War to link museums with educational structures and funding sources were strenuously resisted by the Museums Association and by many leading curators. One or two individuals, whose ideas and beliefs had been forged during the nineteenth century, and to whom the educational role of museums was paramount, continued to campaign vigorously and successfully until the end of their lives to support the developments in educational methods in museums which had occurred at the turn of the century.

Towards the end of the nineteenth century shifts in the provision of schooling and in methodologies of teaching enabled developments in the relationships of museums to schools. The Elementary Education Act of 1870 had established education as important for all children. A system of school boards was established across the country and curricula and methods of teaching became the subject of debate and investigation. Of particular importance to museums was the emphasis on the object lesson, which was stressed not only in school timetables, but also in writings on educational principles (Lawson and Silver 1973:331). The need for objects to work with could be in part satisfied by personal or school collections, but the local museum was also clearly an obvious source of material (Smythe 1966:8). Developments in museum education took place on two fronts: teaching within the museum, and the creation of loan services for sending objects into schools.

Object-teaching

The object lesson was a major feature of nineteenth-century schooling (Lawson and Silver 1973:248). The purposes of object-teaching were to

develop all the child's faculties in the acquisition of knowledge, rather than to merely impart facts or information (Calkins 1880:169). Learning from objects would enable the development of 'sense-perceptions', which, combined with reflection and judgement, could lead on to appropriate activity based on the existing knowledge and competencies of the child. The Report of the Committee of Council on Education (1894–5) pointed out that in schools where object-teaching was used, two kinds of instruction were separated, where in other cases they tended to be confused. These were 'the observation of the Object itself', and 'giving information about the Object'. The Report states:

> Object Teaching leads the scholar to acquire knowledge by observation and experiment; and no instruction is properly so-called unless an Object is presented to the learner so that the addition to his knowledge may be made through the senses.... In Object-Teaching the chief interest in the lesson should centre in the object itself. [Smythe 1966:7]

A contemporary writer states: 'Object-teaching prepares the learner's mind by development begun through sense-perceptions, and continued by observation and reflection, to understand clearly the important facts concerning things and acts, and their relations to spoken and written language' (Calkins 1880).

This writer sets these ideas on the one hand firmly within the child-centred progressive theories of Rousseau, Pestalozzi and Froebel, but also positions them in the context of the seventeenth-century philosophers Bacon and Comenius, both of whom had stressed the need to use the material world, rather than received opinion, to develop knowledge and scientific thinking. Bacon is quoted by Calkins:

> Man, being the servant and interpreter of nature, can do and understand so much, and so much only, as he has observed, in fact or in thought, of the course of nature; beyond this he neither knows anything, nor can do anything.

Calkins quotes Comenius also: 'Instruction will succeed if the method follows the course of nature. It must begin with actual inspection, not with verbal description of things. What is actually seen remains faster in the memory than description a hundred times repeated.'

Bacon and Comenius are also referred to by a second contemporary writer, the principal of the Girls' High School of Berlin. A quotation from Comenius is used: 'Man first uses his senses, then his memory, next his understanding, and lastly his judgement' (Busse 1880). This writer too draws a line that links Bacon and Comenius to Rousseau, Pestalozzi and Froebel.

The value of learning from the real world, and from real things, was indeed stressed even earlier than the seventeenth century by Aquinas, who wrote in the Middle Ages: 'It is natural to man to reach the intelligibilia through the sensibilia because all our knowledge has its beginnings in sense' and 'spiritual intentions slip easily from the soul unless they are as it were linked to some corporeal similitudes, because human cognition is stronger in regard to the sensibilia.' By 'the sensibilia' Aquinas means the

real concrete material world. Abstract notions cannot be fully understood, he states, unless they have some grounding in material experience (Hooper-Greenhill 1988c).

The use of objects as part of the learning process can therefore be placed within a long history and tradition of teaching and learning. Object-teaching was common in schools in the second half of the nineteenth century and many of the methods of teaching from objects that were recommended at that time are recognizable as similar to those methods in use today. The recommendations concerning the presentation of objects to be apprehended, first through the senses, second in relation to things already known, third to be grasped and understood, and lastly to be critically considered, have stood the test of time.

Object-teaching in schools began to decline at the very end of the nineteenth century, coinciding, curiously enough, with a growth of organized visits of schools to museums. Since then, object-teaching has had a bad press, being seen as mechanical and as part of a discredited system of rote-learning. The production of endless object-teaching textbooks showing teachers precisely what to do, and the system of payment by results, both no doubt contributed in different ways to poor teaching. However, the basic principles were sound, and the interest in using objects in learning and teaching must have had a profound influence of the perceptions of museums as educational institutions.

School visits to museums

Organized school visits to museums began as museums were established. At both Norwich (Frostick 1985) and Scarborough (Stephens and Roderick 1983: 32), as we have seen, children were taken on school visits by their teachers. However, it was not clear initially if a visit to a museum counted as having educational value. Traditional teaching was always in the classroom, although the Pestalozzian method had argued for enlarging the experiences of students. In 1895 efforts on the part of Thomas Horsfall and the Committee of the Manchester Art Museum led to an adaption to the day school code to allow visits to museums to count as educational activities (Haward 1918:35):

visits paid during the school hours under proper guidance to museums, art galleries, and other institutions of educational value approved by the Department may be reckoned as attendances ...provided that not more than twenty such attendances may be claimed for any one scholar in the same school year, and that the general arrangements for such visits are submitted for the approval of the Inspector. [quoted in Smythe 1966:11]

Two years later, advice is given to encourage such visits, but only if there is a competent person available to work with the children. This official blessing enabled teachers to visit museums and galleries more freely. In 1899, for example, the girls from St Mark's School, Kennington, were taken out to

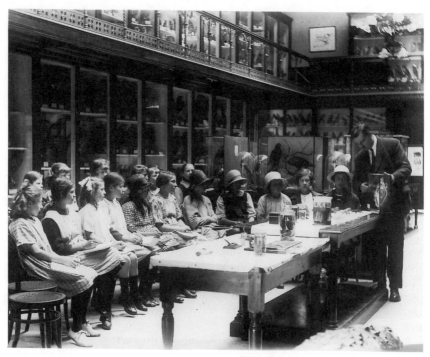

Plate 4 The 'museum demonstrator', H. J. Howard, appointed after the First
World War by Norwich Education Committee to teach at the Castle
Museum, leads a museum class in the 1920s. Courtesy Norfolk Museums
Service.

visit the Tate Gallery, the Tower, Westminster Abbey and Kensington Palace (Lawson and Silver 1973: 381).

The question of who should teach the children in the museum was raised. The teachers felt that the museum staff who had the knowledge of the collections should do so, while the curators felt they had neither the time nor the training to do it adequately. This issue raised the whole question of the educational function of the museum in a new way. The newly founded Museums Association spent much time debating this and a variety of views were expressed. These ranged from that of E.R. Lankester who declared:

> I desire once again most emphatically to state my conviction that the instruction and interest offered by the collections in museums is by no means of a nature specially fitted for childrens' minds. I doubt very much whether children should be taken to any museum, except as a treat, and then only for a very short visit;

to that of E. Howarth who said: 'I sincerely hope myself, that, before long, all provincial museums will come under the management of educational boards, and that they will be directly co-ordinated with the teaching in our schools, both elementary and secondary' (Smythe 1966:4).

One solution to providing a museum teacher was that the education committees should make grants to the museum to meet the cost of a museum assistant who would cover the time spent by the curator in lecturing. Another possibility was that the education committee should appoint a specially qualified teacher to work in the museum. Various and often temporary solutions were tried, but no general pattern emerged.

Loan services to schools

If it was difficult to establish the structures on which to base the provision of lessons in museums for schoolchildren, the development of loan services to schools was more straightforward, perhaps because it was easier to deal with accumulating a collection of objects to send to schools than it was to grapple with teaching appointments, methodologies and training. Liverpool (1884), Sheffield (1891) and the Ancoats Museum (Chadwick 1983:60) were among the first provincial museums to circulate material to schools, although the circulating department of the Victoria and Albert Museum had been in operation since 1864. In 1889 the newly formed Museums Association, with Henry Higgins as its President, had as one of its objectives 'the preparation [by museums] of small educational loan collections for circulation to schools (Rosse Report 1963:288; Lewis 1989:10).

The first loan service was in fact established by Henry Higgins in Liverpool. Higgins had held office in a number of local societies, was a former Inspector of schools, and in 1889 was elected first President of the Museums Association. In 1883 he wrote to the Liverpool School Board on behalf on the museum subcommittee offering to distribute useful duplicate specimens to various elementary schools. This was to be a long-term venture aimed at establishing school museums. The reply from the School Board suggested that a collection of suitable objects that might be borrowed for particular lessons might be of more use. One hundred and six schools were contacted by Higgins and teachers were invited to an evening meeting to discuss the best way forward. A loan service was established the following year with sixty-four schools participating. The loan boxes were delivered to schools on a regional basis in a museum van by a loan services officer who recorded the delivery in a Parcels Book and asked the teacher in receipt to sign. The teachers reported that teaching with the specimens was very popular and that they were always assured of a good attendance at those lessons. In the poorer parts of the city it was reported that attendance would have been very poor but for the cabinets (Chard 1890: 57–58).

The educational principles that lay behind the design of the loan service are important. Higgins had been a student of Pestalozzi and followed his child-centred principles: 'The object of the circulating museum is not so much teaching as training; not so much the inculcation of facts as the illustration of the happiness to be obtained through habits of observation.'

On the type of specimen thought to be suitable for loan services Higgins wrote:

The specimens recommended for object lessons are not costly rarities, but each should be good and perfect of its kind; six or eight inches in length, where such a size is ordinary; not exceedingly fragile, yet all the better if requiring respect and care in being handled by the children;

on the value of specimens:

A specimen of considerable excellence, say a mineral or a shell, will not only assist the teacher in firmly implanting the instruction he wishes to give on its geographical distribution, place in nature, and economic applications, but the beautiful and uncommon thing itself, if sent amongst children to be handled with care, and felt, and looked at closely, will, I am firmly persuaded, excecise a good moral and refining influence on some of them;

on the use of specimens:

'In every possible case the interest of the specimen should admit of being humanized—associated with man, his history, his necessities, his discoveries, his tastes. [Chard 1890: 60–3].

The example at Liverpool was followed elsewhere. Sheffield Museum established an early loan service based on the Liverpool model and with the same collaborative characteristics as that at Liverpool. By 1897 Elijah Howarth, a former colleague of Higgins, was working with the local Teachers' Guild to prepare loan cabinets, with the museum providing the specimens and the Teachers' Guild paying for the making of the cabinets. The selection of specimens for the cases was based on the needs and wishes of teachers. Howarth had strong educational views and stated 'It is a good principle that if you are going to show anything to young persons, a boy or a girl in the school or in a museum, it should be of the best, so that they can learn exactly what it is ' (Howarth 1918:8). These two early examples were influential and loan services gradually began to be established in other places.

The national museums

The development of educational provision took a different form in the national museums, which had found a champion in Lord Sudely, an active campaigner for government support and interest. One of Sudely's aims was that 'our museums and galleries should be made to supplement the work of our schools, and that these two parts of the nation's educational equipment should be brought into one harmonious whole' (Sudely 1913:1219).

Sudely proposed a far better attention to public services so that 'museums and galleries instead of being shunned as dreary and unintelligible deserts would be recognised as attractive places to which the public might gladly and gratefully resort with the certainty of obtaining much delightful and interesting information' (Sudely 1912:271). He pressed for the sale of photographs and postcards in museums, but the main thrust of his effort was for the establishment of guide lecturers. Letters were written to *The*

Times, leading articles picked up the theme, and in 1913 the House of Lords debated the idea. A writer in the *Glasgow Herald* in 1910 pointed out that similar schemes for the general public and for schoolchildren had been in operation in the Metropolitan Museum of New York for the past two years, and for a longer period in the Boston Museum (Anon. 1913:11).

As a result of the work of Lord Sudely, developments could be observed in some of the national museums. Through governmental encouragement and assistance, the British Museum appointed a guide lecturer, Cecil Hallet, in 1911. He gave talks free of charge to groups of up to thirty, every weekday at noon and at three o'clock and at other times by arrangement (Hallett 1913: 44–5). This proved to be popular and two years later a second guide was appointed. The Natural History Museum had followed suit in 1912. The Victoria and Albert Museum appointed a guide lecturer in November 1913 and it was reported that by February 1914, 60,000 people had used their services. By April 1914 the Tate Gallery, the Wallace Collection and the National Gallery had appointed guides.

Sudely's work was hampered by the outbreak of war, but later he resumed his efforts, campaigning until his death in 1922. His obituary in the *Museums Journal* recorded that:

> The museum movement generally suffers a great loss. During the past twelve years his [Sudely's] chief concern was the popularising of our museums and art galleries with a view to making them an educational and uplifting force throughout the country. In working for this cause he found himself faced by deadly apathy and want of vision.

The effects of the First World War

The First World War affected the educational work of museums in relation to exhibitions and provision for schools. In the immediate pre-war years and during the war itself, the educational potential of exhibitions was exploited in quite specific ways. Exhibitions related to health and welfare campaigns were popular and frequent at this time, although some topics related to the reality of warfare were forbidden by the War Office (Kavanagh 1988:167–9). Leicester Museum, for example, in conjunction with the Leicester Health Society, mounted an exhibition on child-care. The Natural History Museum opened an exhibition entitled 'War on House Flies' in 1915, and museums in Norwich, Newcastle, Bristol, Salford and Belfast followed suit (Kavanagh,1988:167). Health, hygiene and food preparation were all popular topics for museum exhibitions at this time.

Along with the concern to educate and inform adults that accelerated with the outbreak of war, new initiatives emerged in provision for children, some of which were to have very long-lasting effects. During the war, many school buildings were appropriated for military purposes, teachers were called up, and a general shortage of resources of all kinds led to some school authorities turning to museums and galleries for specific educational provision for children. The best known example was at Manchester, where a

scheme for working with schools was already in existence. Here classrooms were set up in the museum, and children went on a half-day basis, with the rest of the time spent in their own schools. Trained and experienced teachers were provided and paid for by the city Education Committee, and were given instruction by the curators in the nature of the collections (British Association, 1920:279–80). A well-integrated system was established which developed some basic parameters which remain vital today. These include the concepts of pre- and post-visit work, the training of teachers in collection-specific knowledge, the limitations of the size of classes in the museum, and the integration of the museum visit with schoolwork.

The work at Manchester was described in detail at a conference in Sheffield in 1917, and it is clear that the value of museum learning had been fully recognized by at least some museum professionals. Lawrence Haward, curator of the Corporation Art Galleries, made the following remarks during a discussion of the educational work carried out in Manchester Art Gallery:

> What is perhaps the most obvious is the sharpening of the intelligence and of the powers of observation. Not only is the intelligence of the average child sharpened, but what seems to me to be very valuable is that a boy or girl who appears to be backward or slow in class very often turns out to be keen and intelligent in the Gallery. These visits to the Gallery, then, help the backward, sensitive child, as well as the average child.
>
> Besides this, they have the result, to which teachers rightly attach considerable importance, of increasing the children's critical faculties and their capacity for self-expression. The children are, in fact, being made to think and feel for themselves. [Haward 1918:36].

Other museum education systems were established at Salford (Mullen 1918:21–5) and at Norwich (Durbin 1984; Frostick 1985). Liverpool and Sheffield extended their schoolwork. In Aberdeen, a picture loan scheme had been maintained throughout the war years (Martin 1918:26–8). The Victoria and Albert Museum began making wartime provision for children by opening a children's room in 1915 for holiday activities during August and at Christmas, using volunteer teachers (Kavanagh 1988:169–171).

Museums responded to social need during the First World War by using their resources where they were required. Exhibitions were used to convey information and to communicate ideas that were of immediate and pressing use, and the existing work with children was built upon to construct complex systems for teaching where schools were unable to continue. These efforts were successful in positioning museums in the nation's consciousness in a way that had not happened before. Suddenly museums were perceived as useful and educational agencies were anxious to maximize this. The First World War lent impetus to the educational enthusiasm and pioneering zeal of a group of men who had been born in the mid-nineteenth century and who still carried with them many of the old ideals of their youth. Howarth, for example, was in his mid-sixties at the end of the war, and Lord Sudely was a decade older. Unfortunately, their unquestioning beliefs in the educational role of museums and galleries were not to be upheld by the generation that followed.

Contradictory attitudes and lost opportunities

In 1913 the British Association had, at its Birmingham meeting, established a committee 'to examine, inquire into, and report on the character, work and maintenance of museums, with a view to their organization and development as institutions for Education and Research: and especially to inquire into the requirements of schools'. The work of this committee was disrupted by war and the report was not presented until the British Association meeting in Cardiff in 1920 (Lewis 1989:30–2).

In the report *Museums in relation to education,* the educational role of museums was laid down fairly clearly. There were three main elements: carefully planned exhibitions with objects selected and arranged in such a way as to convey some information and with labels written for the same purposes; work with schools, including the maintenance of circulating collections of objects, and the holding of classes in museums; and the provision of lectures and demonstrations for the adult public. Work with advanced students of all sorts (research students, university students and collectors) was also considered extremely important (British Association 1920:269–70).

This clear understanding of the educational responsibilities of museums and galleries did not mean that the British Association was whole-heartedly enthusiastic about potential new developments in museum education. Indeed, the report took a conservative and defensive stand, particularly in relation to increased links with LEAs. A new Education Act in 1918 had made it possible for LEAs in England and Wales to grant-aid museums for the purposes of encouraging school visits for educational purposes (Miers 1928:11; Lewis 1989:31). (The situation in Scotland and Northern Ireland was slightly less favourable (Miers 1928:13–14)). The British Association report stated, rather defensively, that many museums had, on their own initiative, anticipated many of the actions that such co-operation would entail. Furthermore, it asserted with relief, it had thereby been demonstrated that educational work in museums could be carried out without damage to the other functions of museums. Given an adequate staff and an increased maintenance income, the report continued, museum curators, in conjunction with teachers, could work out suitable ways of developing the educational use of their collections. Teachers themselves, the report stated, had been found to be unable to realize the educational possibilities of museum objects because of their lack of training and experience (British Association 1920:270).

The report described how many provincial museums were already working in liaison with LEAs and with teachers. One hundred and thirty-four museums were surveyed and the report points out that by 1914 instruction was given by teachers alone in 28 museums; by teachers with some assistance from curators in 24 museums; in 16 museums instruction was given by museum staff alone; and sketching parties of students from Art Schools were regular visitors in most of the museums (British Association 1920:270).

One of the report's most interesting features is the commendation of the

educational work of some American museums, which is described in some
detail. Some of the educational arrangements had been observed on a visit
by the Committee to the United States. The Natural History Museum in
New York, for instance, had prepared sets of loan boxes on the subject of
natural history which were sent out to schools in 'special motor vans'. In
1913, 1·25 million students in 501 schools had used these 'circulation sets'.
Teaching collections had been established by the museum, and classrooms
and a lecture theatre were available. Members of staff lectured to teachers
and to children, and a guide service for the general public had been
established. Special handling provision had been made for blind students.
A lantern-slide department had been in operation for some time with a
collection of 30,000 slides which could be borrowed by teachers. Strong
links had been made with Columbia University, with staff holding joint
museum/university appointments and using the museum for teaching.

The committee notes the use in America of the 'docent' system:

> These ladies and gentlemen are chosen for their special knowledge, and are
> maintained either by the Museum or the city, or partly by both, or in some cases,
> as at the Brooklyn Institute of Arts and Sciences, by an Art League. The two
> 'Docents' of this Museum lectured to 114,000 pupils in one year. [British Asso-
> ciation 1920:279]

'Docentry', the use of volunteer guide lecturers, had begun to emerge in
American museums before the First World War and seems to have been
rapidly established (Newsom and Silver 1978: 242–6).

The British Association report comments that American museums have
been able to develop educational work of this standard and quantity because
they are in receipt of large sums of money from wealthy persons and they
also have large enthusiastic staffs. In addition, it is pointed out that Ameri-
can museums are all associated with a large body of rich and cultured people,
who support the museum through donations of money and artefacts. The
report explains that as the educational work of the museum expands, so the
museum is seen to be more popular and useful and becomes more highly
valued by the community, the achievements of the staff are recognized, and
more opportunities are found for the development of research.

These enthusiastic comments sit oddly with the remarks made on the
development of the educational role of museums in Britain, where the
Committee seem to take a rather different view. The links and networks
that American museums and galleries had been observed to depend on
were not recommended. Indeed, the whole tone of the report was that
museums were achieving well on their own, and that curators, with some
assistance, were the best people to carry out educational work. A fear of
being swallowed up by the larger and more powerful educational world may
have lain behind this emphasis on maintaining the status quo and uphold-
ing the institutional integrity of the museum.

Concerns both by government and by some sections of the profession to
maximize the educational potential of museums had been in evidence
immediately after the war. The Board of Education had sent five delegates

to the conference on the educational value of museums, probably organized by Howarth, and held in Sheffield in October 1917. A copy of the report was sent to the President of the Board of Education (Howarth 1918). Central government was reviewing the role of museums and galleries and a year later the Education Act of 1918 encouraged a closer link between local education committees and museums. The Ministry of Reconstruction's Committee on Adult Education (also 1918) went further than this and recommended that museums should be included in any scheme of education for a local area and that with this link they should also be included in any state grants allocated to local authorities. A further suggestion was that libraries and museums should be transferred to the Board of Education and administered by the Local Government Board.

The British Association report was not happy with any of these suggestions, complaining that neither the Committee nor the Museums Association had been consulted. The report advised that:

> the recommendations of the Committee on Adult Education for the transference of Museums by an Order in Council to the control of the Board of Education, may, if pressed too far, seriously prejudice the functions of museums as conservators of material and centres of research.

In spite of the enthusiasm for the educational work of American museums, and the recognition of the fact that this educational work increased the appreciation of and funding for the other functions of museums, this way forward was not seen to be appropriate in Britain. The argument was put forward that museums should be centres of research, like universities. Moreover, it was pointed out, new legislation was unnecessary, as the Library Act of 1919 already allowed both town and county authorities to run museums, and also allowed for the transfer of museums to the education authority, if desired (British Association 1920:268).

These proposals for restructuring the organization of museums at local government level were radical, and had they been implemented, would have resulted in a very different history of museum education. As it was, the recommendations were strongly resisted by museum curators and in many ways polarized views of whether museums were or were not educational institutions. Strong arguments were made that they were not, and perhaps for the first time ideas were articulated about museums as collections of beautiful things *per se*. The Director of Leicester Museum, Dr E. E. Lowe, for instance, pointed out that 'when we long for a rare or beautiful or typical object, we are desiring it for its own sake primarily, and not chiefly because it will educate person or persons unknown' (Kavanagh 1988:173).

The case was made strongly for museums as institutions discrete from schools, and with other functions. These other functions were upheld with pride and fervour. Up to this point, the educational role of the museum had been seen as inseparable from its role in the collection, curation and research of objects. Now, a distinction was drawn between the role of the museum in education and the other functions of the museums. The collection and care of artefacts began to emerge as a distinct activity with its own justifications and its own ends.

5. Between the wars

The Miers Report

In 1925 the Carnegie United Kingdom Trust (CUKT) began to take an interest in museums. This involvement was to be highly significant and far-reaching in the development of museums and galleries. CUKT's first action was to survey the provincial museum field to see how these institutions could be helped. The survey paid special attention to museums in relation to 'public education', that is, education in its broadest sense. Sir Henry Miers, a former Vice-Chancellor of Manchester University, was asked to conduct the survey. Miers had served on the British Association Committee and the Adult Education Committee of the Ministry of Reconstruction and would also be a member of the Royal Commission set up in 1927 to investigate the national museums.

The Miers Report emerged in 1928. There were at this time 530 local museums in Great Britain and Miers had visited many of them. He found that geographical distribution was haphazard, with many towns being without museums. Staffing was very limited, with, for example, only 4 per cent of museums having an assistant curator. Most curators were appointed in middle age with no training, and many also had duties as librarians. Miers found most museums congested and overcrowded with duplicate objects, with labelling systems that were incomplete or intelligible only to experts.

Miers noted that many museums had only recently begun to perform a wider public role. He pointed out that museums existed for 'the purposes of storing, exhibiting and utilising objects of cultural and educational value' and that 'the service rendered by museums was of a threefold nature, according to the extent to which the collections are directed to the needs of (1) the general public; (2) school-children or adults seeking instruction; and (3) advanced students and investigators' (Miers 1928:31).

In relation to the general public, Miers found that most museums were sadly lacking in any thought or provision for their needs. He lamented the fact that only three municipal museums employed guide lecturers for gallery tours as did the national museums. Hardly any museums possessed lecture theatres for more formal lectures. There were few educational exhibits.

Turning to his second category, provision for schools, Miers commented that in 20 per cent of museums organized visits from schools were arranged and were counted as school attendances. In three museums, Greenwich, Leicester and Norwich, he noted that specialist staff were employed. At Greenwich and Leicester, classes were conducted by guide lecturers. In

Norwich a set lecture was delivered and specimens were brought out from cases to the lecture room. The service had begun after classes had been sent to the museum during the war years. Later Norwich Education Committee had appointed a museum demonstrator to work in the museum with children (Durbin 1984: 23).

Miers commented on the schemes at Salford and Manchester, and gave details of numerous other ways in which museums were making educational provision. At Reading, the curator ran courses for teachers, who then brought classes to work with the specially arranged collections; Batley, Warrington, Ipswich, Stepney, Middlesborough and other places sent out loan cases; at Leeds and Salisbury, the curator went into schools with lantern slides; at Haslemere, the objective examinations were noted.

Miers was very critical of the amount of financial assistance that museums received from Education Authorities. Very, very few of either the county or county boroughs or town authorities gave any financial aid. Only ten out of the fifty English county councils encouraged visits by schoolchildren to museums and only three of these made grants to museums. Leeds was found to be an exception, where the Education Authority gave £285 per year to the committee of management of the Leeds School Museum Scheme (Miers 1928:33).

Turning to his third category of service, provision for advanced students and investigators, Miers pointed out that university museums generally had their collections arranged systematically for their own teaching purposes, but did nothing further for other visitors. For adult visitors who were not part of a specific group, there was no provision in the vast bulk of provincial museums. Field clubs and other societies, he pointed out, were not as active as they used to be, and the Workers' Educational Association and other tutorial classes had failed to stimulate demand.

Miers stated quite baldly that if the function of a museum was:

> by means of exhibited objects to instruct, and to inspire with a desire for knowledge children and adults alike; to stimulate ... stir the interest, excite the imagination of the ordinary visitor and also be for the specialist and the student a fruitful field for research [Miers 1928:37–8]

then most museums failed and failed lamentably, partly because of 'the hampering shackles of the museum tradition' but also because of lack of policy. Policies were required for collection, with unwanted gifts being refused, and for display, with each exhibit having a definite purpose. Miers suggested that there was opportunity for experimentation with children's museums, and that a museum for the blind would be a good idea (Miers 1928:42).

Although Miers was clearly shocked and disappointed by the run-down state of most provincial museums, he did point out that 'a livelier sense of the educational possibilities of museums is growing, and it is becoming customary to recognise some responsibility towards school-children' (Miers 1928:55). Many of the recommendations of the report concentrated on the relationships museums could make with their various audiences.

in relation to the general public Miers recommended instituting chang-
...g exhibits, better publicity, a refreshment room, better displays, a 'what-
to-see' leaflet and where possible a comprehensive guidebook. For students
and schoolchildren, an introductory display was recommended, where the
exhibits would have a specific didactic purpose, and be supplemented by
explanatory labels, casts, models and so on. This 'introductory series' or
'index collection' would act as an orientation to the rest of the collections
and would help to make them comprehensible. The introductory section of
the museum was recommended to have labels written in non-technical and
non-scientific language, which would be comprehensible both to children
and to ordinary visitors (Miers 1928:67).

In relation to specific provision for schools, Miers commented that
school visits to museums could be better organized, that special handling
collections were needed, and that a special room for schoolwork was re-
quired. For rural areas, Miers recommended the establishment of a county-
wide system of travelling museums working from a central museum (or
other headquarters) to take museum material into schools. A catalogue of
the material, arranged in relation to the school curriculum with the assist-
ance of directors of education and headmasters could be prepared. The
material could be distributed by 'motor vans', and the whole scheme could
be directed by the education authorities. Miers suggested following the
example of the systems at Brooklyn and St Louis in the United States.

The conclusion of the report made clear Miers' opinion of the great
potential of museums, while acknowledging that the reality, at least in the
provincial museums, was rather grim:

> The time is ripe for a movement that will sweep away the conventional attitudes
> towards museums and arouse widespread enthusiasm for them. To put it bluntly
> most people in this country do not care for museums or believe in them; they
> have not hitherto played a sufficiently important part in the life of the commu-
> nity to make ordinary people realize what they can do.

It is interesting to consider the Miers Report in context. Miers was
surveying museums approximately ten years after the Museums Association
meeting in Sheffield that had spent so long discussing educational possibili-
ties and describing good practice, and at which several Inspectors of
Schools were present. It was also eight years since the the British Associa-
tion report, in which the educational role of museums was treated with
caution, and eight years since the heated debates over proposals to link
museums more closely with LEAs.

It seems from Miers' observations that since the end of the First World
War very few provincial museums had been carrying out innovative and
exciting curatorial work. Miers describes most museums as having no col-
lection policies or strategies, with dingy, static and badly labelled displays,
and with curatorial research work virtually non-existent (the Pitt-Rivers
Museum in Oxford and the Horniman Museum in London are listed as
exceptions to this).

On the other hand it does seem that the educational work of museums

increased during this period, although patchily, with no unified approach and with little assistance from LEAs. Indeed, Miers points out that at this time (between 1925 and 1928) most of the Education Authorities were ignorant of and quite indifferent to the possibilities of learning in museums (Rosse 1963:289). The suggestions made shortly after the First World War, that local education authorities should govern museums, which had been repudiated, had certainly not led to any closer links between museums and LEAs. Only at Manchester and Norwich were Education Committees funding special museum teachers. Most museums at this stage were devising their own individual schemes for educational provision, with the educational work being done mostly by curators.

A report on American museum work

The Carnegie United Kingdom Trust was anxious to bring the example of American museum practice before the museums profession in Britain. Dr E. E. Lowe, Director of the city museum and library in Leicester, was commissioned by the Trust to visit American museums and write a report on what he found there as a companion to the Miers report. American museums had been admired in Britain since the turn of the century, especially for their generous financial support, their large buildings, their attention to display and their educational work.

Lowe noted that museum directors were responsible for generating much of their operating income from voluntary subscriptions. This had led to organized membership systems, and active campaigns to increase interest in and donations to museums. Buildings were newer, larger and better equipped, and many had excellent lecture rooms, reflecting the importance placed on 'the provision of illustrated public lectures as an integral part of the work of the museum' (Lowe 1928:20). Displays were modern, dramatic and well labelled.

In spite of Lowe's outburst eight years earlier against education as a reason for collecting, he recognized the value of museum education and the educational work of American museums was commented upon at length. This included the description of large and elaborate loan services, which loaned material to schools and to individual children; specific departments of museums devoted to work of all sorts with children and teachers; close links with universities and colleges; special school service rooms and buildings as part of museums; and children's museums. Lowe pointed out that even though this work was extensive and well established, neither museums nor schools were satisfied, and the American Association of Museums had convened a joint committee of museum people and members of the National Education Association to look into methods for closer co-operation.

Lowe concluded by mentioning the educational work that was carried out in British museums (Hull, Leeds, Leicester, Liverpool, Manchester, Salford, Sheffield and Warrington), both with and without the help of education committees. If systematic co-operation could be instigated in Britain on American lines, he suggested, 'not only would this add much of

value to the lives of children which would otherwise be lacking, but museums themselves would in the near future be more widely appreciated and better comprehended' (Lowe 1928:31). Looking back, this statement is not without irony. It represents a remarkable change of heart. Had Lowe held these views earlier, the history of museums and museum education might have been very different.

The Board of Education Memorandum 1931

By the beginning of the 1930s, the educational establishment in England was at last beginning to take notice of museum education. With the encouragement of the Standing Commission, the Board of Education published some guidelines: *Museums and the Schools: Memorandum on the possibility of increased co-operation between public museums and public educational institutions* (Board of Education 1931). This acknowledged right at the start that it was beginning to look as though valuable educational opportunities were being lost in museums. The Memorandum showed how the current position had developed, and thoroughly reviewed the contemporary situation in relation to museums' work with schools. Of the 400 museums in England and Wales, about twenty lent objects and specimens to elementary schools, about fifty museums were used by schools for organized school visits and a further hundred or so were used in a more casual and unsystematic fashion.

Different forms of collaboration were described, including visits of secondary schools to museums (where the Memorandum pointed out that girls' schools seemed to have progressed further in this direction than boys' schools); loans of exhibits; visits of teachers to museums; information for teachers about the museum and teachers' courses; identification of specimens and mutual collecting; and the production of reproductions and publications, where the valuable work of the national museums in this field was acknowledged.

Many examples of good practice were given, both overseas and in Britain. The overseas examples included the Brooklyn Children's Museum, the St Louis School Museum and the museum in Cleveland, Ohio in the United States; the Deutsches Museum in Munich, an early interactive science museum; and folk museums in Denmark, Sweden and Holland. The English and Welsh examples included several from London, where the work of the London County Council in collaboration with the Victoria and Albert Museum, the Bethnal Green Museum, the Science Museum and the London Museum was described, as were some teachers' courses that involved an introduction to museums: among other examples mentioned were a room set aside for blind visitors at the Bagshaw Museum, Batley; the school museum scheme in Leeds which had been operational by 1931 for more than thirty years; and the work at Manchester, Norwich, Salford and Salisbury. The National Museum of Wales had recently opened and the displays were arranged with separate classes of visitors in mind, as recommended by Miers; the museums at Merthyr and Newport were commended for their work both in lending material to schools and in well-organized school visits.

It was pointed out that there was no children's museum in Britain like the Brooklyn Children's Museum, and that the nearest to this was the Horsfall Museum at Ancoats Hall.

The Board looked forward to increased collaboration between schools and museums developing in the following decade, drawing a comparison with libraries that had only fairly recently become integrated with the school system. During the 1930s, several significant developments can indeed be noted.

Further developments in schools work

During the 1930s, efforts were made on several fronts to establish museums' links with schools. Carnegie United Kingdom Trust was involved as a funding body in most of these initiatives, since, following the Miers' report, a policy of financial help and encouragement for museums had been adopted. Museum development grants were to be made available, if matched by local authority funds, for work approved by Carnegie. Grants for the extension of museum services in rural areas were also established a little later.

As one event designed to encourage education authorities and museums to work together, CUKT and the Museums Association arranged a display of cased exhibits from the loan services then in operation (Batley, Huddersfield, Liverpool, Middlesborough, Perth, Reading, Salford and Leicester) for the annual conference of Directors and Secretaries of Education in 1931. The specific objective of this exhibition was to demonstrate how museums could be extended into rural areas (Rosse 1963:289).

Leicester Museum appointed a schools officer during the same year, who was later sent (with Carnegie funding) to the United States to observe the educational work of American museums. Ruth Weston described what she saw in detail, including the activities of children's museums, which clearly much impressed her, the operation of loan services, and the benefits of using docents. She returned to establish a loan service at Leicester Museum, funded partly with a grant from Carnegie and with the help of the local authority, which was to act as a model for future schemes (Weston 1939).

In 1936 Barbara Winstanley was appointed in Derbyshire by the LEA to develop a County School Museum Service, again with the help of the Carnegie grant to purchase exhibits. She spent a two-week orientation period studying the loan service at Leicester, and then began to establish her own, although in this case she had no museum on which to base the collections. She bought according to the requirements of the school curriculum, with particular emphasis on local material of all kinds. Initially the objects were cased in small glazed oak cases of a high standard, but these were soon replaced by boxes of a more simple design that although still of good quality, allowed the objects to be removed for handling. The service began in a small way, but by the end of 1939, 500 exhibits, 100 framed reproductions of paintings, and a library of gramophone records had been accumulated. Material had been sent to eighty schools, with exchanges taking place three times per term. Further grants from CUKT enabled the

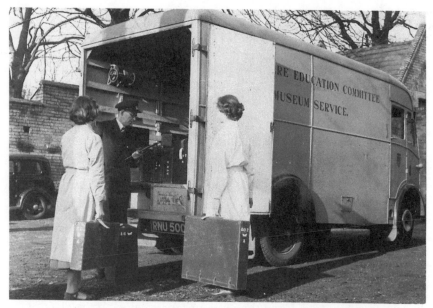

Plate 5 Loading the Derbyshire Education Committee Museum Service loans van in the 1930s. Objects were packed in small cases that could be easily handled and stacked. The boxes were identified by symbols and numbers. Careful checking ensured that objects went to the right places. Courtesy Derbyshire Museum Service.

service to continue up until and throughout the Second World War (Derbyshire Education Committee, n.d.).

A loan service was established in 1936 at Letchworth Museum. The curator, his part-time 'lady custodian' and some members of the Naturalists Society prepared the boxes. Carnegie had given a small grant and requested that the theme of each box should be relevant to the school curriculum. Teachers were asked for suggestions of cases likely to be of most use to them. Topics were mainly related to history and natural history objects and specimens. Forty-four boxes were ready by October and these were exhibited in the hall of Letchworth Grammar School. Ninety-five schools in North Hertfordshire had been circulated with details and about half expressed interest in the scheme (Hunter 1986).

The Markham Report

A second survey on provincial museums in Britain was sponsored by CUKT, carried out by Frank Markham and completed by 1938. This report was a successor to the Miers report of ten years earlier. Markham had in fact been involved with the earlier report, and had also been the Secretary to the Museums Association for a short while. Miers and Markham collaborated

on a number of museum surveys in the British Colonies, including Canada, Australia, New Zealand, South Africa, the West Indies, Fiji and other places (Lewis 1989:53).

Markham was disappointed to find that people were still not using or interested in museums and declared that 'it is primarily because of this lack of understanding that we find the museum movement in this country one of the most haphazard, one of the most neglected and one of the least understood of all civic services (Markham 1938:11). He bewailed the 'indescribable drabness' of many museum interiors, along with the diffused, uncoordinated and undocumented collections.

In relation to display and exhibition work, however, Markham did note some improvement. Effective display, which he called 'visual education', was described as the most important way forward for museums in the future (Markham 1938:84). He recommended that in order to fulfil an educational role, displays should arrest, hold and intrigue the visitor. Each exhibit should have a story to tell, and must tell the story simply, yet purposefully. Markham documented great strides forward in two of the main museum fields, those of archaeology and natural history, but noted very little progress in art galleries. Markham commended the development of special and temporary exhibitions, some of which celebrated topical events, or were related to the school curriculum. He demanded that a much greater attention should be paid to better advertising and much more aggressive publicity.

Markham was pleased to note the growth of educational work. Nearly 400 of the 800 museums in Great Britain received visits from schools, and 150 of these made arrangements for the group to be accompanied by the curator or some other member of staff. Eighty museums had guide-lecturers and eighty museums loaned material to schools. Forty museums had classes or facilities for the blind, and thirty had arranged special exhibits to coincide with BBC radio talks.

Markham commended the efforts made by museums since the end of the First World War to meet the requirements of schools. He described the Manchester scheme with specially trained, seconded teachers placed in the museums, now working with 3,000 children weekly (Markham 1938:115). Similar co-operative schemes, involving teachers working at the museums, between museums and local authorities, are pointed out at Stoke-on-Trent, Huddersfield and Norwich. Other museums were using museum staff to work either with teachers or with children. In Leeds in 1936, 9,000 children visited the City Museum, Temple Newsam and the Abbey House. At Leicester, over 350 talks were given by Ruth Weston to 10,000 children during one school year. Ruth Weston, employed by the museum as a guide lecturer, rather than by the LEA as a teacher, was also available to give public lectures and to work with adult groups from clubs or other organizations.

Various solutions to the problem of who should carry out the teaching work of the museum were by now developing. These examples show three different kinds of workers: teachers seconded from the LEA (but still enjoying teachers' terms and conditions) in Manchester, curators in Leeds, and what we should now call a museum education officer in Leicester. The

last two categories of staff would have worked under local government terms and conditions.

Markham's general recommendations for better educational provision included properly equipped lecture rooms, and better opportunity for children to see and handle material that fitted in with school lessons. He proposed developments on three levels: visits to museums by schools, loan collections to schools from museums, and school museums. Markham also stressed the need for greater co-operation between the education authorities and curators. In relation to adult education, Markham acknowledged that museums could be effective adult education centres, but given a shortage of resources, would perhaps be better confining themselves to the provision of lectures (Markham 1938:142).

Markham lamented the lack of a general museum movement, and proposed a new Ministry to oversee museums and develop policy. Failing this, he recommended that placing museums under the Board of Education might be effective, but he noted the former opposition to this (Markham 1938:171).

The Markham Report, like the Miers Report before it, had looked only at provincial museums. The educational provision in the London national museums is revealed in the survey produced by the London County Council (Rich 1936). Guide lecturers were still offering a service in almost all the national museums in London, and the topics covered are listed in the survey. Many free gallery talks were available in most of the museums. These lecture tours were open to all, except school-parties, who were generally required to book in advance for the lecture. It appears that schoolchildren were offered the same menu of lectures and the same tour format as the adults.

In the years between the two World Wars, the broad educational approach of museums gradually underwent a metamorphosis. Both Miers and Markham had understood the educational role of museums as encompassing displays, exhibitions, publications, publicity and specific provision for groups of adults and children. They had understood and applauded the ambitions of the nineteenth-century men, Sudely and Howarth. As provision for school groups increased and special staff members were appointed to carry this out, a split gradually developed between teaching in museums and curatorial work. On the whole, exhibition work became the province of the curator, and in many museums there was little relation between the teaching staff and the development and design of displays. With the further involvement of local education authorities and the appointment or secondment of people with school-teaching experience, but with no museum experience, this narrowing of the perception of the educational role of the museum could only increase. And as museum staff as a whole became more and more specialized, with the appointment in the 1960s of designers, and then later, press officers, the 'educational work' of museums narrowed still further. Although almost all official reports up to the present day emphasize the broad educational remit of museums, and include in this displays, temporary exhibitions, labelling systems, publications, relations with the community and so on, from the end of the Second World War, 'museum

education' is generally understood to mean the organization and delivery of specific provision for educational groups. In provincial museums, where relations with local education authorities were possible, this was often to be limited to work with schools, which included school visits and loan services; in the national museums, the primary concern was for the adult through the medium of lecture tours, with school groups being allowed access to tours if specially requested and booked.

6. Foundations and philosophies

By the beginning of the Second World War different models of structure and organization existed for the provision of educational services in museums. They included services supplied totally by the LEA, as in Manchester, services supplied totally by the museum, as in the national museums, and a number of forms of co-operation between the two. Educational provision was by now generally interpreted in provincial museums as school services (including both school visits to museums and loan services to schools), and in national museums as guide lecture provision mainly for adults. These initiatives were to be built on after the war, although progress would be slow until after the publication of the Rosse Report in 1963. As part of the improvements, educational philosophies were constructed as those individuals who established museum education services also began to develop ideas about their aims and the best method of achieving them.

A model service in Glasgow

In 1941 a Schools Museum Service was established by the Corporation of the City of Glasgow. This service was extremely successful, and many of its methods were to become models that would be followed by others. The service was born from an enthusiastic collaboration between the museum and the city education authorities. It was to be funded entirely by the city Education Department, but would be housed in the museum with the co-operation of the curators and technical staff. This whole-hearted support from the museum for the idea of the service, and from the LEA in the funding of sufficient staff to carry out ambitious but well-grounded plans, enabled this service to develop quickly and to establish efficient organizational and teaching methods.

During the Second World War, in much the same way as had happened in Manchester during the First World War, the museum was seen as a suitable place to make up the shortfall in educational provision caused by schools that were operating on a part-time basis with depleted staffs. Initially the work was carried out informally, with the curatorial staff organizing the many children they found in the galleries into working groups on specific collection-related topics. In September 1941, however, the Art

Gallery and Museums Committee and the Education Committee resolved to try a three-year experiment. A Glasgow teacher, Sam Thompson, was seconded to the Art Gallery to help schools make the best use of its resources.

The first few months were spent in working out a plan of action. Resources were extremely limited at first. The education officer made his accommodation in a storeroom in the the basement of the museum. Many of the objects that had been on display were in store; the picture galleries had been stripped; and the natural history section had suffered extensive bomb damage when bombs had fallen near the museum building earlier in the year. While planning a way forward, Sam Thompson visited several museums in England where education services had already been established, and very soon rejected the idea of the lecture tour, partly because the museum was not in a fit state to be toured, but mainly because forty children gathered round a display case seemed of dubious educational value. He wanted a museum classroom for observation and handling of specimens, and a second storeroom in the basement was adapted. A display of ethnographic material enlivened the walls, chairs were borrowed from a local exhibition hall, and an alcove was curtained off to double as projection booth and store. Later, provision was made for a small cloakroom.

The schools within walking distance of the museum were the first ones to be involved in the scheme. A series of topics were selected, and a cyclostyled list of 'lessons available' was prepared, each of which could be taught through the use of museum material, supplemented by slides and films. The museum education officer visited the nearby schools and in discussion with the head teacher, invited the teachers to send classes to the museum to 'sample' the lessons that were on offer (Glasgow Art Gallery and Museums n.d.:10).

The methods of teaching and organization that developed were to become those employed by many other museum education officers. It was essential for the teachers to book, which was done directly with the museum education officer (and later by his assistant clerk). On the arrival of the class at the museum, the museum teacher conducted the children to the classroom. Here, objects and specimens were laid out in relation to the topic for the session, and the walls were covered with relevant charts and diagrams. There was a slide projector, an epidiascope and film projector ready for use. As planned by the teacher and the museum education officer, the children would have been already prepared to some extent, and may even have had an introductory talk.

A sample session demonstrates the teaching approach. If the topic to be addressed was 'Birds of Prey', for example, the specimens laid out on the table would have included owls, hawks, a buzzard, a golden eagle, and perhaps a kite. Some wall charts showed the birds in their natural surroundings, while others gave details of the essential characteristics of such birds, such as beaks and claws. At the beginning of the lesson, the children looked at the specimens, and through questioning, the museum teacher lead them to make their own deductions: 'why has the tawny owl such large eyes, soft feathers and brown colouring?'. The emphasis was on the children supplying the explanation of each of the features pointed out. This was then

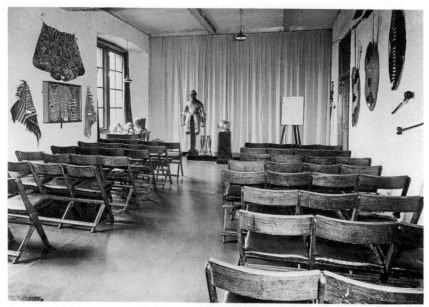

Plate 6 The classroom of Glasgow Museum and Art Gallery Education Service in
1941. Objects relating to the teaching session are displayed on tables at the
front, while other artefacts make the basic space look more inviting.
Courtesy Glasgow Museum and Art Galleries.

amplified through the wall charts. The slides added other details, perhaps
about eggs or nests. Finally, a twelve-minute silent film was projected, which
showed the development of the growth of the owl from fledgling to mature
bird. At the end of the film, the children looked again at the museum
specimen, which would by then have been very familiar. The static speci-
men was seen with the memory of the filmed bird very freshly in mind. A
final part of the lesson was to visit the natural history displays, where similar
specimens could be observed. Each of the lessons was graded according to
the age and ability of the pupils attending, most of whom at this early stage,
were primary schoolchildren. These methods were found to work well with
this age range, and were also effective with children with visual impairment
or who were deaf (Glasgow Art Gallery and Museums n.d.:27–8).

These methods are of interest as they are very different from those of the
guide lecturer. The gallery tour tended to degenerate into crocodiles of
children (or adults) trailing round the galleries in the wake of a guide who
could only be heard by the nearest students. The methods employed in
Glasgow emphasized deductive thinking, handling of specimens, prepara-
tion before the visit, and a concentration on a specific topic. This use of
objects was close to that of nineteenth-century object-teaching. Different
media were used to vary the experience, and the work in the classroom was
related to the displays in the galleries.

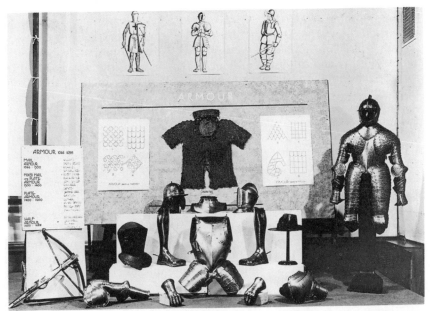

Plate 7 Artefacts and related information assembled ready for a secondary school session in Glasgow in the 1940s. Courtesy Glasgow Museum and Art Galleries.

The museum education service was comprehensive. Schools were primarily provided for as described above. However, a secondary aspect was a small loan service, containing natural history specimens, slides, scale models of historic buildings, and wall charts. In addition to working with school groups, the Glasgow service ran very popular Saturday morning classes, which varied from 'find the object' worksheets, to practical art classes. An annual art competition for children was established, and beginning in 1949, adult education work was undertaken in conjunction with the Department of Further Education, with fee-paying courses being held at the Art Gallery. Special exhibitions, generally of educational work, were arranged by the education officer and his staff.

From 1947 to 1949, 'neighbourhood exhibitions' were organized in outlying districts of Glasgow. These were designed to encourage people who would not normally visit a museum to feel more confident and interested in doing so. A selection of paintings from the permanent collection was shown in a school classroom, which had been freshly decorated and lit for the purpose. Plants were brought in to make the room look more welcoming. Talks were given to schoolchildren during the day, and the exhibition remained open until nine o'clock at night to encourage the children to bring their parents in the evening (Glasgow Art Gallery and Museums n.d. 45).

Sam Thompson worked closely with local teachers, many of whom taught with him while seconded for the day from their schools. From very early days a technician had been supplied by the museum to deal with the film projectors and other equipment, and a clerkess (sic) was assigned by the city Education Department to take the bookings. In 1944 an official Museum Education Department was recognized. The Education Department of the city of Glasgow took over full financial reponsibility for the service and in 1945 seconded a second teacher to work full-time on the project. By 1951 the service consisted of fifteen members of staff, with five teaching staff. Two of these were art specialists, two were historians, and one a science teacher. These teachers all taught a wide range of subjects to primary schoolchildren, but each worked within his/her specialism with secondary school and adult audiences. This division of teaching was to become fairly standard as other museum education departments became established.

From the start of the service it was recognized that both long and short-term policies were necessary: short-term policies to cope with the special circumstances of the war years, and to put the service into action; long-term policies based on a scheme that could come into effect at the end of the experimental three-year period. As the day-to-day work was progressing, a series of reports on the current projects outlined the ways in which an enlarged museum education department might function in the future. Sam Thompson pointed out the need for new premises at the Art Gallery, with properly equipped classrooms; qualified teaching staff; new teaching equipment; a lending library of slides, prints and museum objects; the establishment of branch museums, each with a teacher attached to work with neighbourhood schools; Saturday classes for children; and classes and educational exhibitions for adults (Glasgow Art Gallery and Museums n.d.:11). By 1951, most of these ideas, which had been ambitious ideals in 1941, had come to fruition. Undoubtedly this would not have been the case without confident and detailed forward planning. Success was also due in no small measure to the excellent working co-operation between the museum authorities and the Education Department, and the financial input of the Education Department. A further factor was a great deal of local support, interest and enthusiasm from teachers and head teachers, which enabled projects to be successful quickly and thus for growth and progress to be rapid.

Further developments

Other services of various sorts were slowly established in the years following the war. In 1948 an ambitious scheme was set up at the National Museum of Wales, financed by annual grants from the local LEAS across Wales. A joint committee representing the interests of both the museums and the educational institutions of Wales administered the scheme (John 1950:5). A loan service that covered all of Wales was developed and a centre was provided at the National Museum where groups might be received by Schools Service staff (Rosse 1963:290). The staff were employed as members of the national museum staff, had teaching experience, and specialized in one of the

subjects covered by the museum collections. Although the staff worked as a team, a separate museum education department was not formed at this stage, but each teacher worked under the Keeper of the department of his specialist subject (Rosse 1963:32).

The education officers had to work hard to develop ways of dealing with the very large numbers of children that often arrived at the museum with no specific objectives. The writer of an article describing the service in Wales:

> vividly remembers an occasion in the early years of the Schools Service when some 660 children from North Wales poured into the main hall from one special excursion train organized by British Railways. The Museum was but a short interlude in an itinerary which included the City Hall, Cardiff Castle and the fairground at Barry Island. [Moore 1973:6].

The museum visit was a disaster for the party, and British Rail was approached to prevent such a giant party ever arriving again. At this time there was perhaps little understanding on the part of either teachers or the general public of how a museum should be used. The same writer quotes an American lady to her husband: 'If you will keep looking at the exhibits, how can you expect to see the Museum?' This was a fairly general problem, particularly in the national museums, and education officers as they were appointed had to begin to establish ways of working that would demonstrate the educational viability of museum learning to teachers.

Further services that were established around this time tended to be for the provision of county-wide loans. These included a large loan service independent of a museum set up in the West Riding of Yorkshire in 1949; a loan service officer appointed in 1959 for the Bowes Museum in County Durham, paid for by the County Education Committee; and similar officers appointed in Buckinghamshire, Hampshire and Somerset (Rosse 1963: 290).

Educational philosophies and methods explored

Gradually, during the post-war period, methods of using museums with children began to be identified (it was not until much later that the museum was seriously considered in relation to adult learning). The work of several individuals, Molly Harrison at the Geffrye Museum in London, René Marcousé at the V&A, and Barbara Winstanley in Derbyshire, contributed to this development. All were concerned to find the best methods of child-centred learning, and of practical organization. Fortunately, all wrote up their findings (Harrison 1942, 1950, 1967, 1970; Marcousé 1961; Winstanley 1967).

Harrison and Marcousé both offer useful philosophical insights, Harrison working in a small social history and decorative art museum, Marcousé working at the V&A. Molly Harrison contextualized museum and gallery learning in relation to general educational development. She points out in the 1969 introduction to her book *Learning out of school* (originally

published in 1954) that progressive education works with the following concerns: to widen children's horizons; to relate teaching to individuals in the late twentieth century and to personal experience; to understand education to be active rather than passive; to teach in an interdisciplinary way, through team-teaching, during an integrated day; and to relate to increased leisure (Harrison 1970:9).

Harrison's analysis of the educational potential of museums and galleries covers the use of the objects as evidence, the development of an aesthetic awareness, and social education. Museum and gallery visits open up new learning possibilities through the study of evidence and real things, which can stimulate the ability to concentrate, explore and observe. This skills development is made possible through seeing and handling real objects, which encourages original thought. The play of the imagination and of feeling is more important than the transmission of facts. Close attention to and understanding of beautiful things will help develop a critical appreciation of things in general. Above all, going to a new place and meeting new people will open up a child's world. The opportunities for personal and social education in coming to museums, the making of the visit, the travelling, dressing and behaving in an appropriate but individual fashion, are emphasized as of equal importance to other aspects of learning.

Harrison highlights the essential groundwork for the visit by the teacher, detailing the importance of the pre-visit, the discussions with the museum staff, the preparation of both children and parents, and the selection of things to be looked at. Possible activities at museums are discussed, including handling exhibits, using working models, note-taking, drawing, dramatization, making music, reading, and using worksheets.

Marcousé takes a rather different, but equally valuable approach. She emphasizes the importance of learning to see. This is far more problematic than at first appears, she contends, and points out that the process of seeing is linked to 'our tactile sense, to visual memory, to imagination, to past experience, to our predilections, to the ability to discriminate, and to our sense of values' (Marcousé 1961:2). Marcousé is careful to indicate that her experience has been of teaching in a museum of fine and applied art, and that her methods apply in this kind of context, but not necessarily elsewhere. Her emphasis is on the development of critical visual abilities and aesthetic awareness.

Marcousé is very critical of museum teachers who swamp the experience of the object with words. Her own approach is to find ways to encourage the child to spend time looking, a great deal of time looking. This is best achieved through sketching, where the child has selected an object that relates to the theme being studied, and where drawing is carried out simply to enable standing and staring. The drawings themselves might be quite slight, and are merely the medium through which an object may be viewed.

The importance of follow-up work is discussed in 'The Listening Eye', and interesting examples are provided. One is of a class of twelve-year-olds who had sketched 'outdoor scenes' in the Far Eastern gallery. Back at school they were asked to describe from memory the trees they had seen in the exhibits.

'The tree trunks are dented', 'thin', 'almost always twisted', 'the needles of the pine tree are thin', 'pointed', 'spiky', 'thin as a pencil stroke', leaves are 'pointed', 'pear-shaped', like 'tents or triangles', 'round like pancakes and covered with black lines', 'pale green', 'blue green', 'yellow green', 'black lines on pale blue'. [Marcousé 1961:10].

Thus the drawings and the memory of the visit provided a resource for language teaching. These methods, focusing as they do on the individual experiences of children through activity and response to an engagement with material objects, were to be deeply influential in the coming years, and were eventually to lead to the virtual abandonment of the guided tour for children, although this method was to be retained for adults.

7. The birth of a profession

The Rosse Report

At the beginning of the 1950s only a handful of specialist education staff were employed in museums. It was not until after the emergence of the Rosse Report in 1963 that museum education work began to develop on a larger scale. The Rosse Report was very enthusiastic about museum education:

> It seems to us impossible to over-estimate the importance to future generations of teaching children the use and significance of museum objects, and we urge those local authorities who have not yet developed, or assisted museums in their areas to develop, a school museum service to do so without delay; and especially to provide a loan service in all rural areas. [Rosse 1963:33].

The report drew attention to the fact that the provision of museum education services was still very haphazard, and that there was no organized service available to the majority of schools. The different ways in which LEAs and museums might co-operate were outlined. The report pointed out clearly that the money spent by LEAs, whether county councils or county boroughs, on museum school services was 'relevant expenditure' for the purposes of the grant from central government for educational and other purposes. In Appendix E of the Rosse Report, Barbara Winstanley commented on the different needs of urban schools who were able to visit museums, and rural schools which required loan services.

The Rosse Report discussed teacher-training. It pointed out that some work had been carried out in this direction, particularly in Manchester and Glasgow, where short courses for teachers on the nature of the collections and the use of museum material in teaching had been arranged. In 1951 the Ministry of Education had asked René Marcousé to experiment at the Victoria and Albert Museum on methods of teaching both younger and older children in museums (Marcousé 1961). She had also been running courses to which training colleges from all over the country could send students if they wished. The Rosse Report recommended that training in the use of museums should become a standard part of the syllabus in all teacher training colleges (Rosse 1963:33).

In contrast with reports earlier in the century, there was very little

emphasis in the Rosse Report on the broad educational remit of museums. The main body of the report was concerned with curatorial matters in relation to different kinds of collection. There were no separate sections on 'visual education' or 'display' or on 'visitors' or 'public services' as there were in both the Miers and the Markham reports. A separate chapter on 'educational activities' covered 'school museum services' and 'museum training for schoolteachers'. A very short one-page section on 'social activities' covered ways in which museums might engage the attention of their local publics.

This lack of attention to the fundamental educational role of museums is an indication of how far things had changed since the Second World War. Although in 1920 the profession had resisted formal control by education committees, educational work was felt to be a major task of curators, as Markham noted in his report. Up until the Second World War, museums were still, in rhetoric at least, claimed as a source of inspiration to the general public, as the university for ordinary people, and as institutions of visual education for the child and the adult. This broad educational function was as important as any other work that the museum might undertake, if not the main *raison d'être* of museums.

The Rosse Report demonstrates a shift in emphasis. The main priority for museum workers was now seen to be curatorial work and care of collections. 'Educational work' is reduced to work with schools, and this is on the whole dependent on the co-operation of the LEAs. In part it was the very co-operation of the LEAs that limited the educational focus to that of schoolchildren and teachers. Where there was no financial input from the LEA, curators were still talking to school groups, and on some occasions working with adults, but this was in addition to their other duties. As specific personnel were appointed with the aid of the LEAs, these individuals tended in many cases to form a separate category of museum staff. Where the teachers were directly employed by the LEAs, different salaries and leave arrangements applied. These structural differences between education staff and curators were exacerbated by a different focus in relation to collections, and by different work patterns. Once individuals were appointed to work with schools, curators tended to withdraw from giving talks to school groups themselves and in many museums the two categories of worker went their separate ways.

The Rosse Report was concerned with provincial museums, and not with national museums. In the national museums, 'educational work' tended to mean the provision of lecture tours for the adult public. Here the staff were generally employed as members of the museum staff, and were subject to the same terms and conditions as the other members of staff. There was no appeal for the involvement of the LEA (except in the case of the National Museum of Wales) and thus there was no specific emphasis on working with schools and teachers, although most guide lecturers would give talks to children on request. However, even though there were fewer structural divisions between the two staff categories, different objectives in relation to the museum and its collections sometimes caused misunderstandings and resentments.

Plate 8 Schoolchildren studying part of the ethnographic collection at the British
Museum in the 1950s. Courtesy the British Museum.

The first specialist group of museum workers

As people were appointed specifically for educational work, a forum was set
up which was to become the first of the specialist groups in museums.
Following a meeting of the Children's Subject Section of the International
Council of Museums (ICOM) in London in 1948, the Group for Children's
Activities in Museums was established. This acted as the unofficial British
National Education Committee of ICOM. In 1963 the group was renamed
The Group for Educational Services in Museums (GESM) and then again
in the late 1970s The Group for Education in Museums (GEM). The
successive renaming of the group reflects a new shift of perception of the
nature of 'museum education'.

Where many people who were working in museum and gallery educa-
tion in the 1970s had originally been employed to work with schools, it soon
became clear to them that the educational possibilities of museums extended both to formal groups other than schools, such as adult and uni-
versity students, and to informal groups such as families and other museum
visitors. The educational potential of the displays of the museum was also
increasingly regarded as a legitimate focus for educational workers, at least
by museum education officers, who began actively to demand a voice in
exhibition planning meetings.

Further reports and publications

The Rosse Report stimulated the development of further museum educa-
tion services, amongst which were Nottingham, East Sussex and Yorkshire.
In 1963, thirty-four museums employing full-time qualified education staff
were listed in the register of the Group for Educational Services in Muse-
ums, and by 1967 this had expanded to forty-eight (Carter 1984:436). By
1978 eighty-five museum education services, including those of the national
museums, were mentioned in official reports (Drew 1979:51).

In 1967 the first method book was produced for museum education
officers. Entitled *Museum School Services,* it was published by the Museums
Association (Cheetham 1967) and was intended as a general guide for
museum officers, and for committee members and officers of local authori-
ties who were concerned with establishing or administering a museum
education service in provincial museums. It was also addressed to teachers.

The book detailed the types of school service that were in existence,
describing these as either based on a county borough or borough museum,
and partly or wholly funded by the LEA, as at Bristol or Leicester; or a
county service, either based on a county museum, as in Buckinghamshire,
or independent of a museum, as in Derbyshire. The administrative arrange-
ments, the local factors affecting the type of service, the networks and
contacts the school service required, accommodation, staffing, budgets,
and teaching methods were all dealt with thoroughly.

Cheetham recommended without reservation the collaboration with the
LEAs that had emerged in the development of museum school services. He
stated that only the very large museums could offer reasonable facilities to
schools without financial aid, and that in addition, provision without the
involvment of the LEA and a thorough investigation of the likely demand,
would not be sensible. Budget costs (without buildings, but including staff,
transport and materials) were given for three different types of service:
1. Town or city (loan and teaching) £3,000–£5,000 p.a.
2. Town or city plus rural area (loan and teaching) £5,000–£10,000 p.a.
3. County (loan) £10,000–£18,000 p.a.
Cheetham discussed at length the various ways in which different school
subjects could be related to the collections in museums, and pointed out
how most museum objects enabled the opening up of the compartments
into which knowledge was traditionally divided in schools. Problems and
potentials in the use of worksheets were examined, as was the value of
handling museum objects.

New influences

By the end of the 1960s, educational visits to museums had increased
sharply, and museum education staff soon found themselves unable to
meet each group in person. New methods were evolved to meet this rise in
demand, including the production of resource packs and special methods
courses for teachers (Carter 1984:436). At this time, too, there was a rapid

general increase in teachers' support services, including the establishment of teachers' centres and urban and rural interpretive centres. Museums began to work closely with many of these bodies, and the establishment of the Open University and BBC local radio stations offered further opportunities for collaboration.

HMI Museum Committee was established in 1965, at first as a working party and then in 1971 as a Committee. Along with this, the post of HMI with national responsibility for museum education was established. Week-long annual courses organized by HMI and DES in the use of museums began (Moffat 1988b).

An important development in the 1970s was environmental education, work with the natural environment. With an increased interest in conservation education and the development of visitor centres and open-air museum sites, a new category of education staff emerged, the interpretation officer, who could generally be found working in country parks or historic sites.

The idea of 'interpretation' had come to Britain from the National Parks of Canada, where interpretation staff were involved in setting up displays on the ecology and other aspects of the parks. These interpretation centres were not museums, as they had no permanent collections, and indeed their displays were often reliant on two-dimensional rather than three-dimensional material. Interpretation officers had a broad responsibility to the visiting public, extending from the content of visitor centres to the provision of guided tours, and often the entire management of visitors.

The educational philosophy of the interpretation movement stemmed from the early work of Freeman Tilden (1957), whose main emphasis was on the making of relationships between the viewer of a natural phenomenon, and the phenomenon itself. His work was directed at interpretation officers who, often without any teacher-training, found themselves charged with giving tours of forests and parks to mixed groups, often of families, in a leisure environment. Later, his work was to be usefully reread in the context of cognitive psychology (Hammitt 1981).

A new form of museum made its appearance during this period. Independent museums, often run as private charities, were founded. These museums tended to be in the countryside rather than in town centres, and, with limited public funding, relied on appealing displays and lively events to attract the paying public. Although these museums also welcomed children, and in some cases were fairly heavily reliant on school bookings to boost their income, educational work was often relegated to temporary and untrained staff. A heavy emphasis was placed on interpretation through displays, using the most up-to-date design approaches, and where schools were making only limited use of the museum, a guided tour through the exhibition areas sufficed. Later, some of the larger independent museums, such as Quarry Bank Mill, Styal and (much later) Ironbridge Gorge Museum, established comprehensive education services.

The early 1970s saw the publication of several important reports: *Report on Museums in Education*, Council for Museums and Galleries in Scotland (1970); *Museums in Education, no. 1*, Museums Association (1970); *Museums*

in Education (Education Survey no. 12) from the Department of Education and Science (1971); *Pterodactyls and Old Lace* from the Schools Council (1972).

The DES Report described the situation in England and Wales at the time. In contrast to many of the earlier reports, the national museums figured strongly. HM Inspectors were overwhelmed by the educational potential of museums, but noted that the use made of the enormous resources of museums was uneven, and in some museums, disorganized. Too many first-degree students completed their studies without using museums, and too few teachers were introduced to the potential of museums. The report highlighted the need for better accommodation for the educational work of museums, the need for development in adult and informal education, and the importance of teacher-training.

The Wright and Drew reports

The Wright Report on provincial museums (Wright 1973) devotes a chapter to museum education, perhaps indicating an increased attention to this area of museum work, although the Drew Report (Drew 1979) in discussing a national framework for museums, limits its observations on museum education to five paragraphs of the entire report.

The Wright Report stresses the need for appropriate accommodation, for fuller involvement of the LEAs, and for work with teachers in initial teacher-training and on in-service work. The structure of a museum education department is discussed, with recommendations that it should form an integral part of the museum and be on an equal footing with other departments. The education officer in charge would have the following duties: the supervision of the loan service; organization of and participation in a lecture service; involvement with (if not responsibility for) display and publications; the arrangement of group visits of all kinds; contact with educational institutions; helping individual students, and advising the curator on the nature and extent of information required and the potential of educational technology (Wright 1973:42).

This is an interesting job description, and one which is clearly based on a very broad view of the educational role of museums. The skills of the education officer are recommended to include all the main communicative functions of the museum, and are not seen as being limited to providing a service for visiting educational groups. The recommendation that education officers should be involved in, if not, indeed, in charge of display and publications is, in the light of contemporary and even current practice in museums, quite extraordinary. In almost all museums, even in the 1990s, museum education staff are still working to have any real influence in the objectives and interpretive methods of museum displays. Very few education staff have much of an impact on museum publications, although this is currently seen by education staff as of lesser importance than the improvement of displays. The Wright Report asked for an increase in the staffing of educational work in museums, and recommended that in future develop-

ments more attention should be paid, in the context of the raising of the school-leaving age, to the needs of young people at the end of their school careers.

The Drew Report emerged in 1979, produced by a working party established by the Standing Commission on Museums and Galleries to follow up some of the recommendations of the Wright Report, and especially to produce a plan for a national system for museums. Museum education does not feature largely in the report. The development of education services in the 1960s is welcomed, as is the support given by the Wright Report, but it is noted that recent limitations on local authority expenditure has resulted in a flagging of this development. The comments on structures made by the Wright Report are repeated, as is the description of the nature of the work to be undertaken. A fully integrated museum department employing its staff as museum employees is explicitly preferred to a department staffed by seconded teachers, because of the broader approach to the whole educational needs of the museum that is necessary.

The report suggests that although in the past the Standing Commission had recommended that educational facilities set up exclusively for schools and colleges should be funded in their entirety by LEAs, some negotiation might in fact be appropriate in order to develop the broader service required. The museum itself, in other words, should recognize its educational duties, and be prepared to supply funds and staff to discharge them (Drew 1979:52).

In relation to the national framework, the report has very little indeed to say about the place of museum education services, except to mention that one of the tasks of the Area Museum Councils would be to foster the overall development of museum education services in their areas, and that this might be done through the proposed county-wide consultative committees (Drew 1979:36).

Much of the impact of the Wright Report had, in any case, been lost in the turmoil of local government reorganization in 1974 (Carter 1984:436). Many museum professionals had felt that museums should be regrouped in relation to general education, but in the event many found themselves being governed through committees concerned with leisure. One effect of this was to link museum education departments more closely with country parks and visitor centres, but a direct link to the education authorities would undoubtedly have had a more stimulating effect on museum education.

Conclusions

By the mid-1970s a professional identity was beginning to emerge, which ten years later had consolidated to such an extent that the Group for Education in Museums had become the largest and most active of all the specialist groups of museum staff. In 1983 there were 362 professional posts in education in 154 museums.

At the beginning of the 1990s, most of the major national, provincial and independent museums have well-established museum education depart-

ments, many of which consist of several highly specialized and experienced members of staff. Various forms of co-operation with LEAs have emerged in provincial museums, but no national system. After the Second World War the use of guide lecturers in the national museums was seen to be less and less relevant from an educational point of view, but it was not until the early 1970s that the majority of museums appointed education officers to replace them.

Different well-tried methodologies have emerged, but on the whole services tend to work on two fronts, the provision of teaching services, and the provision of resources for teachers. 'Teaching' is very broadly interpreted, and includes lecturing, gallery talks, handling sessions, art work, demonstrations or role-play for both adults and children. The provision of resources includes support for teachers and group leaders in the form of written and visual material, teachers' courses, and, in some of the provincial museums, loan services.

Most museum and gallery education departments have strong links with their LEA colleagues, and in many museums and galleries without specialist staff, these links have also been made. Many museums have found some kind of solution to the problems of accommodation, with the largest museums providing several rooms for both teaching and staff offices.

A review of the main reports and documents of the post-war period has revealed several ambiguities and contradictions in relation to the educational role of museums and galleries. Most of the reports work with a very broad view of the educational remit of museums, which, in the event, have turned out to be at odds with the work that most museum education staff undertake. Most education staff today work on the planning, production and delivery of organized courses and events of all sorts, while the planning and arrangement of exhibitions is often carried out by curators, and the learning opportunities that exhibitions could present are not always maximized.

While many of the reports themselves throughout the century have offered a clear and often visionary view of what museums could become in relation to the enjoyment, inspiration and education of the public, it has not been until very recently that this vision has been carried through into the practices of museums and galleries. Since the end of the last century, the examples of excellent and exciting work shine out in contrast to the more general mediocrity. Lack of adequate funds throughout the period, the devastating effects of two world wars on staff recruitment and availability, and on continuity of work, and at crucial moments a failure of vision, nerve and consensus, have taken their toll from the achievements of museums as a whole.

On the other hand, many of the staff appointed to work in this often difficult and confused environment, have been skilled, dedicated and highly committed individuals, several of whom managed to build up specific teaching methods and organizational structures that were to comprise a new educational field. As museums have emerged into active, lively and increasingly publicly-oriented institutions during the last twenty-five years, their educational work has become stronger and more confident.

Part two. *Management and methodologies*

8. *Museum and gallery education today in context*

A new emphasis

In many countries across the world, museum and gallery education has now reached the point where a very solid body of practice has been laid down, experienced and committed officers are in place, and a very firmly grounded self-confidence is emerging (Hooper-Greenhill 1987b: 6–8). Museum and gallery education is now acknowledged in the museum world as a vital and integral part of all well-managed museums, and in the educational field as an essential aspect of enlightened state provision.

Many influential forces come together in Britain at the present time to emphasize the importance of museum education. The educational roles of museums and galleries were recently highlighted by the Minister for the Arts, Richard Luce. On opening the Museums Association Annual Conference at York in 1989, he urged museums to plan for a growth in museum education. In setting out three 'challenges of the future' for British museums and galleries, the Minister pointed to the need to expand the educational role of museums, and to spread excellence and access. A new attention to visitors' needs in museums and galleries is required by a new economic relationship with the public, in the context of a reduction in core government funding. The development of the leisure industry has, in fact, meant a general increase in visitors to museums and galleries, although demographic shifts in the structure of the population suggest that this public is changing a little. The establishment of the National Curriculum offers museums and galleries new opportunities of making links between collections and curricula, although new school funding arrangements have involved many museums in problematic renegotiations of LEA support.

New possibilities and new structures are emerging for education in museums and galleries in Britain, and in other countries too, museum and gallery education is being reviewed, evaluated and actively developed. The report of the American Association of Museums in 1984, *Museums for a New Century*, discussed museum education in detail, and prioritized the need for further research into museum learning processes (American Association of

65

Museums 1984). The *Journal of Museum Education* has recently responded by inviting educational theorists to apply their knowledge of learning theory to the museum context (Hein 1990). In Australia, museum education staff are reviewing their philosophical approaches (Sadler and Morris 1989); in New Zealand and in Canada the professional practices of museum educators are being scrutinized and evaluated (Thomas 1989; Canadian Museums Association 1989).

One development that may follow the processes of professional evaluation and review is the development of museum education policies and guidelines. In South Africa, for example, the work carried out by education officers over the last few years in identifying and developing their functions (Zyl 1987a; 1987b) has resulted in an extremely elaborate museum education policy document that analyses the educational function of museums and galleries in the context of museum communication (Southern Africa Museums Association 1989). In Ontario, a comprehensive series of guidelines for small historical museums has been developed, including some for education and interpretation (Ontario Ministry of Culture and Communications 1985). The implementation of these guidelines has been encouraged by the need for each museum to have educational policies, even if very basic, before federal grants can be released.

In Britain, the Museums and Galleries Commission is actively involved in discussions concerning the development of museum and gallery education policies, with the intention of relating this in due course to the requirements for their national Museum Registration scheme.

Changes in museums and galleries

Museums and galleries in Britain have recently been undergoing a period of rapid change. Shifts in structure and funding include the development of plural funding, with its consequent need for sponsorship as fund-raising management, and moves towards the privatization of sections of the museum operation. Museums are referred to at government level as the 'museums industry', and by marketing people as the 'museum business'. The 'heritage industry' has been identified as a £30-billion market-place (Rodger 1987:28) and the governing bodies of museums are trying to identify their market share within this.

The first reaction to the need to enter the market-place tended to focus on the stimulation of a mass audience. Quantity of visitors was the objective, with the rather naïve assumption that once people were through the doors, their pockets could be unloaded. Educational work in this context looked old-fashioned, labour-intensive, expensive and rather irrelevant. This crude initial approach has been superseded recently by more sophisticated ideas with the emphasis on plural funding requiring greater attention to visitor satisfaction. Marketing officers and senior museum managers are beginning to realize that it is not enough simply to attract people in: people will only visit and revisit if they feel welcome to the museum and comfortable once they are there. Marketing analyses and strategies are being applied to

all museum tasks, including museum education (Sutton 1989).

Visit quality is beginning to matter as never before, and concepts concerning qualitative experiences, and different levels and styles of educational provision are now much more acceptable. In the complex costing of exhibitions, for example, it is acknowledged that where entry fees are kept very low, and where the experience is good, visitors will spend the equivalent of the entry charge in the museum shop or restaurant (Greene 1989). This type of economic argument can be used by museum and gallery educationalists to justify increased resources for the improvement of the visitor's experience.

Sensitive visitor analysis with clearly defined objectives, such as that carried out for the National Portrait Gallery by OPCS (Harvey 1987), reveals information that can support and direct both general visitor policies and specific educational provision. For example, at the National Portrait Gallery, nearly half of the visitors specified that one of their hobbies (or a secondary job) was painting. This provides support and justification for the practical art sessions provided for adults at the gallery. It might even provide justification for restructuring and extending these sessions as a revenue-generating educational service.

Museums and gallery education sections are becoming far more aware of the need to be cost-effective. As cost and budget-centres are identified within institutions, education staff are required to identify the cost of the provision of different types of service. It has been worked out, for example, that the cost of borrowing loan material from local authority museums is approximately £10 per loan item; the cost of a child's day visit to Clarke Hall Educational Museum is identified as £15; an overnight stay at Ingleborough Hall outward bound centre in Yorkshire will cost each child £25. These costs have emerged where LEAs have reviewed their support of museum education, but an increasing attention to value for money can be generally identified. Precise arguments are being developed as to what provision may be charged, and what type of activity should remain free. Each museum is developing its own answer to these difficult questions, depending on its own philosophical approach, its method of funding educational work, and the nature of its audience.

The development of a 'market-sensitive' approach (Anderson 1989b) in museums means researching the audience, and building on the qualitative work in which museums and galleries are already experienced. Marketing managers from many sectors of the leisure industry continually stress the needs of visitors, and the necessity to focus on *their* interests, *their* experience. One of the characteristics that museums can use to distinguish themselves from theme parks and other related institutions is a unique, qualitative, consciousness-expanding experience, which is based on the real thing. Museums need to develop this aspect of their marketing, and also to develop the concept of the multi-level experience, with enjoyable and pleasurable activities tailored in different ways for different audience segments. Quality of provision and intellectual integrity are essential here, and the traditional scholarly base of the museum is essential. Poor-quality research, and facile interpretations of the past or the present are not helpful

and in the end are not worth it. Intellectual strength should be one of the ways in which museums can provide a better, more worthwhile product than other institutions. It is cautionary to note the analysis and condemnation of 'history' as mere nostalgia, or, worse, as a useless past, manufactured at rapid speed by the 'heritage industry' in order to capitalize on the new leisure market (Horne 1984; Hewison 1987).

Wider social changes

There are a number of general changes in society that are of relevance to museums and galleries in relation to their educational functions. Demographic shifts, the further development of the discerning leisure consumer, a potential move from the hard-edged market-oriented 1980s to a 'greener' 1990s, and changes in the European Community will all have specific, if sometimes rather unpredictable, effects on the demands of museum audiences.

Leisure forecasters have identified parts of the 'general public' in Britain that are likely to change in the next few years. The 'under-fours' as a segment of the population is growing, and young families will be increasingly evident in the profile of museum visitors (Henley Centre 1986). It is already fairly common for museums to offer activities that all the family can enjoy, such as the drawing days at the V&A and the Natural History Centre in the Liverpool Museum. In the future, activities and special physical provision will need to be designed for very young children, their parents and teachers. The Xperiment! gallery in the Manchester Museum of Science and Industry has a space designed for and labelled 'Under-fives', and one of the museum's five classrooms is furnished with appropriate and high-quality tables and chairs.

'Grey-power' (or perhaps more kindly, 'silver-power') is also increasing, with the population gradually becoming older. As the proportion of young adults decreases, and the proportion of retired adults becomes greater, museums and galleries will need to design programmes that can travel to day-centres and hospitals, and that use appropriate methods such as reminiscence therapy (Hooper-Greenhill 1987a: 41; Beevers *et al.* 1988). Museums are therefore likely to be working more with both younger and older age-groups than is the case at present.

According to leisure theorists, the amount of discretionary free time is likely to increase, but people are more likely to spend it either at home, or in one of the 'total destination' environments that are being developed. Museums will be competing in an aggressive and highly researched leisure market, where most leisure institutions will be working with not only a more carefully defined set of objectives than museums, but also a higher level of funding. The choices made by people of how to spend their free time will be made very carefully, and museums and galleries will need to pay attention to discerning visitors with high standards and expectations.

As a new decade begins, a moral shift is can be identified. A movement away from the market-centred philosophy that prioritized the demands of

the individual, to a more socially-aware philosophy that focuses on the needs of the planet, can be observed. An awareness of the interrelationships of people and planet, of technology and quality of life, and of sensitive uses of precious resources on a world-wide basis is likely to reinforce spiritual and human values. Museums have always been closer to these values than to economic values. Museums and galleries are committed to maximizing pleasure through knowledge, and particularly knowledge of other cultures and other places. In a more ecologically-sensitive climate, new relationships can surely be made between people, the environment, and the collections.

In the last few years, a boom in museums has taken place in France, Italy and above all West Germany, with new institutions in Munich, Frankfurt, München Gladbach, Essen and Stuttgart. During the 1990s, the European Community (EC) will become a supranational body. Much of the discussion of the effects of this at the present time is not directly focused on the educational functions of museums, but it is useful to note that the International Council of Museums (ICOM) describes museums as powerful means of informal education and as instruments of intercultural dialogue (Hebditch 1990:35). There is considerable discussion on the cultural, as opposed to the economic, aspects of the EC, and the Committee of Cultural Consultants has proposed that access to cultural resources is a human right and a public good, irrespective of the trading or economic benefits.

ICOM operates through Committees, and the Committee for Education and Cultural Action (CECA) has been one of the strongest for many years. With closer links between Eastern and Western Europe and greater overall economic and cultural cohesion, there is much that this group could achieve. With a greater movement of people and ideas across Europe, and increased cultural tourism with ever more sophisticated audiences, museum educators will need to be informed and aware of events in other countries, and the methods and aproaches used by their European colleagues.

Changes in the field of education

There have been enormous and far-reaching changes in the British educational field in the last few years. Often implemented at great speed, and in conjunction with a cut-back in teaching resources in real terms, these changes have required teachers to modify and adapt their approaches and their attitudes successively. Many of the changes have been based on educational approaches that are of use to museums and galleries, and indeed during the last five years, government has gradually accorded public recognition to the contribution these institutions have made to general educational delivery.

Her Majesty's Inspectorate (HMI) have led the way forward with courses and invitation conferences on different aspects of museum education. Teacher-trainers and local authority officials have been targeted in an effort to increase awareness of the potential of museums. Much work has been done in monitoring events in schools and museums and information

has been made available in a succession of free reports detailing museum projects in a number of different areas of the country and in relation to a number of curricular concerns, such as multicultural education, primary education and GCSE (DES 1985a;1985b; 1986a; 1986b; 1987a; 1987b; 1988a;1988b; 1988c; 1989a).

The Office of Arts and Libraries (OAL) have funded several booklets on museum education and the new educational initiatives (Goodhew n.d.: 1988; 1989) and one on new approaches in general (Hooper-Greenhill, 1989b). OAL has also funded a new bibliography for the Group for Education in Museums (Bosdet and Durbin 1989). The educational potential of an arts experience has been acknowledged by both OAL and DES in the joint documentation of examples of good practice in schools (DES/OAL 1990).

During the last decade, various curricular initiatives have emerged. In 1983 the Department of Trade and Industry, through the Training Agency, became involved in educational provision, with fourteen pilot projects in the Technical Vocational Educational Initiative (TVEI). At the same time the Certificate of Pre-Vocational Education (CPVE) was introduced. Both schemes aimed to bring the world of work closer to the classroom, giving students experience of the work environment and enabling the development of work-related skills and qualifications. The use of new technologies was emphasized and considerable government funding was made available to facilitate this (Millar 1989). TVEI is now available to all secondary schools and there are a number of ways in which museums have been involved in the project. At Beamish, for example, older secondary students have been involved in work experience, and at Leicester, TVEI funding has paid for materials, transport and teacher cover for groups visiting the art gallery as part of an extended project.

In 1986 the General Certificate of Secondary Education (GCSE) was introduced in England, superseding the previous examination structures. Both GCSE and TVEI, and, in Scotland, Standard Grade (Lawson 1987), stressed the value of learning from real experiences and promoted teaching and learning methods that were active, problem-solving, and experiential. Resource-based learning, investigation, and an emphasis on assessed course-work rather than final exams all highlighted the value of museums and sites in the learning process (Millar 1987; Tanner 1987).

Museum and gallery education staff responded enthusiastically to the challenges of the new educational initiatives in schools, recognizing that their skills and experience in working with artefacts and sites were of value to teachers. Some museums drew up guidelines for teachers: Ironbridge Gorge, for example, produced *The GCSE and museums: a handbook for teachers* (1987), which described projects on some of the museum sites for many areas of the curriculum. Suggestions for the ways in which teachers and museum education officers could co-operate were identified (Paterson 1987), guidelines for curators were outlined (Whincop 1987), and a very practical and comprehensive checklist of ideas and suggestions for developing museums as a resource for GCSE was produced by the North of England Museums Service (Anon 1987). The Area Museum Service for South Eastern England (AMSSEE) published examples of good practice in

age	description	key stage
5 or under	Reception (R)	KS 1
5 - 7	Years 1 and 2 (Y 1-2)	KS 1
7 - 11	Years 3 to 6 (Y 3-6)	KS 2
11 - 14	Years 7 to 9 (Y 7-9)	KS 3
14 - 16	Years 10 and 11 (Y 10-11)	KS 4
16 - 18	Years 12 and 13 (Y 12-13)	

Figure 8.1 New ways of referring to school year-groups (*National Curriculum: from policy to practice*, DES, 1989).

relation to all the new exams, written by the teachers concerned (Goodhew n.d.;1988).

Many museums and galleries took stock of the service they were offering. Leicestershire Museums education service, for example, working closely with teacher-trainers at Leicestershire Polytechnic, radically reviewed its practices in the light of the new educational requirements. A small table exhibition of screens and artefacts that described the work of the service was taken to schools and used as a way of making new contacts and identifying new needs. The exhibition provided a focal point in space and time for a meeting with teachers. Following a series of discussions and presentations, the museum education staff are now designing courses and materials jointly identified as necessary. These include teachers' courses on the study of artefacts, and support material for museum visits including videos and document packs (Avery-Grey *et al.* 1987).

In 1988 the Education Reform Act became law in England and Wales. Among other things, this introduced provision for the National Curriculum and the Local Management of Schools (LMS), both of which have far-reaching implications for museums. The National Curriculum provides teachers with detailed and precise objectives which are described in the Attainment Targets (ATs) and the programmes of study (Moffat 1989). A

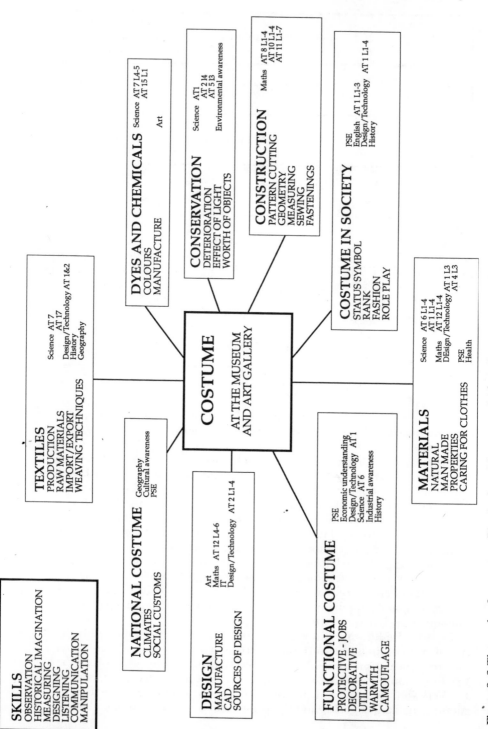

Figure 8. 2 The study of costume at Birmingham Museum and Art Gallery can be related to many different attainment targets and levels.

publication prepared by the National Curriculum Council and written specially for museums will be available during 1991.

The core subjects of the curriculum are English, maths and science, and the other foundation subjects are technology, history, geography, music, art, physical education, and for older students, a modern foreign language. Religious studies are also required. Four Key Stages (KS) are identified which describe the age and year-group of students (see Fig. 8.1) (DES 1989b). Cross-curricular elements are identified, including dimensions (personal and social development, equal opportunities and multicultural issues); skills (communication, numeracy, information technology and problem-solving); and themes (economic and industrial understanding, health education, environmental education). The sequential development of children throughout their schooling is emphasized and the experiences of students are documented in the programmes of study.

For the first time detailed learning programmes have been laid down for all teachers and children in England and Wales to follow. This means that museums and galleries have specific guidelines to follow in their work with schools, and specific contexts within which they can present their objects and activities. Studies in museums and galleries are now being marketed showing their relationships to Programmes of Study and Attainment Targets, and also the various levels of attainment at which children in different Key Stages will be working.

An example will show how this can work. All objects can be approached from a vast number of standpoints. The accompanying diagram (see Fig.8.2) from Birmingham Musem and Art Gallery shows how some items of costume are presented in relation to many different ATs, to personal and social education (PSE), and across many different curriculum areas. Studying the construction of costume could entail work with Maths AT 8 (measures—estimate and measure quantities, and appreciate the approximate nature of measurement); and AT 10 (shape and space—recognize and use the properties of two-dimensional and three-dimensional shapes). Studying the design of costume could entail work with Maths AT 12 (handling data—collect, record and process data), but as computer assisted design will be an aspect, the cross-curricular skill, information technology (IT) could also be included. Teachers need to be able to justify the museum or site visit in relation to the National Curriculum, and museums can help in this by showing how the experiences they offer are valuable and relevant.

Many museums have, in fact, been rereading their collections in relation to the National Curriculum. At Clarke Hall in Wakefield, for example, the seventeenth-century house is being used as a huge science resource with cross-curricular links with maths, English, technology, music and history. Although the Science Attainment Target 6 (AT 6—Types and Uses of Materials)—at levels 2–4, was the main focus, other Attainment Targets (ATs 1, 6, 10, 12, 13, and 14) of the primary science curriculum have also been addressed (Pitt 1989). *Museums and Primary Science* (Goodhew 1989) explores the use of museum collections in the National Curriculum for Science for 5–11-year-olds. Many museums have been working with Information Technology, one of the cross-curricular dimensions (Bennett 1989).

Plate 9 'Me and Donna' complete a circuit at the Museum of Science and Industry, Manchester. This is part of work for the Science Attainment Target 11 - Electricity and Magnetism. Courtesy the Museum of Science and Industry, Manchester.

Some museums have begun to relate their permanent displays to the National Curriculum. All the exhibits in the discovery gallery Xperiment! at the Manchester Museum of Science and Industry can be related to the ATs for science, and a teachers' guide describes these links. As new galleries are designed at the museum, the National Curriculum is scanned for ways in which the displays can be arranged in order to maximize their educational potential.

The Local Management of Schools (LMS) has been established by the

Education Reform Act. This has meant the devolution of school funding from the LEAs to individual schools. There are two main areas relating to the educational functions of museums and galleries. One is the employment of staff, which affects local authority and some independent museums, and the other is the charging (by the school) for school visits, which affects all institutions. DES circular 7/88 covers the former, and DES circular 2/89 the latter (Davies 1989:25–7).

Many LEAs have, as we have seen, contributed in a greater or lesser degree to the expense of providing a school service in their local museums and galleries. This contribution includes the total or part payment of salaries for staff secondments, payment for school visit transport and funding of the loan service. With LMS, most of the budget for education in a local education authority area is devolved to the schools themselves, which can thereby make decisions on how the money will be deployed. Some funds remain with the LEA: a proportion of the budget for certain mandatory exceptions (such as administrative elements), and a proportion for 'discretionary exceptions'. The latter proportion of the total education budget is 10 per cent until 1993, by which time it must be reduced to 7 per cent.

'Discretionary exceptions' can include teachers' centres, outward-bound centres, school psychology services, structural maintenance, and so on. Most museum and gallery education services, where they are funded or part-funded by the LEA, have been classed as discretionary exceptions (Divall 1989). These services may well come under threat of being discontinued. Reduced funding may ensue either immediately or in 1993. Where LEAs decide not to continue to fund museum education services, individual schools may choose to 'buy' museum education if they wish, although the logistics of this are problematic. In some areas, museums are currently fighting hard to retain their share of funds, and many, although not all, are succeeding. In any case, the funding for museum and gallery education services, unless funded totally by the museum, has moved onto a more precarious footing, and during the next few years, the map of the distribution of museum and gallery education provision across England and Wales could be redrawn.

The ERA maintained the right of free education, and laid down guidelines about how visits out of school were to be funded. In the first instance there was much confusion over whether schools could continue to ask parents to pay for visits to museums and sites, many visits were cancelled, and some museums suffered a severe drop in numbers of visitors. It is now clear that the organization and funding of visits will not change very much, although teachers must be alert to the wording of letters to parents asking for voluntary contributions towards the cost of the visit. However, the recent survey carried out by the Inner London Education Authority indicates that if museums and galleries which have not previously charged for school visits begin to do so, many teachers will find this very difficult (Adams 1990).

The ERA has had effects on the administration and funding of those collections which are owned by universities and polytechnics. In the central

budgetary organization, no heading has been identified for museums and collections. Although this has never been the case, the funding structures following the ERA are much more tightly controlled, and consequently those museums or collections which are currently not funded with a discrete budget of their own will find it more difficult to argue for adequate finance.

Conclusions

In looking at the current context for museum and gallery education for schools it is apparent that the early 1990s represent a period of unprecedented change. These changes are operating across society as a whole, in the field of museums and in the world of education. Museum and gallery education is in the process of rapid adaption and adjustment to take account of both positive and negative elements of change.

On the positive side, museums depend more and more on the perceptions and support of their visitors and it is those museums which offer a qualitative, challenging and in-depth experience that will survive. Museum education staff have many skills and much experience to offer in this context. New educational arrangements mean that museums and galleries can demonstrate their relevance in precise and quantifiable ways. On the negative side, for those who are dependent on local authorities, funding is not secure. Some services may, in fact, cease. Others may find themselves with very limited opportunities for the future.

It may be that the nature of the audience for educational provision will change. As the school environment becomes more complex and problematic, so new leisure audiences, especially older and younger groups, will become more prominent in the audience profile of the museum. As a result, museum and gallery educators may find that the balance of their service needs to be adjusted. Revenue generation may become a very pressing concern very quickly, although most museums would prefer not to charge for educational programmes. It may even be, as is already happening in the British Museum, for example, that education staff redirect their time and resources to pay more attention to maximizing the educational impact of permanent displays and temporary exhibitions. Each service will negotiate its own way forward according to local conditions, but all will have to manage change.

9. Management issues 1: policies and staffing

Structuring educational provision

The development of educational services in museums and galleries during the twentieth century has been, as we have seen, relatively sporadic and haphazard. Particular forms of provision have emerged as responses to specific local needs and possibilities. There is, therefore, considerable variety across institutions in the management, structure, financing, staffing and objectives of educational services, although some patterns can be discerned in relation to specific types of museums, and some basic principles can be suggested.

In relation to the structure of education departments in museums and galleries, most of the recent major official documents make the same proposals, although some are more explicit than others (Wright 1973; Drew 1979; Williams 1981; Miles 1986). The Miles Report contains a detailed chapter on museum education (Miles 1986: 50–62). The Williams Report discusses museum education in the context of the communicative function of the museum, which it sees as a 'keystone in the conduct of the whole museum' (Williams 1981:21). It is pointed out that 'the status and standard of a museum's education department are measures of that institution's commitment in the field of education.' The report goes on to deal with structural provision for education in the larger museums and stresses that education should have a properly constituted departmental structure in the same way as the other sections of the museum, with the Head of Education at Keeper level. This structure is endorsed by the Hale Report (Hale 1987:47).

This principle can also be applied to middle-sized museums where an education specialist should be positioned at an equal level in the structure to other specialists (subject curators, marketing officers, design officers). The education officer should be fully integrated into the management structure of the museum or gallery, and should be fully involved in management planning and decisions, even if the salaries are paid by the LEA (Shorland-Ball 1989).

Where museums are small, and each staff position carries many functions, educational activities tend to be left to those who are interested. If no-one wants to work with local teachers or give talks to groups, nothing happens. If

a staff member is particularly enthusiastic or experienced, then the opposite may happen. This is clearly idiosyncratic and wasteful. Where there are no specialist staff and resources are few, it is important to make policy decisions on what proportions of the available staff, time and funds can be allocated to the various functions that museums need to fulfil in order to be effective.

Educational roles and functions

The primary role of the education department is to maximize the educational potential of the museum in the most appropriate way and to act as enablers for the public (Reeve 1988). This includes formal and informal education, and provision for leisure time. Some or all of the following may be offered: workshop sessions providing many different kinds of experience for students in schools, colleges and universities; advisory courses for teachers; written or audio-visual material to help plan classes or for self-guided learning; loan services and mobile exhibitions; lectures, talks, demonstrations, events and other leisure activities for children, families, or the adult public.

These activities may take place either inside the museum or gallery, or in an outside venue, often in collaboration with a second party. A recent survey undertaken by GEM confirms that most services encompass teaching children, providing lectures for adults and in-service training for teachers, and producing resources for schools. In addition, education officers will be running the education department, including financial management (Siliprandi 1990:14).

A second major task for museum and gallery education staff is working jointly with curators and designers to maximize the learning opportunities of exhibitions and displays. This often includes reviewing the exhibition texts, and advising on the relevance of the exhibition for schools. Best practice demands more than this, with educators being involved in exhibition planning from the start, including the identification of target audiences, and discussions on teaching points, concept level, narrative style and so on.

Much of the work of museum and gallery educationalists requires links with an extensive network of agencies outside the institution; equally, a cooperative network is required inside the museum for maximum achievement. Staff may operate across a number of museums. In a county service like Oxfordshire Museum Service, for example, the education officers may offer programmes and organise events in any of the museums operated by the service, and may also collaborate with the University museums in the city of Oxford. In Manchester, the city museum education service which is largely funded by the LEA is organized on a city-wide basis and covers the Manchester Museum, the Athenaeum, the City Art Gallery, and the Manchester Museum of Science and Industry. This service is jointly managed, although individual members of staff are based in specific museums.

In establishing or reorganizing the educational work of museums and galleries major decisions have to be made concerning the nature and balance of the provision. The balance of the services can vary enormously. At the Horniman Museum, for example, the museum teachers spend

nearly 100 per cent of their time in face-to-face teaching. This is supplemented by the Keeper of Education who organises active sessions for out-of-school groups and for adults. At the Natural History Museum, on the other hand, nearly 100 per cent of the time is spent in the preparation, piloting and evaluation of high quality worksheets, teachers' materials, and in the Teachers' Centre. At the British Museum, the Head of Education prioritizes work with curators over the planning of exhibitions and displays in the planning of his own personal time. At Hitchin Museum, North Hertfordshire Museum Service, the museum teacher has a loan service with a rigorous timetable of sending objects to and from schools at frequent intervals. Any face-to-face teaching must be fitted into this schedule. Each museum or gallery must review the possibilities and decide on the priorities for their own service.

Museum and gallery education policies

One of the basic management tools that helps to identify, select, prioritize and evaluate the educational roles and provision of museums and galleries is the policy document. Without a clear idea of aims and objectives it is difficult to decide which of the host of possible activities is relevant or appropriate. In a rapidly changing society, with major shifts in the educational system, increased competition for leisure time, and increasingly unreliable funding for many institutions, it has become necessary for museums and galleries to clarify their educational functions and ambitions. Many places are consequently reviewing or consolidating their positions in order to make best use of scarce resources, and in some instances to ensure survival.

Policy documents should set out the educational principles on which future actions will be based; they should act as an efficient management tool for the organization of staff, the deployment of resources and the evaluation of standards; and should demonstrate the museum's commitment to its visitors and potential visitors, including schools, and their changing needs. A document such as this is useful for strategic planning at all levels, is helpful in supporting funding applications to sponsors or governing bodies, and is useful in identifying and demonstrating concrete achievement at a time of increased accountability (Scadding,1990).

One museum that has reviewed its position very thoroughly is the Royal Naval Museum, Portsmouth (Scadding 1990). The museum has examined and defined its overall aims and objectives for the 1990s as a necessary prerequisite for the development of the policy for educational work. Following this the existing audience profile will be ascertained. As a quasi-national museum in a tourist area, and the only British museum concerned exclusively with the history of the Navy, this audience includes the local community, national and international tourists, serving and ex-serving naval personnel, and scholars, students and special interest groups.

The various visiting groups will be considered in relation to the range of communicative and educational strategies that the museum can use, including exhibitions, collections, publications, demonstrations, media presenta-

tions and so on. The museum has no education officer (although it does have access to museum education advice through the Hampshire 'Defence of the Realm' project), and so must consider how to maximize its learning opportunities mainly through these self-directed learning techniques. It will also have to decide how far, and where, a didactic approach will be taken. Ideal aspirations will have to be matched with realities, as it will not be possible to fulfil the needs of all sections of the audience all the time. Priorities will have to be decided upon, short-term and achievable goals established, resources allocated, and evaluative procedures identified and established.

This museum has taken a very broad approach to the development of its educational policy. As a small museum without specialist education staff, the specific educational role is considered alongside the general communicative functions of the museum. In each museum or gallery the education policy will be the result of the context within which it is produced. Two examples from overseas illustrate this well. In the Metropolitan Museum of Manila, in the post-revolutionary Philippines, the education staff are charged with demonstrating the nature and effectiveness of child-centred teaching to teachers who are accustomed to very unadventurous and traditional teaching methods. The educational policy here focuses on the development and implementation of active learning techniques. In Zanzibar Museum in Tanzania, resources are very limited and local distances are great. Therefore the educational policy centres on and emphasizes cost-effective, low-budget outreach work.

Where there is an education officer seconded by an LEA, the educational policy will be determined in part with reference to the requirements of the LEA. An example of this can be found at the Smith Art Gallery and Museum in Stirling in Scotland. Here a teacher was seconded by Central Region to the Art Gallery and Museum for twenty-three months in the first instance. The initial task was to establish an education service for the benefit of school pupils in Central Region and to address the needs of the wider community. The goals set reflected this task. The former Inner London Education Authority (ILEA) museums, the Geffrye and the Horniman Museums, both established an anti-racist policy in line with the ILEA policy for other educational institutions. Where the requirements set by the LEA are limited to work with schools, and the needs of the wider community are not addressed, decisions on how to deal with this will have to be made, as the educational role of museums and galleries extends beyond children and their teachers.

The many variations of structure, function, funding, and consequent objectives can lead to education services operating in a very idiosyncratic, and sometimes spasmodic fashion. The development of a policy will help in defining a more coherent way forward.

The ideal education officer

The ideal qualifications and experiences required of a potential museum or gallery educationalist are virtually impossible for one person to aquire in

one lifetime! The ideal person will have successful teaching experience in primary, secondary, tertiary and community education; knowledge up to degree level of the full extent of the museum collections; a museum studies qualification and museum experience; will be a fluent communicator with skills in all media, including audio-visual media and exhibitions; will have a flair for working with objects; will be an excellent manager; will be prepared to work unsocial hours; and will be able to work with different specialists. In practice, education staff will begin with a selection of these attributes, and will find that many of the others accrue as time goes on.

Museum and gallery staff should be trained and experienced teachers. This is recommended by the Group for Education in Museums, and by the Miles Report (Miles 1986;62), and endorsed by the Hale Report (Hale 1987:33). A successful teacher will have good communication skills and experience of working in educational establishments, both of which are essential for museum and gallery education work. However, museum education staff need to be able to relate to both primary and secondary schoolchildren and teachers, and in many cases they need to be able to work with adult and family groups as well. Teaching skills are generally developed for only one of these audiences, so considerable adjustment and development will be needed on transferral to the museum or gallery environment. There may be a problem for teachers leaving the classroom in that careers are interrupted and salaries are very likely to be reduced. Promotion prospects may be threatened if a return to schooling is envisaged.

Education staff should have a basic expertise in the subject-matter of the collections with which they will be required to work. In some cases, of course, staff will have to work with a variety of collections such that no one qualification will provide the necessary knowledge. In this case, time must be allowed for the development of relevant specialist knowledge, although expertise will be quickly acquired through working with the collections concerned. In all cases, however, newly appointed education staff will need sufficient time to research the collections and to identify and develop ways of relating the artefacts to the needs and interests of the groups with whom they will be working. Specific museum objectives may require staff with special skills and experience. At Sheffield and Dundee, for example, where outreach work in the community is a priority, officers with this kind of experience have been appointed. At Dundee, the appointment is linked to further training provision.

Where there is the possibility of employing several education staff, these should between them represent experience covering different subject areas in relation to the various divisions of the collections. It is also helpful, where possible, to employ staff with different age-related teaching backgrounds. Museum education has an interface with all sectors of school-based education, informal provision for children, and all sectors of formal and informal adult provision for learning and cultural enjoyment. Staff should be employed to help negotiate this interface according to the educational policies of the institution concerned. Where it is not possible to employ staff to make specific links and working relationships, networks should be established with the relevant advisers and specialists. LEA advisers and inspectors

for subject areas and for other aspects of the delivery of the curriculum, will enable links to be built with in-service training of teachers. Urban or environmental studies units, local theatre and arts groups, play organizers and librarians are all potential collaborators. Where curators are performing the educational function themselves, there will be an even greater need for links, networks and collaborative work.

The employment of staff

Full-time specialist education staff are employed in different ways in different types of museums, with a variety of employment, remuneration, and working practices. No national system exists, and museum and gallery education staff, although forming a strong professional group, experience a variety of terms and conditions of employment, and of tasks and functions, depending on where they happen to be working. This remarkable and unsatisfactory system has its roots in the history and development of museum and gallery education services, and it is interesting to note that other countries have also experienced various forms of employment with very similar implications during the last sixty years (Park 1989).

National museum education staff, including teachers, adminstrators and technical staff, have in the past been employed as civil servants on civil service pay scales along with the other museum staff. In general, museum (civil service) hours with museum holidays are worked, although as staff are now employed by Trustees rather than by the government, in some instances new terms and conditions are being put in place. Education departments in the national museums generally take responsibility for the provision of services for all sections of the museum's clientele, including adults, children, tourists and so on. Activities are organized outside school terms for children and families. Strong links can be built with museum colleagues, such as curators, designers, and marketing officers, all of which share the same work culture.

In local authority and independent museums the situation is a little more complex. Local authority museum education staff can be employed directly by the museum and financed by the leisure committee budget, or may be financed by the education committee budget to teach in the museum, or may be financed by a combination of monies from both these sources. In Leicester, for example, the LEA pays four-fifths of the salaries of the education staff, and the museum service pays the remainder. The staff are museum officers, with museum salaries and holidays, but tend to work exclusively with schools and teachers. Work with adult groups is covered in the main by curatorial staff. In Birmingham, a secondment system is in operation, where teachers are employed directly by the LEA, working teachers' hours and with teachers' holidays and payscales, and are seconded to work in the museum, again working only with schools. Not all LEA-funded posts are limited to work with schools; some LEAs have also encouraged the development of work with families and the local community.

With the introduction of Local Management of Schools (LMS), the financing of museum school services must be renegotiated. With 90 per cent of the money available to fund schooling going directly to individual schools, the employment of museum teachers must be funded either from the 10 per cent (reducing in 1993 to 7 per cent) of the budget remaining in a central pool for discretionary items, or by a consortia of schools, or museums themselves must find the money for salaries. Some local authorities may find ways of funding teachers from budgets other than the schools budget. Whatever solution is found, the employment of museum education staff will become more problematic and in some instances services appear to be very much under threat of reduction.

In the past, and currently, LEAs have seconded teachers to work in museums and galleries. These secondments are sometimes semi-permanent, but can also be of a short-term nature. This has sometimes been very successful, but there are problems that can and do arise. These relate to two main areas, one connected to difference in work cultures, and the other economic and structural.

The work culture problems stem from the difference in environment between the museum and the school, and can be particularly acute where the secondment is short-term. The objectives of schools are comparatively narrow, being limited to specific audiences and specific targets, although it is recognized that these targets relate broadly across social, cultural, personal and knowledge-based education.

The objectives of museums and galleries are in many senses impossibly wide, covering a multiplicity of audiences and a vast range of targets. Teachers do not at first understand this difference in focus. Teachers form a fairly coherent body of professional workers, with a national payscale, a recognized career structure, and a relatively consistent set of attitudes and approaches. It can be difficult for teachers to understand the different professional values and attitudes to be found in museums, especially as not all of these values emphasize the educational potential of museums and their objects.

It can take a long time to adapt to the culture of the museum, which is in many ways diametrically opposed to that of the school, with very different value systems, time-scales and attitudes. In addition, new teachers must learn about the collections before they can use the objects for teaching. Where 'the secondments are short, a year or less, culture shock can sometimes prevent much achievement. However, if good management systems are in place, if permanent colleagues can work alongside the secondee, and if short-term achievable and realistic goals can be identified, then mutual benefit should accrue. Where secondments are longer, these cultural problems will be lessened as expertise and familiarity increase.

The structural and economic problems of seconded teachers, and particularly permanent seconded teachers, are more intractable. Where teachers are paid on teachers' scales, it is possible that the salary will be more than that of curatorial colleagues, and in small museums, more than the senior staff of the museum. In addition, teachers' terms and conditions include many more weeks' holiday than are enjoyed by curatorial col-

leagues, and shorter hours each day. Career progression for museum cura-
tors is not always easy, as the profession is small, and workers tend to be very
highly specialized. Often there is only one position in the region that
relates to the level of experience and expertise that curators represent and
that is the one that is already held. Where people are not free to move
geographically, this problem is compounded. It is not uncommon, there-
fore, for curators to remain in the same job nearly all their working lives. As
museum salaries are extremely low (outside the national museums) in
comparison with wages of other professionals, it is not difficult to see how
someone coming into the museum from a different culture, with a different
set of values, with different terms and conditions of work, and with a
(sometimes substantially) higher salary, can be treated with a certain
amount of resentment. It is important to recognize that most of these
problems are structural in nature, and not due to the innate personality of
the post-holders. Much could be achieved by thorough induction courses
in the museum for new members of the education staff, supplemented by
supportive guidance, the opportunity to meet fellow educators and observe
them at work, and the opportunity for museum training.

Other forms of secondment apart from those of school teachers have
emerged. The Tate Gallery Liverpool has a lecturer seconded for one day
per week for two years from the University of Liverpool Department of
Adult and Continuing Education, with the task of reviewing adult educa-
tion provision; Ironbridge Gorge Museum education staff have included
secondments from Wolverhampton Polytechnic for one day per week dur-
ing the academic year, funded through monies allocated to the Polytechnic
from the Department of Training and Industry for in-service training in
industry; the Head of Education at Ironbridge Gorge Museum is himself a
seconded adviser from Shropshire LEA.

Section 11 monies (Local Government Act 1966) have been used to fund
posts in a handful of local authority museums, including Bradford, Leices-
ter, Kirklees and Ipswich. These posts have been designed to focus on work
which relates to ethnic and cultural diversity. One of the posts at Leicester is
speci-fically for multicultural education, while the others have a more
curatorial brief and work has concentrated on making broad-ranging com-
munity links, and developing exhibitions related to local ethnic
populations (DES 1988c).

In some museums, such as the Ashmolean Museum and the Tate Gallery,
a 'docent' system based on North American ideas is in operation. A
'docent' is a part-time volunteer guide/teacher. In North America docents
are used extensively to provide educational services , and have been since
1907 (Newsom and Silver 1978:14, 242–6). Here rigorous training pro-
grammes for volunteers are organised by the museum or gallery before any
teaching is carried out. Elaborate handbooks have been produced to guide
the docents in their work, which give information on their duties,
reponsibilities, benefits and position within the museum (Smithsonian
Institution n.d.). The museum may employ a docent-coordinator, who
designs the educational programmes, pilots them in the galleries with
children or adults, trains the docents and organizes them in their teaching.

At the Ashmolean Museum, the school education service is provided by docents, who run their own training programme and management system (Mattingley 1984: 82–6). At the Tate Gallery and the V&A teams of volunteer guides are trained and managed by the Education Department and provide a daily gallery guide service for adults.

Volunteers and Manpower Services Commission workers have been extensively employed in educational work in museums in the past, particularly in independent museums, although changes in the nature of short-term employment or training schemes make this kind of employment almost impossible at the present time. Most of the larger independent museums now have systems of seconded teachers in place, although in at least one independent museum, the Manchester Museum of Science and Industry, substantial financial commitment is made from the museum's budget to supplement LEA funding.

A new form of educational funding is making its appearance at present and that is the use of sponsorship to pay for education staff. At the Barbican Art Gallery in London, British Petroleum PLC have sponsored an education officer to work for a period of three years. At the Tate Gallery Liverpool new areas of outreach work were developed through funding by British Telecom on a temporary basis for an outreach worker (Jackson 1989). This outreach work has now been recognized by the Trustees as an appropriate educational field for the Tate Gallery. At the Greater Manchester Museum of Science and Industry, National Power is funding a teacher to work in the electricity gallery. At Dulwich Picture Gallery, funding for part-time teachers to work with special needs and schools in the inner-city area has been raised from sponsorship.

Although sponsorship may usefully supplement existing educational provision in the short term, and may enable the opening-up of new and innovative areas of work, it is no substitute for permanently employed education staff. Permanent and skilful staff are in fact a prerequisite for the sensible design and use of sponsorship packages.

Forms of employment can vary enormously from institution to institution, but on the whole, very few education services depend on volunteers. Almost all education staff in museums and galleries are permanent members of staff, except for those posts funded through sponsors which tend to be for a limited number of years. There are signs that the employment of temporary staff, employed on a project basis, may be increasing, and it may be that this is one of the consequences of LMS. If this does happen, there will be severe consequences for the development and continuity of work.

Museum education personnel do not constitute large sections of the staff of museums and galleries. The Museums Association study *Museums U.K.* gives an indication of the distribution of educational staff in museums and galleries. The report suggests that less than 5 per cent of total full-time staff (including security staff) are employed in education, conservation or design work (Prince and Higgins-McCloughlin 1987:80). Education staff at the time of the survey made up a tiny percentage of the staff as a whole: 1.8 per cent in national museums, 3.6 per cent in local authority museums, 2.1 per cent in independent and other museums.

The slightly later GEM survey showed that most departments consisted of between one and seven people, although there are one or two services that are larger, such as services at Glasgow and at the British Museum. Approximately two-thirds of these staff are female and one-third male, except for those in the higher salary ranges, where, somewhat depressingly, the proportions are reversed. Salaries were found to vary considerably according to the funding arrangements. Salaries in the national museums and posts funded through the LEA were roughly comparable, but those posts funded either by local authorities or charitable trusts on museum curator grades were approximately one-third lower. Museum education staff were found to be well qualified: of the respondents, 91 per cent had a degree, 64 per cent had a teaching qualification, 24 per cent had a master's degree, and 19 per cent had a museum qualification (Siliprandi 1990:14). Many museums and galleries do not have specialist education staff, and in these cases it is often the curators who carry out educational work, although at least one major report has pointed out the problems both of questionable standards of educational work and of dilution of curatorial work and that may be inherent in this solution (Miles 1986:52).

The Museums Association study also showed that approximately one third of all museum visits are made by children, and given that some museums are unable to discriminate in their figures between adults and children, this figure could in fact be substantially higher. At the exhibition 'Armada 1588–1988' at the National Maritime Museum in 1988, for example, 50 per cent of the visitors were school-age children. Although museum education is not only concerned with work with children, the mismatch between the percentage of child visits (30 per cent of all visits) and the percentage of education staff to provide for them (less than 5 per cent of the total museum staff complement) is very striking.

This is the kind of statistic that underlies the story one hears about a large national museum whose visitor figures were falling, but whose education department was turning away customers because they were over-stretched. Most museum education workers in large and small museums *are* over-stretched. With museums looking desperately for ways to demonstrate their relevance to society in the late twentieth century, this is a thoroughly ludicrous situation, and one that must be changed in the very near future. However, the solution to employment difficulties is not straightforward. Considerable loss of parity with the teaching profession would ensue if all posts were to be funded at the same levels as those of curators, with consequent difficulties of attracting and retaining experienced staff; on the other hand, the existence of two sets of terms and conditions in one institution is divisive.

10. Management issues 2: organization and planning

Organization

One of the main tasks of an education department is the organization of workshops for group visits. This can be a complex business, with staff, space and activities to be managed. Workshops are generally publicized with leaflets or flyers, which describe the activities, give details of the educational benefit, (incuding reference to the National Curriculum if appropriate), the amount of time required and the booking process. Basic details of the museum, its address and opening hours are also included. Teachers' newsletters are sometimes used for this purpose. Both these documents can be distributed through the LEA schools mailing system, and/or through a mailing list that has been built up by the museum education department.

For effective management of group visits, either by an education department or by curators working on their own, a booking system is required. In many museums and galleries it is impossible to ensure that all group visits have been booked in advance, but certainly it is vital that all those groups who want to work with museum staff must book beforehand. It is also helpful if teachers or leaders bringing groups for a self-directed session can inform the museum or gallery in advance, as this can avoid over-crowding, or disappointment due to gallery closures or other problems.

A booking form should be devised to record the relevant information for each group. This includes the name of the school or college, the name of the teacher in charge, the number of participants, their age and other relevant characteristics which will help the museum teacher prepare either in educational terms or in relation to physical needs (poor readers, wheelchair-users, etc.). A sample form is reproduced in *Museums and the curriculum* (Goodhew 1988).

Booking can be carried out by letter or by telephone; in many ways, a telephone conversation is best, as this is a critical point of contact. It is best if the teacher bringing the group and the person who will work with the group in the museum can speak to each other directly, to ensure that each is clear about what is expected and what is on offer. Sometimes teachers'

Horniman Museum Education Centre 1986/87

breakdown of 1163 school groups

217 secondary school groups

811 primary school groups

48 groups with learning difficulties

37 groups with physical disabilities

32 groups from English Second Language Centres

18 groups with emotional and behavioural difficulties

breakdown of 82 adult groups

23 groups from art and further education colleges

20 from community groups and clubs including some for disabled people

11 groups of teachers in training

9 groups of teachers in service

7 groups of mentally handicapped people

4 groups of teachers from overseas

2 groups of English Foreign Language students

Figure 10.1 Some statistics about the nature of groups that can be generated through the diary of the Education Department.

objectives can be discussed and more clearly identified at this point. Sometimes it can be found that the teachers' aims cannot be satisfied by a museum visit, in which case it is a good idea to point this out at this stage. Most museum education staff want to offer a custom-designed workshop for each group, and this can only be done if the advance information is adequate. At this point, too, any work to be carried out at school/college before the visit and any related visits can be discussed.

Following the completion of the booking form and the accompanying telephone conversation, the teacher can write to the museum to confirm the visit. Any initial booking letter from a teacher must be responded to with a letter of confirmation from the museum. The arrangement must be logged in the education department diary, and the booking form filed to be retrieved in time for preparation for the visit. It is convenient to file

booking forms alphabetically by the teacher's surname. The teacher's name must also then be entered into the diary when the visit is logged. The diary entry should also record the name of the school, the gallery or classroom space to be used, and sometimes the name of the museum teacher to work with the group. The diary entry and the booking form thus work together to record the arrangment, to reserve the relevant space and the relevant teacher, and to hold the necessary information about the nature of the group and the objectives of the teacher in order to enable detailed prepartion for the visit. Most education departments work with some variation of this system, and the best way to develop one for a particular service is to observe one or two others in operation, and then design an individual system appropriate to the specific context.

Detailed diaries are essential for the day-to-day management of an education service and must be kept rigorously up to date to avoid double bookings. Diaries also have other management implications for long-term efficiency and development. Mailing lists can be developed from diary entries and the accompanying booking forms. Comprehensive lists, or lists divided by type of institution (primary, secondary school, college, etc.) or by geographical location, or by subject taught, all have specific applications when mailing details of workshops for art teachers, for primary schools, or for schools in a particular LEA area. LEAs can themselves, of course, provide lists of their own schools. Detailed statistics on the nature of the take-up of the education service can also be developed from the diary entries. The total numbers using the service, the geographical range of visits, the percentage of primary as opposed to secondary school visits and so on can all be logged. Visitors to the department can also be listed.

The Horniman Museum, for example, logged the use of the Education Centre during the academic year 1986–7. Over 190 term-time teaching days, 1,245 organised groups came to the Centre. Fig. 10.1 gives a detailed breakdown. This breakdown was used as part of a report on the work carried out by the Education Centre which was presented to the new Trustees by the museum staff when the Horniman Museum changed its status from a local authority museum run by an LEA (the Inner London Education Authority) to an independent museum. The records kept by the Stirling Smith Art Gallery and Museum in Stirling show an increase of 82 per cent in school visitors from December 1987 to December 1988. This was vital information in the decision made by Central Region on whether to continue to support the post. The records of the organization of the loan service kept by the education officer at Hitchin Museum, North Hertfordshire Museum Service, were such that when the local authority was looking for a way of implementing computer documentation in the museum, it was the organization of the loan service that was chosen.

All this information is, therefore, vital for such purposes as museum annual reports, reports to LEAs, funding applications, and applications for further staff, and although keeping detailed records may appear a chore initially, neither the day-to-day running of the service nor long-term development is possible without it. Most museum and gallery education services are in fact impressive in their knowledge of the users of their services. With

the trend towards the identification of performance indicators for museums, these details will become even more vital.

Accommodation

Specialist educational accommodation, often seen as a luxury, is a necessity (Cheetham 1967). It should include an office for dealing with bookings and administration; a classroom (with a sink) for object handling, and art work; a lecture room for lectures, conferences and seminars; a storeroom for a handling collection, worksheets and equipment; a lunch-room for students; and access to toilets and cloakrooms for bags and coats. Ideally, this accommodation should be sited in one place and should be near an entrance to the museum where coach parking is possible.

In many museums, this list would be seen as asking for the moon, although the provision at the Horniman Museum in London, the Museum of London, and the Manchester Museum of Science and Industry, for example, comes very close to the ideal. The provision at the Greater Manchester Museum of Science and Industry includes five classrooms, one equipped for 5-year-olds, a technical workshop, an audio-visual room, a reprographic room, a computer room, a general office and an office for the Head of Education, and a staff-room for the seven education staff. There is also access to the adjacent conference suite when this is not in use.

Occasionally, education sections have their own exhibition space. This is the case at the National Portrait Gallery, where a basement suite includes a space where education staff can mount exhibitions that can be opened to the public if desired. Ideal accommodation should not be so self-contained that it prevents the access of groups to the main museum and its displays and collections. Visiting groups should see at least some of the museum as well as the education department! Where the education work includes a loan service, with administration, drivers, object-cleaners and design staff, specialist accommodation is necessary (Cheetham 1967: 20).

Access to a library for education staff is important. At the British Museum, the Education Department has its own very extensive library, which includes books on the collections and related subject areas, museological books and educational books. Sometimes this can be made accessible to teachers and students. A teachers' resources room is worth serious consideration and can contain books and other reference material; a photocopier, and materials and suggestions for teachers to make their own worksheets; videos and slides that can be borrowed; and postcards, posters, notes on objects and other materials that can be purchased.

Perhaps the most impressive educational accommodation is to be found at the Natural History Museum in London, where an enormous basement area has been converted for the use of the education department, funded by Shell UK (Middleton 1990). The space offers schools a main assembly space, coat and bag space for 1,750 visitors, and a refreshment area for 320 at any one time. This is supported by a snack-bar, and colour-coding facilitates the allocation of space. Seminar and meeting spaces are pro-

vided, as is a Teachers' Centre, a resource room with reference material. A Discovery Centre with handling material for 7 to 11-year-olds has also been incorporated. The spaces can be used by family groups during weekends and holidays. As the museum is visited by 180,000 schoolchildren each year, these new purpose-built facilities will be well used.

Budgets

The educational work of the museum should have a clearly identified budget, which relates to the scale of the tasks identified and to the educational ambitions of the museum. Funding will be required for materials and equipment for projects, fees for freelance lecturers and demonstrators, the cost of the production of publications, staff travel and training for professional development. Where many freelance staff are used, as in some of the larger national museums, there will be considerable funds to deploy and choices to be made. Where there is an emphasis on the production of books, or teachers' materials, staff will have to learn about unit costs, balancing quality and quantity, and deciding on how much profit to make, if any (Anderson 1989b).

In many museums, budgets for educational work are very low, in the region of £500 for materials, for example. Many museum education staff have become adept at finding small pockets of money, perhaps from local sponsors, or from winning competitions. The Geffrye Museum, for example, has used both of these methods with success. In 1990 the museum won a commendation in the category 'imaginative educational work' in the Gulbenkian Museum and Gallery Awards. The programme that won the award, 'The coming of light' (Bastian 1989) was funded in part by £5,500 given to the museum by ICI, the Royal Society and other sponsors.

Other museums and galleries are attracting funding for educational projects. At the Tate Gallery Liverpool, three-quarters of the project budget for 1990 was raised through sponsorship. The Tate Liverpool has a very tight control over the funding of its educational work. In some instances new projects are devised and costed in detail, to be implemented if the funds can be found. For example, for an arts project involving community artists, an art gallery and local schools might include £900 for fees to community artists, £350 for materials, £200 for transport, and £800 for a modest advertising leaflet. Each of these items might be sought from a different source: the fees to artists from the LEA in which the schools are based (or, with LMS, from the schools themselves); the money for art materials from a local paint manufacturer; advertising costs might come from the gallery's education budget; and the funds for transport from a local charity. In this way, the expense of the project is shared and when the total amount has been promised, the project can go ahead. This form of budgeting allows for some flexibility. If one local company is unwilling to provide sponsorship, another might fill the gap. If the museum provides services across several LEAs, the LEA to provide the funds will be the one whose schools reap the benefit, and so on. In some cases, sponsorship in

kind can cut the costs of projects and is worth considering.

Increasingly, education sections are being designated as discrete cost centres within the museum, and the true costs of different forms of provision are being identified. Cost-effective management is called for and in some cases revenue generation is an important component of the educational mix. Although this may have to be faced, the education department should not be designated a profit centre within the museum. The decision on whether educational activities should be used to generate income is a moral one. Education for all is still an important philosophical objective, and in principle free access, where it exists, should be preserved. This is not to deny that some aspects of the educational provision might quite justifiably become revenue-generating, and might subsidize other parts of the service that should be offered free of charge. It is part of the task of the educational manager to control the balance, but it is also important to consider what proportion of time is being spent on revenue generation and whether this is appropriate. A policy document might be helpful at this point.

Communication within the department

Clear communication is necessary both within the education department and within the museum. In all too many cases, there are large gaps in communication either within departments, or between education and curatorial workers. Successful management depends to a large extent on good communication and on effective consultative processes. This is as true in the management of museum education services as anywhere else.

Regular management meetings should be held, on either a weekly or a monthly basis. The education department at the Tate Gallery Liverpool meets weekly to review the diary for the coming week, and has regular two or three-day 'think-tanks' to consider new practice and to review existing work. It is a mistake to be teaching continuously so that forward planning is neglected.

Clear delineation of responsibilities and tasks is important and should be understood by all. It should be clear, for example, when bookings are taken or appointments made, who is the relevant staff member. Staff development should be considered and allowed for in planning and in the budget, including seminars and conferences, training or retraining to keep up with new educational methods and new museum issues.

Museum and gallery staff working in the educational field need to be very aware of current changes in the world of education. This means having access to training days, and possibly also to longer courses. The Group for Education in Museums offers one-day seminars for education staff and curators; some museum staff have been allowed to join teachers' training days organized by LEAs as part of the training for the delivery of the National Curriculum; HMI run occasional short courses, and an annual training week arranged jointly with English Heritage; some of the providers of the longer museum training courses, such as the University of Leicester and the Ironbridge Institute, also offer day courses.

The only full-time training for museum education officers is at the University of Leicester, where a core curatorial course in Museum Studies is supplemented by a subject option in museum education. The course is designed for those who want to work in museums doing educational work, and is open to teachers (and others) wanting to change their teaching environment, and curators wanting to develop their educational skills. The course is available on a one-year full-time or a two-year part-time basis and leads to a Master's Degree in Museum Studies. As the work is organized in modules, it is also possible to follow the museum education option courses without attending the complete Museum Studies course.

Networks outside the museum

The success of museum and gallery education services is closely geared to the efficacy of relations outside the museum. There is no doubt that provision can be designed without discussion with the user groups, and in some of the larger museums which are very popular this works quite adequately. However, the most successful and effective educational projects take account of the opinions and needs of those for whom they are designed. The best way forward is often collaborative, as the Art Education Officer at Leicester Museum found when she wanted to develop a GCSE project for local art teachers. The involvement of the art adviser in the project development group enabled aspects of the work to go ahead that would not otherwise have been possible. The art adviser encouraged the mounting of an exhibition of the work produced by the schools involved, and a poster to advertise the exhibition was paid for by County Hall. The LEA photographer documented both the exhibition and the work as it progressed in schools following the museum visits, which enabled the museum education officer to put together a set of slides.

Later, the TVEI co-ordinator became involved, and during the second year of the work, when a new and larger group of teachers were planning their museum visits, he was able to provide TVEI money for materials for classroom follow-up work, transport to the museum, teacher cover in the classroom, and film for documentation. The offer of funds, particularly for new materials, made the project seem very attractive to the art teachers, who were able to buy, for instance, woodblocks and ink, or oil-paints, which would otherwise have been out of reach. Collaboration can act as a stimulus, and can provide additional resources, both for education staff and for curators carrying out the educational function. Perhaps the contacts made are even more valuable in the latter case.

Contacts with organizations outside the museum perform a number of functions. New approaches to designing projects can be devised, relevance for specific groups can be ensured, awareness of the work of the museum or gallery can be increased, funds and other resources can perhaps be raised. The contacts to be made should include those responsible on a local level for educational provision, including the LEA (Paterson 1989), and other bodies such as the National Trust, the Countryside Commission and other

providers of environmental education, representatives of those groups for whom provision is being developed, local institutions of tertiary education and training, and local arts groups. Some projects have worked very successfully with the involvement of a cross-section of partners. In Warwickshire, for example, the museum service worked with local secondary schools, English Heritage, and the University of Warwick, in the planning and organization of a large-scale, week-long 'living history' project.

It is important that links are made with teacher-training colleges. During the Armada exhibition at the National Maritime Museum in 1988, the education department collaborated with Goldsmiths College in the design of an interactive discovery area for very young children, linked to the exhibition. This was later staffed by students from Goldsmiths, whose knowledge of early childhood development theories helped them make the appropriate relationships with their young customers (Anderson 1989a). Other links with teacher-training establishments include the well-established collaboration with the University of London Institute of Education and many of the London national museums. Institute students spend some time in the museums, working with the museum education staff, and later are able to bring groups from their teaching practice schools on a visit (Paine 1989).

Links with universities can take many forms and should not be forgotten. The Open University and the National Gallery collaborate over art history courses, for example, and the conservation department of Glasgow Museums offers a one-term course to students from the Glasgow School of Art. On the whole, these links are not as extensive as they could be, and for some museums, and particularly local authority museums, they could be strengthened. Local and community groups can usefully be approached. Multicultural work must be carried out in association with the various ethnic and religious groups (Nicholson 1985), while work with special audiences such as the blind, will necessitate contact with the Royal National Institute for the Blind and local schools or day-centres (Pearson 1989).

Networks can also be established between museums. Sometimes the links between collections are such that useful joint projects can be designed. The theme of the English Civil War involved the use of three museums and a curriculum development unit: at the National Portrait Gallery students examined the portraits and values of the major personalities; at the Geffrye Museum, period room reconstructions led to discussions of home life and the effects of the war; at the National Army Museum, weapons, tactics and strategies were examined.

Primary school groups spent one half-day in each institution, and the Cockpit Arts Workshop then visited each of the nine participating schools for one day, and used drama, art and video activities to recall the museum visits and synthesize the various experiences (Heath 1976). Links between museums can be helpful to museums without specialist education staff, as a project organized jointly with an education section from a nearby museum would enable the curator to benefit from the expertise of trained educationalists.

Links need to be made with the media, both the local press, radio and TV stations for publicity, and national educational TV networks to relate

museum projects to the programmes teachers are using in schools (Reeve 1988: 83, 86). A recent ITV schools series 'Seeing and Doing', for example, included one topic on old and ethnic music. Children who were following this programme visited the Horniman Education Centre, observed various instruments from around the world, listened to the sound of them being played in their places of origin on tape, and were able to try some for themselves.

In all, the variety and extent of the network outside the museum that museum education staff require as a basis for their work is enormous, and can be very stimulating. The establishment, development and maintenance of networks must be regarded as an integral aspect of the educational work of the museum or gallery, and must therefore be included in any policy or strategy.

Networks and roles within the museum

In addition to working with colleagues of all kinds outside the museum, museum and gallery education staff also need to work closely with colleagues within the institution. Museum educators need to be aware of and sympathetic to the duties and priorities of curators and other specialist staff. Equally, curators and others need to understand both the needs of the museum or gallery educator in carrying out their own tasks, and the ways in which educators can contribute to the tasks of others.

In many museums, curators play a vital part in the delivery of educational services. This takes place through contributions to the lecture programme, through organization of activities and events, through enabling access for the public to the 'behind-the-scenes' area of the museum, and through talks outside the museum. The CSE examination course in Museum Studies devised in the late 1970s by education staff and a teachers' working group based at the National Portrait Gallery (Morris 1985), for example, would have been impossible without the input of curators, the registrar, the shop manager, the designer and the conservator of the Gallery. In many museums, generally the smaller ones with no specialist education staff, the curator is also reponsible for educational provision.

In addition to contributing to taught sessions, there are other ways in which curators and educators can collaborate, as the music session at the Horni-man Museum described above demonstrates. First, as part of the collection process, the instruments and their social and technical backgound were documented, which provided information for the museum teacher to draw upon. Second, the tapes of the instruments being played in their original environment were obtained as part of the collecting process, and copies for groups to listen to were made available. Third, some artefacts were collected that are suitable for handling and even for using. These are modern instruments which had been collected for this specific purpose, and include West African Drums, a Yugoslav fiddle, and an Australian didgeridoo.

It is sometimes difficult for teachers and new education staff to understand why objects are not as freely available for classroom use as they might

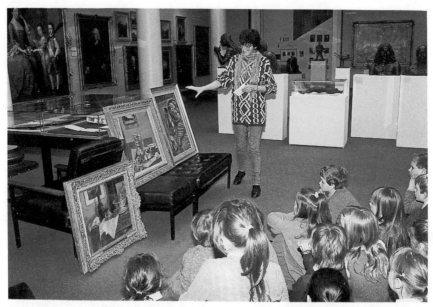

Plate 10 Good working relationships between education and curatorial staff are important. The Art Education Officer from Leicestershire Museums Service shows children some works from the painting store that are not normally on display. The Fine Art curator can rely on the Education Officer to treat the paintings with the care they require. Courtesy Leicestershire Museum, Art Gallery and Records Service.

expect. It is important to understand that the main concern, and indeed duty, of curators is to safeguard the well-being of their collections. This means expending much time and effort on maintaining and improving documentation, storage and object research. Some curators are also involved in enlarging their collections. These basic tasks need to be in order before the artefacts can be used for educational purposes. If nothing is known about an object, if it has been allowed to deteriorate, or even get lost, then its educational value is severely impaired. Best practice ensures that curators consult the needs of educators as part of the development of their collecting policy, as has happened at the Horniman Museum, where the multi-ethnic nature of the local school population, a cross-cultural focus in modern curricula, and the active learning methods used by the museum teachers have all been acknowledged.

Many, if not most, museum objects can never be handled by museum visitors. However, it is possible to make some things available: objects which are robust, such as domestic items, sculpture or fossils; parts of objects such as pottery fragments; and objects which can either be replaced, or are not rare, can all sometimes be used. Curators and educators need to be sensitive to each others' needs in this area, and in the last resort, the release of a museum artefact for handling is always the curator's decision.

The communication skills of museum educationalists are of value to museum management as complementary to those of other museum and gallery staff. Museum educationalists are perhaps unique in their professional approach which must be sensitive, empathetic and able to react to the broad range of needs (social, physical, emotional and intellectual) of all kinds of visitors. Communication with visitors is either through direct face-to-face encounter where enthusiasm, approachability, empathy and respect are vital, or through prepared written or visual material that is fully informed by previous direct face-to-face communication and related research. It is of prime concern that visitors of all sorts should find their visit enjoyable and motivating, bearing in mind that people evaluate in relation to their own criteria. These skills, approaches, and objectives are complementary to the communication skills of designers and marketing officers. It is by working together for the health and survival of the museum, and for the best experience possible for the range of visitors that resources will be maximized. This collaboration needs to be built into the management methods of museums, through team-work and good communication and consultation strategies (Locke 1984).

The educationalists of the museum have much to offer in the planning and production of permanent and temporary displays. This has been recommended for years by many reports (e.g. Wright 1973:42; Williams 1981:22) but few museums have adopted this as part of their policies. Where this has happened, qualitative changes have emerged in the interaction of visitors with artefacts. For example, in the air gallery at Nottingham Castle, where the education officer was fully involved with the writing of the labels, visitors can be observed spending longer than usual in front of each painting, and discussing aspects of the painting that the label has suggested, such as the changes the artist made in the painting.

Planning committees for exhibitions should include education staff. In making decisions on which exhibitions to mount, the views of the education staff should be sought. If education programmes are expected to be arranged in line with these exhibitions, the timing of the school year must be considered. How many exhibitions with excellent educational potential are planned to straddle the summer holidays neatly, or the Christmas carol concert bonanza? With schools encouraged to use museums and their exhibitions far more in their teaching, it makes sense to inquire widely into how exhibitions can relate to consistent syllabus demands, programmes of study, and attainment targets. It is also useful to plan programmes of exhibitions that, for example, show how to use museums, how to 'read' objects, or how to use a group of related objects in many different syllabus areas (Reeve 1988: 87).

Management issues are extremely complex in relation to the educational functions of museums. The confusion of employment levels of staff, the variety of relationships to other museum functions, and the detailed and rigorous planning that is required on a day-to-day basis makes this a vitally important aspect of museum and gallery education. If the management of the service is poor, learning potential will not be realized.

11. *Learning in museums and galleries: philosophy and method*

Objects and institutions

The possibilities for learning in museums and galleries are far-reaching. On the one hand, the collections can be studied as sources of information in and about themselves, but on the other hand, objects can form part of a less specifically focused learning process. The careful scrutiny of a Minoan urn, for example, can reveal information on Minoan technology and culture, but equally the decoration on the urn might be used as the source of a fabric design, and the function of the urn might be compared with a baked-bean can in a comparative study of containers.

Objects can act as catalysts in the learning process itself: the material aspect, the 'realness' of objects, enables the possibility of an arousal of interest or a focus of attention that is qualitatively different from the attention given to the written word. The study of both natural specimens and material culture demands the use of the senses allied to the work of the brain.

Studying in museums and galleries can be related to the collections, but can also be directed by the institution itself. What are the social roles museums and galleries play? Who visits them, and why? How do the institutions work? Who does what and why? All of these aspects of museums, the study of which is called 'Museum Studies', are potential areas for useful learning, perhaps as part of a social studies, art history or humanities course, as a course in its own right, or as an aspect of personal and social education (PSE).

Using artefacts and specimens in learning

An enormous variety of approaches exists to the use of museum collections in learning. Artefacts and natural objects can themselves be the focus of

attention, the 'object of learning'. The first questions to be asked will concentrate on immediate aspects such as: 'what does it look like?', 'how many parts is it made up of?', 'where did it come from?', 'who made it?', 'why?', 'for whom?', and then 'what has happened to this object since then?', 'has the object been changed?', 'what did the object mean when it was made, and what does it mean now?'

This way of looking centres on the object itself, its material properties, history and provenance. Even a two-dimensional painting can be treated as a three-dimensional object from this point of view. It can be seen to be built up of a number of layers (canvas, ground, paint, varnish, frame) and of different materials. How many parts is a painting made up of? Natural objects such as geological specimens can also be interpreted by asking basic questions about what is seen. Some geological specimens, such as fossils, have once been living creatures and can be treated as such, with questions concentrating on how the living animal moved, lived, fed itself (Knell and Taylor 1989:75).

All historic artefacts and many of the natural specimens that are to be found in museums have complex histories of movement from one place to another, have often suffered damage and repair, may have been witness to momentous events, and may have had particular significance which may have shifted over time. Museum catalogues can sometimes be very useful in describing these matters, which can require a great deal of original research. In some cases, and at some levels, the original research could be carried out by students, although this is particularly appropriate for contemporary articles, and for non-museum objects.

Some things, and perhaps particularly art objects, can tell a story, put a point of view, record or explore a response to a phenomenon. They have a deliberately communicative and expressive function. This is obvious for paintings, say, but can also apply to a building, a piece of furniture or costume, in varying degrees. Bess of Harwick's great sixteenth-century house in Derbyshire has her initials built into the fabric of the façade, for example, and the animals carved onto the Natural History Museum in London tell us its function. The examination of the intentional messages of objects can be fascinating, particularly where the messages are no longer topical and are therefore more or less invisible.

Objects can also be read for their unintended messages. All artefacts are the product of their time and place, and in their material, shape, decoration and so on will reveal technological possibilities and cultural values. An analysis of the Forth rail bridge in Scotland shows how the availability of new materials and processes from Germany, examples of bridges from Tibet, and nineteenth-century English attitudes to style and taste were all factors in the eventual design (Baxandall 1985:12–40). A large seventeenth-century bed with heavy hangings that offered the occupants both warmth and privacy tells us something about both the construction of houses and also the way in which people lived in them. And what do the mounted antlered heads of moose and deer tell us about attitudes to animals at the time that the mounts were made?

Interpretations of objects are rarely constant, varying according to the

time, place, background, opinions and degree of knowledge of the inter-
preter. The eighteenth-century portrait by Gainsborough, 'Mr. and Mrs
Andrews', shows Mr Andrews standing with a dog and gun next to a bench
upon which his wife is seated, wearing a fashionable dress. The couple have
chosen to be portrayed in a landscape with stooks of corn, which is in fact
their country estate. This painting represents contemporary upper-class
attitudes to men, women, and property to one viewer, and the relationship
between man and nature to another (Berger 1972:106–8).

All artefacts and many natural specimens have a range of possible inter-
pretations, and, in the learning process, this is one of their strengths. An
individual response to an artefact, or to a specimen, is a personal expression,
and as such has value in its own right. For some children and some adults, any
interpretation, or response, expressed through words, drawing, feelings or
music, however small, is a major acheivement. For others, complex inter-
pretations can be experienced and communicated by all kinds of methods,
and the initial personal response can be informed and developed through
further analysis. In educational terms, the 'accuracy' of the interpretation is
sometimes secondary to the value of the response to the interpreter.

The meaning of objects is fluid. Museums and galleries tend to classify
artefacts and specimens to suit their own internal systems of departmental
division and management of collections. Thus objects can be observed with
accession numbers on them, and are often displayed along with other objects
of their type which are cared for by the same museum department. How-
ever, objects can look different and mean different things when they are
presented or grouped with a different collection of companions. A seven-
teenth-century wooden chair, for example could be displayed with a
number of accompanying artefacts (see Fig. 11.1). Each context will high-
light a different facet of the original chair. If it is accompanied by other objects
made by the same maker, the chair will be revealed as part of the work of a
craftsman, and might be seen as the most beautiful (or ugly) of all the things
that were made, or as a chair made for a particular customer with particular
requirements, or as a chair made in difficult circumstances. Some of the
paintings of the seventeenth-century painter, Mary Beale, for example, were
made when she was very poor and had to use onion sacks instead of canvas.

The chair could be displayed together with other kinds of chair: the
aspects that would be emphasized could be those related to designs, uses
and technologies of chairs. How would a seventeenth-century French chair
compare with a late twentieth-century coach seat, for example, or a Brazil-
ian sedan chair? The chair might have been donated to the museum by a
specific person, along with the rest of a large collection. If displayed along-
side these other things, the chair would begin to illustrate taste, personal
idiosyncracies and values, wealth, and the history of the museum.

Where objects can be classified and reclassified, it follows that they are
interdisciplinary, and can usefully be employed to reveal and transcend
subject boundaries. The Islamic Studies project at the Metropolitan Mu-
seum of Art in New York explored ways of using Islamic art in mathematics.
The complex geometric designs found in every aspect of Islamic art are
examples of applied maths, and maths teachers studied these with their

Figure 11.1 The various themes and meanings stimulated by one specific object can be manipulated and controlled by the other things with which it is grouped.

students. This was also integrated with art and social studies (Norman and Stahl, Unesco survey). In a similar way, working with artefacts can relate to many different attainment targets of the National Curriculum, as has already been described on page 73 (see Fig. 8.2).

The educational value of using artefacts

Artefacts are not age-specific or dependent upon what is already known about them. Independent meanings can be made by young and old, and artefacts can be equally motivational at all levels. The sense made of objects will not be the same in all cases, of course. Meaning will be informed by maturational level, life experience, knowledge and so on. But often the sheer excitement of object exploration is sufficient to open new doors, to lead to new activities, to ask new questions.

Objects are necessary to verify abstract concepts at all stages of the development of knowledge in relation to them. A beginner may work from the object in the same way as a learned scholar. The artefact itself is the final arbiter of accuracy and relevance. Thus we can return to an object at

many different moments in the process of acquiring knowledge, and discover immediate relevances. The object acts as a 'document' to hold and record knowledge, with the capacity not only apparently to vary as we learn more, but also to enable us to recall what we know.

In addition to being endlessly responsive to our imposition of meanings, objects have a materiality to which we react, particularly through touching, and which demands a reponse from both the body and the mind. This particularly vivid form of response opens the possibility of the beginning of an engagement in the holistic interactive process which is required before learning can begin. Our immediate involuntary response to objects can short-circuit the often difficult transition between passivity and active engagement and learning.

It is sometimes possible to use photographs and slides instead of real things, but often this will result in a diminution of the experience. Two-dimensional reproductions remove all feeling of scale and solidity from objects, presenting a 15-foot fresco and a tiny coin in the same way. As human beings of particular sizes, we react to scale in different ways. We may find larger things intimidating or awe-inspiring; we may find small things comfortable or in need of a protective stance. Our bodily responses to size and scale are impossible at a slide-show.

Texture vanishes too. The rough, lumpy, animal feel of a woven blanket, and the smooth, sensuous, slippery texture of silk, are reduced to a colour impression. We have to use our experience and imagination to guess from the colour what the texture might be. If we have no experience of either that colour, or that texture, this is impossible. Colour is changed anyway, in the photographic process, and of course, many two-dimensional reproductions are in black and white. Sometimes this is better than nothing, but the deprivation of the senses, particularly those of touch and smell, and the resultant dilution of information, must be noted.

Experiencing the real thing can enable holistic learning (Matthews 1980:93–4). Holistic learning is to know things in relation, to understand how parts relate to the whole. An analogy to explain this is that of a group of blindfolded people around an elephant. One holds its tail and says she is holding a snake; another holds the leg and says its a tree; a third holds the trunk and thinks it is a lizard. The blindfolds are removed and they see they are all holding parts of the same thing. The study of objects enables relationships to be made between culture, technology, people, social structures, the past, the present and the future, in a way that can enable holistic learning to progress. If it is true, as Aquinas suggested (Hooper-Greenhill 1988c), that we learn better and at a more basic level through the concrete and the material than through abstractions, then we have a deep requirement for objects throughout life to give us a sense of being in the world, and to have a solid material basis for our mental symbols and abstractions.

One of the most exciting possibilities of working with objects is the development of thought itself (Delahaye 1987). Working with real things enables all kinds of thinking to occur, including making comparisons, remembering, making relationships, classifying, interrogating, moving from concrete observations to abstract concepts, extending from the known into the

Figure 11.2 Touching, looking, listening, smelling, and (occasionally) tasting can be used in the preliminary exploration of objects and environments.

unknown, and from specific observations to generalizations. The unique feature of the occurrence of these processes in museums and galleries is that they happen spontaneously in conjunction with an almost involuntary use of the senses. Learning becomes less contrived, more enjoyable, and genuinely exploratory.

Using the senses to learn from objects

Looking, touching, feeling, listening, smelling and tasting are all ways that an initial response to an object can be stimulated (see Fig. 11.2). Clearly, not all of these are necessarily possible or desirable with all objects, and for many objects, looking remains the only means of access.

Where it is possible, however, touching and handling objects can be exciting and can increase motivation to learn about the object: where it came from, whose it was, what it is and so on. The thrill of handling something which is very old, or very unfamiliar, is something which museums and galleries can offer which is generally unobtainable elsewhere. Most people need to be taught to handle things, to pick things up, to look underneath, and inside, to examine the materials the object is made of for signs of wear, or for a maker's mark. Careful looking combined with careful touching can discover whether a dish was made in a mould, for example, was hand-built or turned on a wheel. Touching can reveal temperature, and lifting can demonstrate weight; from this further conclusions can be drawn about the nature of the material. Feeling a bump, a blemish or an abrasion can indicate the amount and type of use the object has undergone.

Plate 11 Everyone can learn through touching. The opportunity to do so is
sometimes limited to groups with special needs, although some education
staff have a handling collection that can be used with booked parties.
Here, a young visitor enjoys feeling one of the exhibits in 'Discovering
Mammals', a special exhibition for the blind and partially sighted at the
Natural History Museum in 1985. Courtesy the Natural History Museum,
London.

Touching an artefact that has been produced by someone or something
very remote from the day-to-day can be extraordinary. Putting fingers into
the finger-print of a long dead sculptor, for example, or hands into a
dinosaur's footprint, is a very special experience.

If it is possible to use the other senses in relating to the object, this
broadens and deepens both the experience itself and the type of informa-
tion that can be assimilated. Some objects can be listened to: musical
instruments, or machines being demonstrated, for example. Some objects
can be smelt, such as a cedar-wood steamed box made on the west coast of
Canada. Herbs and many other natural specimens, or things made out of
natural materials such as leather, can also be smelt. Not many objects can
be tasted, but in some museums it is sometimes possible to cook in, say, a
seventeenth-century way, and eat the results. In an art workshop in the
Musée d'Art Moderne in Strasbourg, where a painting of Braque's was the
stimulus, and the children were working with a still-life of pears and apples,
at the end of the session the fruit was first smelt and then eaten. Most
museum and gallery educators are aware that it is the experiential aspect of

Plate 12 Listening and handling enhance the learning potential of objects. Here, 12-13 year-olds from Edenham High School, Croyden, experiment with a variety of instruments from around the world. Photo: Keib Thomas. Courtesy the Horniman Museum and Public Park Trust.

the encounter with artefacts that is the most valuable thing they have to offer, and most activity sessions will be organized to utilize more than one sense. Many sessions will involve not only the senses, but also the body, with games, trying on costumes, making art or other objects, role-play, measuring and weighing and so on.

On the whole, looking is the sense most likely to be employed where no specific programme of activity has been arranged with the museum staff. Looking is often problematic and it is not the simple naïve sense that some have considered it. It is difficult just to look. This is made easier through drawing, handling, discussion, or looking for a specific purpose, such as to describe the object to a person who cannot see it. Looking through a magnifying glass, a card frame, or from an unusual angle may help.

What is seen depends on what is known; thus museum curators will see an artefact in relation to the research they have done or will do on it, an artist might see the object as a source for ideas, a young child might see it as something strange and possibly frightening. As knowledge deepens about a particular object, more things will be looked for and seen. If the presence of

Plate 13 There are very few museum objects that can be tasted! However, eating and drinking unfamiliar things, dressed in strange clothes, in an environment very different from home or school, is a memorable experience. Here, children eat their way into the past at Clarke Hall. Courtesy Clarke Hall Educational Museum, Wakefield. Photo Barry Wilkinson.

a maker's mark, for example, is known to be a possibility, perhaps the object will be turned upside down. If a piece of furniture has come from a house where there was a fire, the change in the colour due to smoke damage will be noticed. Looking at a building after having carefully examined some related rock samples will lead to the building material being studied in a different way.

Looking on its own is a distancing sense. It is less immediate and less physical than the other senses. This is particularly true when looking through the glass of museum display cases. Looking in conjunction with handling is quite different: holding a small something, or stroking a large something, is a physical activity which *demands* an involuntary physical response and seeing and feeling will go hand-in-hand. Looking on its own does not provoke initial involvement in the same way.

Sustained looking, however, requires cognition, an incorporation and interpretation of the object in such a way that it can be re-presented to the gaze as part of an individual world view, which is both personal and social. This is a difficult and complex process which needs teaching and learning, but it is, in fact, vital to the appropriation of the object into the existing mental set, the existing experience, of the looker. It is this experience on which knowledge and interpretation of the world is based. The study of objects can shift or develop this interpretation of the world, but only if a relationship with the existing meaning given to the world by the looker in question can be made.

Plate 14 Looking can be stimulated through drawing. A student on a further education BTEC course has been introduced to the traditional crafts of West Africa though a talk given by the museum teacher. Some suitable artefacts were provided in the education room for close observation and handling. Now the student draws as part of her own follow-up work in the museum galleries. Photo: Keib Thomas. Courtesy the Horniman Museum and Public Park Trust.

Plate 15 Sight is perhaps the most obvious sense when learning in museums, although it is not as straightforward as it initially appears. Children look very closely at oil paintings and their frames. How do they relate these pictures to their own experience of proliferating mass-produced images? An adolescent boy looked, thought hard and asked: 'Is it a big print, Miss?'Courtesy Leicestershire Museum, Art Gallery and Records Service.

Meanings are individual, fluid, unstable and precarious, and exist within social, cultural, personal, political and economic contexts, some of which overlap, and some of which are contradictory. We are daily engaged in making sense out of the world; making, changing or confirming our own meanings, and the meanings other people make. This is done in part, of course, through the material culture that surrounds us, and it is done, in general, through a very spontaneous process. We feel comfortable or un-comfortable in a particular situation according to how we read the disposi-tions of material culture in that situation. Part of teaching people about and through objects is to uncover and reflect upon this social skill, this skill which is necessary for social life, and which all people have, but usually without examining it. This skill is the basis upon which object-teaching starts and it is revealed or uncovered through sense perceptions, which can be analysed, questioned, verified and reinterpreted.

Building up the picture

An initial sensory exploration can reveal a considerable amount of informa-tion about an object, and can lead to an involvement with it. This can then be built upon through the discussion and investigation of that exploration, during which process many questions will be raised that perhaps cannot readily be answered, and many avenues for future research will be opened (see Fig. 11.3). Museum education officers who have researched the objects will know some of the answers to many questions, but they need to work closely with the leader of the group in selecting which and how much information is offered. The initial discussion when the session was booked should offer guidance on this.

The main problem in teaching with objects is to avoid an early end to the lesson. 'What's that?' 'Oh, its a wooden chair.' Giving the object a name has the effect of ending the process of inquiry before it has begun. It is important to open up as many areas as possible in this initial stage of looking, and to ask questions that prompt a further look for an answer: 'What forms of decoration can you see on the chair?' A follow-up question might draw on existing knowledge: 'This chair has no upholstery. Why wouldn't it be uncomfortable to sit on?' Earlier information about the padded clothes of the early seventeenth-century would be called on to supply an answer.

The direction of the initial exploration can be manipulated and some shaping of the experience can be carried out by a skilful teacher, according to the aims of the object-study. For example, if the museum teacher knows that the reason for looking at, say, the bridge at Ironbridge, is for the students to begin to think about the material from which the bridge is made and that this will later be related to other uses of iron, data pertinent to the material properties of iron, and its use in making a bridge of this type, would be focused on instead of the social effects of bridging the river at this point. It would be a mistake, however, to make this initial exploration too narrow, as one of the interesting things about working with objects is

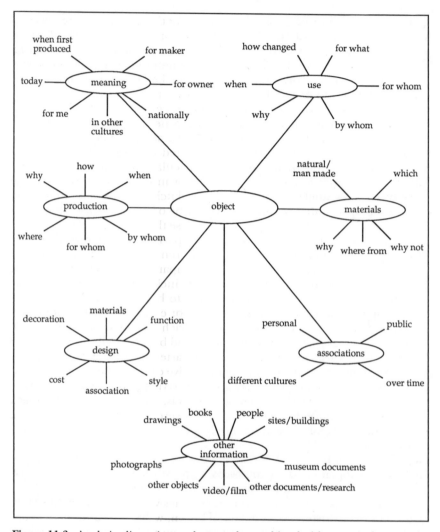

Figure 11.3 Analysis, discussion and research, combined with sensory data, can be used to explore the object in depth.

their interdisciplinary effect, the way in which they cross subject boundaries, open new ways of looking at things, and demonstrate how, for example, technology has a social effect. It is much easier to learn abstract concepts like the material properties of iron, if it is linked to concrete effects.

The information assembled through sensory exploration and its analysis can be discussed, and related to previous information and experiences. If this is a group exercise, which is often the case, individual perceptions and impressions can be compared with the perceptions of others. Knowledge

can be shared. This is a particularly interesting thing to do with adults from various backgrounds, as it might turn out that one is, for example, a trained chemist, another knows about building bridges, a third is a fisherman, a fourth made a study of the early nineteenth century at school, and so on. From all this varied experience, a remarkable body of information can be built up on, for example, the bridge across the river at Ironbridge. A synthesis of all this material demands the input of further information, and may promote research by the teacher, the learners, or all together.

Hypotheses on and deductions from the use and meaning over time and through space of the object may be suggested and discussed. The seventeenth-century wooden chair, or the semi-circular bridge made of iron, can be compared with those we have at home, or in our local area. Maybe the wooden chairs at home fold up because the kitchen is small, and the chairs in the sitting room are big and padded. Maybe our local bridge, which goes over the railway, can barely be noticed because the road goes over it without a change in level or style. These simple comparisons can be revealing.

Comparisons can also be made with different cultures. Museums have a powerful function to perform here. The comparative display of things used for the same purpose in time and space including our own time and location would immediately enable people to begin to decode unfamiliar objects. A museum display which enabled, for example, a comparison with a modern glass water-jug, a bushman ostrich egg, a Greek urn, and a sixteenth-century Tudor leather bucket would be fascinating. The National Curriculum in Technology indicates that artefacts should be treated as solutions to design problems. The comparative display just described would present some solutions to the problem of carrying water. Additional information (presented through relevant objects, photographs, documents, etc.) about why these particular solutions were reached would provide a genuine detailed learning experience.

Learning about museum processes

The study of objects in museums and galleries will generally lead to questions about why the object is in the museum, what it is that curators and conservators do all day, and what is a museum for anyway (see Fig. 11.4). These questions are an intrinsic part of museum and gallery education, and one of the functions of the education officer is to inform people about the roles and functions of museums. This is perhaps more difficult for the teachers planning a museum visit unaided to deal with, but many of the questions will probably have fairly obvious initial answers, and others should be used as research questions for verifying later, either by asking the museum or by book research (Harrison 1973; Ambrose 1987). The study of museum processes and activities is, however, particularly fruitful when carried out in conjunction with a museum or gallery. Sometimes the project takes place in the school classroom (Uldall 1982), or is part of adult education work in the community (Riksutstallningar 1976:119).

The municipal museum of Odense in Denmark has built up a collection

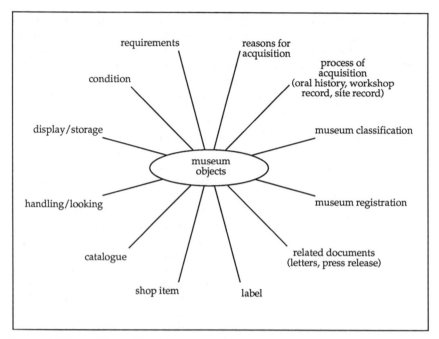

Figure 11.4 Working with objects in museums and galleries can often lead to questions about how museums acquire, research and care for their collections.

of artefacts which can be lent, in bulk if required, to local schools. These are objects that either have no great value to the curators of the museum because they are unprovenanced and undocumented, or are duplicates, or are objects that have been specially collected for loan purposes. The museum's aims in making the objects available are, in essence, to democratize museum processes, and give the community the opportunity and the responsibility to work with material culture in the same way as curators, but without any interference from the museum. This is seen as a chance to overturn the cultural elitism of curatorial professionalism and to reverse the one-way communication channel that has tended to be the norm in museums.

The objects are generally used by the schools during special 'features weeks', when normal teaching is suspended and there are opportunities for extended projects and interdisciplinary team-teaching. Students are able to study the material culture borrowed from the museum through making visits to parents, grandparents, local factories, shopkeepers and other museums. Craftsmen, like the blacksmith at a smithy, for example, could be visited as part of a study of iron artefacts.

The emphasis is primarily on practical investigation, with the written word as a support where necessary. The results of the investigation is displayed in an exhibition at the school, designed and mounted by the

students for themselves and each other. The role of the museum has been consciously limited to lending objects, exhibition cases, and material for teaching such as charts, maps and books. The museum has limited its role to that of an enabler, in the confident expectation that others apart from the experts are capable of 'managing our culture' (Uldall 1982). The students are transformed from passive spectators at an exhibition to active makers and doers.

The CSE Museum Studies developed at the National Portrait Gallery (NPG) at the end of the 1970s approaches the investigation of museum functions and processes from a different point of view (Morris 1985). This course was deliberately designed as an examination course to help second-ary schoolteachers justify a museum visit. The course has a fairly complex structure: teaching of museum functions is generally taught at the NPG, and then supplemented by visits to other museums and galleries. The gallery staff, including those in the exhibition office, design office, conser-vation studio, registry, publications department, frame shop, press office, photographic collection, education department, library and archive, are involved in explaining their tasks, training, schedules, costs and experi-ence. Pupils visit the specialist areas 'behind-the-scenes', and can see, for example, galleries being set up or dismantled, ultra-violet lamps and other conservation equipment, storage areas and boxes of archive material.

The core of the course focuses on learning and understanding about museum tasks. Museums and galleries are then used in two specialist op-tions on, for example, 'domestic architecture from 1880 to the present day' or 'a study in character, historical or fictional'. As part of the course, ten visits must be made to museums and galleries of different types, so that an understanding of the range of institutions can be built up.

The course has been run successfully for over ten years, though its continuation may be jeopardized by the recent changes in educational structures. The course has been very successful for the students involved, who have grown in confidence and knowledge in relation to museums and artefacts, and to the professionals with whom they have worked. One of the teachers, working with a sixth-form group, has written of his students: 'the growing ability to talk, question and listen in an adult way has been one of the real pleasures in running the course.' Exam results have been pleasing. For the museum staff concerned, the course does represent a great deal of effort for a small number of teachers and students. However, it should be argued that the in-depth qualitative learning that the course has provided more than justifies the work required.

The potential for learning in museums includes learning from objects and learning about museums and what they do. The realization of this potential involves careful and detailed planning and co-operative working between museums and teachers.

12. Programme design and evaluation

Planning for learning in museums and galleries

The educational use of museums and galleries is potentially vast, but what steps do we need to take to ensure that learning really takes place on museum visits? In common with all other educational processes, the nature of learning in museums must be understood and the learning process carefully planned and assessed.

There is some evidence to show that schoolteachers do not always recognize the learning potential of a visit to a museum, gallery or site, and that therefore learning opportunities are missed. The work carried out on the visit is not always integrated into the curriculum, and visits tend to be seen as a chance merely to acquire information rather than as an opportunity to develop the processes of learning (Clarke 1989). Children are often confused about the functions of the visit. Teachers sometimes do not have fully defined educational objectives, and tend to rely on the experience of the visit as a justification in itself.

Although research in this area is all too scarce, there are one or two useful studies that are helpful in thinking about the basic organization and planning of visits in order to maximize their learning potential. The studies make points that alert us to the aspects of planning that are specific to museum and gallery visits.

Research from America suggests that when schoolchildren are taken to a new place, their reaction to the novelty of the environment is such that it is necessary to design tasks to encourage exploration (Falk, Martin and Balling 1978; Falk and Balling 1980). Most field trips to museums, galleries, sites and nature centres (and these researchers are involved with environmental education) are to stimulating settings that are unfamiliar to the children; the disorientation the children experience in such an environment needs to be assuaged by exploration. This need to explore the space before feeling comfortable can interfere with knowledge-based tasks, unless these tasks can be carried out in an exploratory mode.

Most museum and gallery educators are aware of the need to put audiences of all ages at ease in strange spaces. Some children, for example, arrive at a museum not knowing what it is or where they are. The trip through the galleries can be additionally disorientating. On arrival at the

place where the educational session will take place, some basic orientation is vital before settling in to the main purpose of the visit. This preliminary phase is also necessary if an education officer is conducting the visit, to make an initial relationship with the group, and, even if the class-teacher is acting as leader, to refocus the attention of the group. Exploratory behaviour, such as data gathering, using a variety of methods, needs to follow quite quickly after this, but hopefully, after an orientation and a fairly brief statement of basic themes and methods, the exploration will be structured and knowledge-related, in addition to being a discovery of territory.

As might be expected, the older the children, the more ready they are to tackle unfamiliar settings. Older children may well thrive on day-long visits; younger children benefit from shorter visits to more familiar settings in and around their school and neighbourhood, such as the local museum or nature centre. Repeat visits at all ages are particularly useful; the first visit can emphasize familiarization activities, while the second and later visits focus on more conceptual material.

The nature of museum learning is the subject of a second study. Pond questions, from the point of view of the history teacher, whether children do in fact learn anything from museum and gallery field trips (Pond 1983; 1984 and 1985). He experiments with Piaget's work in assessing museum learning and discovers that those children who have progressed beyond the stage of concrete operational thinking are better able to make use of the visit. Does this mean that a museum visit is inappropriate for younger children? Pond comes to an alternative conclusion: that the finite, structured problems with which Piaget's work is mainly concerned do not represent a characteristic historical approach.

Pond suggests that the study of history is the attempt to construct, on the basis of such evidence as survives, a narrative of particular human action and activities (Pond1985:33). This is achieved through speculative and directed imagination. Thus, in museum and gallery visits, it is appropriate that teachers give children an opportunity to forge emotional and imaginative links with the past. The usefulness of museum and gallery visits lies in the opportunities to use the imagination, and to engage the thought processes in open-ended speculation.

This is clearly appropriate for history teachers. But how generally applicable is this finding to groups working in other subject-areas? It may be more relevant than might at first seem. A highly-structured assessment of a school visit to the Franklin Institute Science Museum in America came to the conclusion that although interactive science exhibits can teach science, the strength of the museum visit is in the affective rather than the cognitive domain (Borun and Flexer, Unesco survey).

The researchers carried out various tests to study enjoyment, interest and motivation on the one hand, and recognition, comprehension and application on the other, in relation to the experiences of students in the museum. The students experienced either a visit to certain interactive exhibits, or a museum classroom lesson on the concepts the exhibits were designed to teach, or the latter followed by the former. A control group was also tested. The results showed that the interactive exhibits used in the

experiment taught science concepts as well as the didactic lesson. More importantly, however, students perceived the exhibit as far more enjoyable either than a normal classroom lesson, or than the museum classroom lesson. In addition, the students perceived the visits as an effective method of teaching science. However, the greater success lay in relation to the students' attitudes, enjoyment and emotions. Given that any learning will be more effective if students find the teaching enjoyable and fun, the museum seems to win hands down.

Both Pond and Borun and Flexer offer the conclusion that the true learning potential of the museum is in the opportunity for the imagination and the emotions to engage in an enjoyable way with knowledge-related concepts through active learning. This will be a familiar idea to most museum educators, who will have discovered this to be true in practice. In planning museum and gallery programmes, there is no point in replicating that which can be done elsewhere. The experience of the visit should enable the making of imaginative and emotional links to artefacts, specimens, historic sites and environments.

These affective links will only be successful if they relate to the world of the specific child or adult. In teaching appreciation of art, for example, it is highly unlikely that these links will be made through a recitation of artists' names, dates, historical styles and influences. Where the learners are sophisticated and familiar with the subject-matter, this information will be relevant. For beginners, an introduction to looking at paintings is far more important. A basic principle is to work from the knowledge and life experience of the audience, rather than the knowledge and life-experience of the museum teacher or curator. Clearly this means finding new beginnings for each group, or group-type (Whitechapel 1989:16).

For schoolchildren, the needs of the National Curriculum must be borne in mind. Out-of-school visits are encouraged in the official literature, particularly where one visit can provide thematic, knowledge-related, or attitudinal stimulus in several areas of learning (DES 1989c:9). HMI have identified the need for more talk and discussion, particularly in the secondary school, in order to handle new ideas, to develop reasoned argument, to internalize experiences and find personal expression for them (DES 1989c:10). Museum visits can offer opportunities to satisfy this need, and can also satisfy the need for breadth and wholeness, active learning, and first-hand experience on which abstract ideas and generalizations can be based. Again, a deficiency is pointed out at secondary level (DES 1989c:11).

In planning for adult visits the needs of the learners are also paramount; but adult audiences will also benefit from experiences on which discussion and abstract concepts can be based. Adult audiences are more likely to be offered a more formal approach to learning which focuses on specialist academic knowledge, but this is not necessarily the best way forward. The needs of the specific group may suggest an alternative approach. The video which was made about the Scottish Museums Council's Leisure Learning Programme (Stewart 1988) shows how an artist discussing paintings carried out while travelling on her own found herself talking to a women's group about the pleasures and problems of travelling as a single woman and how

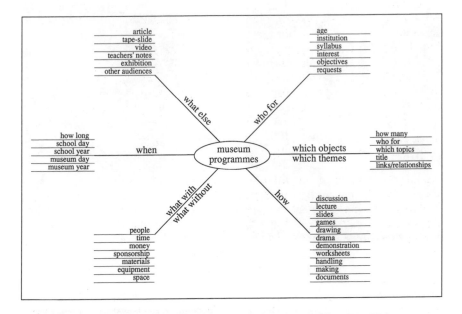

Figure 12.1 Issues in the planning and management of museum programmes

this affected the images she made. Lunchtime lectures at the Museum of London were extremely successful when based on a handling session. An opportunity to do things together as a family has been welcomed in some museums. The Tate Gallery Liverpool runs a programme called RSVP (Retired Senior Volunteer Programme) with a group of older people who bring friends of their own age to the gallery. Similar approaches are used in America (DES 1988a). The basic principle behind working with adults is that of collaboration and consultation. The groups are not homogeneous, and there is no curriculum document to consult, but some guidelines and examples can be found (Collins 1981; Bown 1987; Carr 1986; Jones and Major 1986).

For the museum education officer, planning is complex and multi-layered. The role of the education officer in the museum is to make links, networks and connections between the internal world of the museum and the external world. Hopefully, carefully designed and managed policies indicate which relationships from the many possible are to be pursued. In designing programmes for specific audiences, it is the education officer's task to identify and understand the requirements of the group concerned and to select from the total experience of the museum an encounter with those objects, processes or even individuals that will benefit the group most.

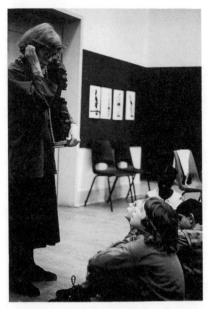

1. Rachel talks to the children and shows them the sculptures, asking them what they can see, and telling them a little about the origin of the works.

2. 'How are the sculptures like us?'

3. Some of the works are passed round for handling and close looking. The children share their reactions and talk among themselves.

4. Part of the space is prepared before the group arrives with the tools and materials they need to draw and then make masks in clay.

Plate 16 Detailed practical planning, careful structuring of time and type of activity, preliminary liaison between teacher and museum staff, and a selection of appropriate objects, are all necessary to make a museum visit a success. Sometimes, too, partnerships between institutions can be very fruitful.

5. The children draw with large crayons in preparation for making the masks.

6. They begin to make some masks inspired by the heads they have looked at and handled.

7. Rachel and the children's teacher work together with the children.

8. One boy with very poor vision works largely through a sense of touch.

Here the University, the museum, and the school work together. Beaumont Lodge Primary School works with Rachel Sullivan (from the University of Leicester Department of Adult Education) at Leicestershire Museums with the Makonde exhibition of African carvings.

In designing the programme, the education officer has a number of questions to ask. Who is the programme for, what objects or themes are appropriate, what methods should be used, what resources are available, what constraints are likely and how can all the work be put to best use? (see Fig. 12.1). As the answers to each of these questions are identified, the specific programme will gradually develop.

The structure of the visit

The structure of the school visit to the museum needs very careful thought and detailed advance planning. Some specific guidelines relating to visits to museums, galleries and historic sites are available to help teachers plan both the educational objectives and the use of the venue (Adams 1990:1–63; Ambrose 1987:108–11) Most museums and galleries will have their own visit guidelines, generally in leaflet form, which indicate what facilities exist on site and what school services are offered. These are generally made available by post to teachers.

Most of the best visits to museums and galleries form part of a three-part unit: preliminary preparation, museum or gallery visit, follow-up work. The preliminary work may be carried out in school or out of school, and is used to prepare the students so that the maximum value can be gained from the visit itself. The museum or gallery visit acts to motivate, stimulate, provide a physical experience, and consolidate learning, and as such is successful either fairly near the beginning of a programme of study, or fairly near the end. It is essential that the experiences of the visit are recalled, discussed, evaluated, and responded to back in the classroom, otherwise much of value will be lost. Very often although the museum visit is only one component in a programme of study, it is the hinge that articulates other aspects of the learning process, and as such is essential to the course of study (Woodward 1989).

In the planning of visits, it is essential that the teacher can survey the site in advance, particularly if this is the first time the venue is to be used. The preliminary visit can be used to locate the toilets, coach-parking space and other practical details; to pinpoint any unexpected potential disasters, such as the lunch-room being closed for redecoration, or the road in front of the museum being dug up; and to analyse the spaces that will be used. Sometimes worksheets are written or adapted on preliminary visits. It is also useful, if the museum education officer is to be part of the visit, to discover precisely what the day will comprise and to agree joint objectives and procedures.

Many teachers, at least when they first start to use museums, are not clear about what is possible, and so objectives are often not completely formed. Detailed discussion with museum staff about the possibilities and activities that the museum can offer will help. It is worth paying particular attention on the first visit to make sure it is a success; further visits will be much easier to plan. The complete course of study the teacher is planning might include visits to other institutions or sites, churches, record offices, historic buildings, or parks, for example. It is helpful for the museum education

He looks Old ; Rrinly bad, missbly, cold, upseet Poor He looks about 58 years old He looks H like H whon's to Kr cry

Plate 17 A twelve year-old boy records his reponse through drawing and writing to the portrait of W. H. Auden by D. Bachardy at the National Portrait Gallery.

officer to know which other places are being visited as then links and references can be made to them.

The museum visit will take one of a number of forms. It should offer a variety of stimulating activity, enable the children to come into contact with

objects and displays, and allow sufficient time for a visit to the museum shop and toilets. Lunch arrangements, and arrival and leaving time must be carefully worked out and everyone who needs to know must be informed. Helpers in particular must be given information to enable them to play their parts. This should include practical information on what happens when, where, and for how long, but if helpers are to work with small groups in the galleries, it might also need to include concept- or object-related information.

Follow-up work stimulated by the museum visit should also form part of the course of study. This will relate to the objectives of the teacher and the possibilities are endless. Some primary schoolteachers will use the experience for writing or language work; some secondary schoolteachers might encourage further research into the objects seen at the museum. A visit to the Tate Gallery Liverpool enabled children in Year 7 to discuss with an artist some of the issues that interested contemporary sculptors, and draw some sculptures. The follow-up work was for the children to produce a sculpture of their own based on what they had observed.

Children who had visited Speke Hall in Manchester as part of GCSE course-work later wrote descriptions of the hall, placing it in its historical context, and used their notes on a series of rooms in the house combined with background knowledge of the period to help them imagine what it would have been like to be a Roman Catholic priest sheltering at the Hall (DES 1988b). Sometimes practical work, such as spinning, weaving and carving begun in the museum, can be completed at school. Some work has been known to last many weeks, as for example at the school that decided to turn its own classroom into a Victorian schoolroom after seeing a reconstruction in a museum. Parents helped students make costumes, and research using archives and artefacts was undertaken. In one secondary school pupils in Year 8 established their own museum about the Second World War after seeing a local display. The acquisition of objects by donation or gift, and the planning and arranging of displays, was supplemented by inviting elderly people to come and talk about their experiences (DES 1985b).

Most children and teachers alike respond to and enjoy extended study through repeated visits. One of the delights of the CSE Mode 3 in Museum Studies (Morris 1985) was the growth in confidence and knowledge about museums, galleries and London itself that could be observed in the students. For some students from the Convent of the Holy Family School in Balham who were among the first groups to participate in the course, the visit to the National Portrait Gallery was the first time they had crossed the Thames from South London. By the end of the two-year course, they were seasoned travellers across much of central London and beyond in their pursuit of museums to visit and their staff to interview.

Methods and content

In deciding on the methods and content of the visit, the need for exploration should be borne in mind. Casting the group in role as detectives, or a film-crew, or teachers of another group, for example, will give a purpose to

exploration and at the same time a slant to the way in which objects and settings are studied and assessed. The National Portrait Gallery CSE group found a new motivation in looking at eighteenth-century portraits when they learnt they had to present them to younger children.

Methods should provide a focus on developing imaginative and emotional links with artefacts and ideas. At St John's House, Warwick, the Mayes family and the Price family have been invented as a focus for activities using objects from the social history collections. Taking groups of children to York and understanding that they might find it difficult to imagine the way it might have been in the past, Pond used museums where the children could enter into the setting, like the Kirkgate street and the period rooms at York Castle Museum (Pond 1985).

Methods should vary according to the age-range of the group. Younger children are very willing and able to suspend belief, to enter into drama and role-play, to act out stories. Themes used with primary schoolchildren tend to be large scale and related more closely to everyday life, such as food, transport, celebrations. Methods are often emotionally explicit in a way that older children would find difficult. Methods used with older children are active, but tend to be more cognitively oriented, and have a strong relationship to the curriculum.

For example, in a large-scale reconstruction of the visit of Queen Elizabeth to Kenilworth Castle in 1575, the emphasis for primary groups would be on enjoyment, physical activity, role-play and large-scale group work, whereas the emphasis for secondary school groups would be on more careful, controlled, smaller group work, with a greater awareness and control on the part of the students of the outcomes of their work, and an overt responsibility both to an integrated conclusion and to making their own and a group record. The primary group might 'live' the event; the secondary group might set it up as a formal tableau, with lights, props, and so on, and film it. The objectives for the primary group would focus on imaginative, emotional involvement and on social experience; the objectives for the secondary group might be skills oriented (lighting, use of video camera, construction of costumes, historical research) and related to an examination course for which documentation of the project would be produced.

Plate 18 *(overleaf)* A reconstruction of the visit by Elizabeth I to Kenilworth Castle in 1575 is recreated by a consortium of institutions including primary and secondary schools from Warwickshire and Coventry, Warwickshire Museum Service, English Heritage, and Warwick University. Specially prepared and trained teachers, released for the week from their schools, take lead roles in the drama, but the main part of Elizabeth I is played by a professional actress. Sixteenth-century language is spoken throughout the day-long event. The day is structured through preparation for the Queen's visit in the morning, and the visit itself in the afternoon. The visit is used as a way of contextualising the experience of the day, and of motivating the learning process. Those classes that were lucky enough to attend the event provided a review for those back at school who did not, through an Elizabethan Afternoon for parents, students and school governors.

1. Young militia-men with arms practise drilling in the castle grounds to be ready to escort the Queen when she arrives.

2. Other young people practise dancing in order to dance for the queen. Some costumes have been made at school, and some provided by English Heritage.

3. Lunch, provided by Coventry School Meals Service, is eaten in the middle of the day. Not everyone appreciates the austerity of the 'sixteenth century' meal. Clearing up must be organized, in role, by the teachers before the afternoon can begin.

4. The Queen has arrived. She is entertained by Lord Leicester, her host, and his people, who bring her the gifts they have made earlier, which include posies, potions, platters, embroidery, sweetmeats, punch, and of course dancing and music. Courtesy Warwickshire Museum Service.

Many museums have traditionally prepared worksheets for use during class visits (Reeve 1983; Fry 1987; Durbin 1989). These can lead to either very good or very bad experiences. Bad worksheets are those which are not specifically geared to the needs and abilities of the group using them, direct attention to the label rather than the artefact, do not encourage thoughtful looking and use of observation, are too long, are limited to a 'see it, tick it' approach, and all in all prevent rather than promote learning.

Good worksheets are carefully planned, tried and tested in relation to specific objectives, are age-related, encourage deductive thinking, are theme or person-based, are limited to a few key objects, often use drawings and illustrations in imaginative ways, enable follow-up discussion either at school or at the museum, and may enable modifications by the teacher. Some worksheets are produced in 'suites' or series, with the same approach in each, which can be successful.

Working with objects

There are many tried and tested ways of using objects in learning (Marcousé 1961; Harrison 1970; Morris 1989; Durbin *et al.*1990). Perhaps the most important thing to start with is the need to slow down the process of looking at objects. Given no guidance or help, most people spend very little time looking at objects in museums or galleries, and the few short seconds that are spent are rapidly reduced after the first two or three display cases. English Heritage has recently published two teachers' handbooks that are particularly useful in describing appropriate methods (Morris 1989; Durbin *et al.*1990).

It is generally recognized that special techniques are required to enable both adults and children to look. Drawing to discover the characteristics of an object is useful, especially when a focus on a specific aspect, say texture or form, is suggested. Objects can be drawn to show how they work, or to demonstrate size or scale, using measurements. Sometimes viewing-aids are useful, such as card frames, or magnifying glasses. Drawing comparative details is a good way of building up information to be used later. For example, making a collection of mouths or eyes from portraits to use in mask-making, or a collection of tea-pot spouts for use in tea-pot designing. Concentrating on the detail in question does not prevent looking at other aspects.

Describing an object verbally in response to questions from someone who cannot see it but has to draw it, is fun and requires close looking and careful use of language. Descriptions in writing, perhaps on a prepared sheet with identified aspects (colour(s), decoration, size, number of parts, etc.), can promote careful attention. Devising a sheet for use with several objects would be also be interesting.

One of the easiest ways of seeing the specific peculiarities of any one object is to compare it with another which is similar but not the same. Many objects are difficult to decipher, because they have an apparent 'naturalness' and inevitability that is difficult to overcome. Comparison with an-

other solution to the same problem is one way to solve this. The comparison of two Byzan-tine mother and child icons, for example, highlights the difference in size and relative position of the figures, the features in the faces (*are* the eyes painted in the same way in both paintings?), the use of colour, and so on. The same technique works equally well with two steam engines or two mounted owls.

Presenting an object to a friend can be interesting. The information to be given must be identified, selected, structured and communicated. Would different decisions be made if the object was being presented as though it were for sale, or if the presenter had just spent a great deal of money on it? Weighing and measuring, and recording the results mathematically require particular skills. Sometimes costume or armour can be tried on, although in most cases this will be limited to the use of replicas.

Touching has previously been discussed, but it might be useful to reflect that there are degrees of handling. If an object cannot be picked up, perhaps it can be stroked, or touched while resting securely. Even if it cannot be touched, very close looking is valuable in itself. Most people need to learn how to handle museum objects with care, and museum teachers should present objects in such a way that they demonstrate basic guidelines. Fragile and irreplaceable artefacts should not be touched at all. Even robust objects should be held with both hands, over a table that has a soft cloth on it. Cups or pots with handles should not be picked up by the handles. Objects for handling in museums should be prepared and put away by museum staff rather than by the students, and need to be stored carefully to minimize damage. Regular checks should be undertaken to monitor any problems.

Some techniques can be identified that enable a detailed response to or analysis of one or more objects. For example, the comparison of two objects with the same function but which differ in time, environment, value, or material, leads to useful discussion. Any collection of things can be classified into sets, by material, by colour, by use, by association, or by cost. Using fragments is more effective than may at first appear: archaeologists work from fragments and must reconstruct the complete object, if not complete societies, from this evidence. Fragments of pottery can include a variety of clays, glazes, profiles and so on. What kind of vessels do the fragments come from? Why have pot fragments survived? What perhaps has not? What effect does this have on our reconstruction of the past?

One of the most useful effects of using objects for teaching is the amount of discussion that can be generated. This can be used either in the museum or afterwards, back at school, to develop oral skills such as vocabulary, clarity, audibility, the exchange of ideas, listening and responding to others, and the development of evidence. There are also opportunities during discussions to make sure that cross-cultural perspectives are reviewed, and that cultural stereotyping is analysed. Responses to some museum objects can often reveal unconsciously-held values and opinions.

A response to an object can sometimes take the form of the making of a painting, a sculpture, or a group art-work, which might explore the ideas that interested the artist. Would students understand the work of Mark Rothko

more if several small groups each painted a sheet with blue and red paint and hung them up in a room? Could this environment be used for anything? What would be appropriate? What music or poetry would be in keeping?

Many of the methods that are useful in working with objects focus on devising problems that can be solved by examining or exploring the object, that make relationships between objects and other artefacts or other forms of evidence, or that make relationships between objects and the material or mental world of the student. In using any method, the teaching objectives are crucial and must be defined in order to select or develop the appropriate approaches. Objectives might be related to study methods, such as giving students an understanding of how to read an artefact or specimen; or be concerned with stimulating and motivating, such as wanting to use discovery learning for motivation at the beginning of a term-long project on 'The Victorians'; or be designed to use the visit to synthesize and integrate a quantity of material, such as wanting to study Inuit objects very carefully as a conclusion to working with a television series on Eskimo/Inuit life.

Evaluation

Most museum and gallery education departments are engaged in informal assessments of their provision, at many different levels. In terms of quantitative evaluation, most organizers of educational services know how they are used. Diary statistics give a good idea of the nature of the take-up of the service, and some museums have related this to demographic information on types of school, geographical location, population figures and so on. Warwickshire Museums, for example, know that slightly less than half of their customers come from outside Warwickshire, and that this has remained constant after the introduction of a small charge per child for these schools. With local management of schools (LMS) and an increasing emphasis on cost-effectiveness, most services have a clear idea how much their various services cost, and how much they would cost if structures were to change.

Qualitative assessment is generally more difficult to make and for most education officers is based on monitoring the ratio of return visits, listening to comments from teachers, watching the reactions of teachers and children during the visits and, where possible, thinking about the quality of work produced by the children. Some museum staff are able to visit schools and observe follow-up work; some are able to display work done on visits or afterwards, in the museum.

Evaluation of programme design is carried out in the museum by considering the educational and motivational value and use of the objects chosen; assessing the nature of the questions used to stimulate looking and thinking (descriptive, interpretive, judgemental, synthesizing, etc.); identifying and evaluating the amount and level of response and contribution from the audience; observing the role and response of the teacher.

Evaluation of the success of the visit as a whole is carried out at school by considering the effectiveness of the practical arrangements; assessing

Plate 19 An artist works with a group at the Tate Gallery Liverpool. While she
discusses the works on display, the museum education officer and the
classteacher evaluate the visit, discuss the responses of individual children,
and consider follow-up work and possible future collaboration. Courtesy
Tate Gallery Liverpool.

whether or not the objectives were achieved; considering the amount and
quality of the work produced as follow-up; relating the benefits to the effort
and costs of the visit. The ILEA survey, to be discussed in Chapter 15,
demonstrates a considerable level of satisfaction with museum visits (Adams
1990).

Very few formal evaluation studies have been carried out on museum or
gallery education programmes by researchers in Britain. In contrast, there
is now quite a considerable body of work on the effectiveness of exhibitions
(Miles 1982). Science museums in America have been particularly con-
cerned with evaluation of their (mainly interactive) exhibits (McNamara
1990), and it is in this area too that some studies have assessed the learning
of scientific concepts (Feher and Rice 1985).

The studies based in science museums tend to reflect the methods most
common in the scientific community; positivistic in tone, involving the
measuring of variables, the comparing of pre- and post-test scores, and
explanations involving formalistic generalizations. These methods can be
suitable in the measurment of scientific laws, but it is doubtful whether
such methods are appropriate in the evaluation of most museum education

Plate 20 The Queen arrives at Kenilworth Castle in 1575. Children and adults are immersed in an imaginative, emotive and dramatic holistic experience, which has been carefully prepared and will remain in the memory for a long time. How are such experiences to be evaluated? Naturalistic methods are most appropriate here, but the effects over time are difficult to measure. Courtesy Warwickshire Museum Service.

programmes, given their emphasis on imaginative, emotional and affective aspects. More appropriate are the naturalistic and ethnographic methods that have been evolved by some researchers into educational evaluation (Stake 1979; Hein 1979; Kushner 1989).

Naturalistic methods aim towards understanding a phenomenon, rather than explaining it; emphasize experiential knowing rather than statistical data; and focus on observation rather than measurement. The presence of the observer is acknowledged as part of the phenomenon to be observed. The contexts, including the often political uses, of evaluation, are regarded as a factor to be acknowledged.

Naturalistic methods have been used to evaluate a museum education department (Otto 1979). The questions asked by the professional evaluators had the effect of directing the thoughts of the museum educators and helped them define their collective goals. Specific goals, for example in relation to the effectiveness of a leaflet, were also achieved.

Naturalistic methods have also been used in America to evaluate museum education programmes (Hein 1982), but these methods are not

well known in museums elsewhere. Naturalistic methods involve working with the museum education staff as colleagues, identifying the desired outcomes for the research, and then selecting the appropriate data sources. The match of programme-related issues or interests with the means for collecting data is generally presented in the form of a matrix to identify which means will address each issue. Interviews and observations are carried out and documents are gathered and studied. As much of the information derives from the ordinary activities connected with the programme (meeting notes, participants' products, correspondence, etc.), some of the documentation is carried out by the museum staff. The findings are presented in the form of a report.

Different forms of report containing different types of data will be required for different audiences (Munley 1986). In formulating appropriate approaches to evaluation, it is important to identify the objectives and the audiences of the report. For example, an internal review of the effectiveness of a programme designed for children with special needs would not ask the same questions or demand the same data as a report of the activities of the education section intended for the governing body in the context of a reduction in the museum's funding. The former would concentrate on identifying the expectations of the teachers, the students, and the museum education staff; perceptions of the experience after the event would be related to these expectations, and conclusions drawn in relation to level of satisfaction, benefits and lessons to be learnt. Much of the data would be descriptive and qualitative; subjective opinions would play a very large part. A report for a governing body to justify continuing the service would need more 'hard data', and the use of performance indicators to describe the numbers of service-users in relation to the local school and/or adult population; the uptake of teachers' (and other) courses; the level of use of rooms, staff and equipment in the education section; the costs of the service relative to the number and type of users, and so on.

There are very few museum or gallery education services that are beginning to work in this way as yet, but as resources become tighter in Britain, and demands increase, methods of evaluation, assessment and performance are likely to move into a higher priority. Already, there is a keen interest in discovering appropriate methodologies, and one or two services are engaged in active development of theories and strategies (Clarke 1990b).

Part three. Audiences and approaches

13. *Working with the whole community*

During the last twenty years, museums in Britain have gradually begun to acknowledge their responsibilities to their publics. Inward-looking attitudes that prioritized attention to collections have slowly been replaced by a realization that the caring must go hand in hand with sharing. Research indicated that visitors tended to be white, middle-class, well-educated, and generally of the same social background as museum professional staff (Hooper-Greenhill 1988b). Audiences for art galleries were more exclusive than audiences for museums (Hooper-Greenhill 1985a).

During the 1980s, most museums and some art galleries began to develop active strategies to develop their audiences. The impetus for this came from a number of directions. One of these was related to democratic and humanistic impulses. A very genuine concern to work with all those whose rates and taxes support museums could be observed. A second thrust came from the economic climate. In times of stringent accountability and reduced resources museums had to develop new practices in order to be seen by governing bodies to provide value for money. A third pressure for change could be identified as a response to the newly aggressive and competitive leisure market in which museums and galleries found themselves placed.

These varied pressures for change have had different effects in different museums, depending on local and specific circumstances. In some museums and galleries, the moves to work with new audiences have been part of management policy; in other museums, particular individuals have imposed their own concerns on a sometimes reluctant management. In some instances, education staff have led the way, in others, curatorial staff have been instrumental in this. Local authority museums have found it easier to develop close relationships with their many local communities, while national museums have, in the main, concentrated on adapting their display techniques.

The pace of change has quickened over the last ten years, and new concerns have emerged during this period. Attention to the needs of those with physical and mental disabilities is a long-term concern and can be traced back to the beginning of the century, but new developments can be identified at the end of the 1970s. The beginning of the 1980s saw an emphasis on involving New Commonwealth citizens in museums, and, in local authority museums, a handful of staff were appointed to work in this

135

direction. Their efforts have had far-reaching effects. In the last few years, families and other groups (the under-fives and the elderly) have become a focus of attention. As the percentage of elderly people in society increases, all museums and galleries are aware of the need to develop strategies to attract this section of the population, which has, in the past, been very much under-represented.

Special needs provision

Museums and galleries have been concerned to provide for those people who have special needs due to either physical or mental impairment. These needs are many and varied. The World Health Organization's definition of disability includes people who are totally or partially blind or deaf, or who are otherwise physically impaired, as well as those who are mentally ill or mentally handicapped, or who are speech-impaired, or who have hidden handicaps resulting from conditions such as epilepsy or due to ageing (Pearson 1989:22).

It is possible that as many as one in ten of the population is affected by disability. Museums can be difficult places to visit even if active, able-bodied and fit. They are often exhausting, and both physically and mentally demanding. For people with disability, museums and galleries often present insuperable barriers, which can range from the problems of parking and initial access, through to staff who do not know how to help, and displays that are poorly lit and, if upstairs, perhaps inaccessible (Thorpe 1987:7–13; DES 1987b:3). Often there are few seats, and no refreshments, even of the simplest kind.

However, although many museums remain intimidating and difficult for people with disabilities, a thin thread of provision of activities and events for those with special needs can be traced back to the beginning of the century (Deas 1913; 1927; Charlton 1933; Bartlett 1955; Whittaker 1966). Some museum education departments were involved in special education from early in their establishment. At the Geffrye Museum, for example, Molly Harrison learnt that meticulous preparation of the security staff, and the materials and spaces to be used, were important for success, as was the size of the group (Harrison 1967:62–9; 1970:52–6). She was clearly working with children with all kinds of disabilities and from different special schools.

During the 1960s and 1970s the provision for special needs increased in museums. By 1975, interest and concern resulted in a conference for museum professionals which was held at Leicester, jointly organized by the Group for Educational Services in Museums (later to become GEM), the Departments of Museum Studies and Adult Education of the University of Leicester, and the Leicestershire Museum Service (Sorrell 1975). The seminar identified and discussed different forms of disability, including mental retardation, and physical handicap, including visual impairment. Learning difficulties and possibilities associated with various forms of impairment were identified. The work of local and national organizations and the necessary physical modifications to buildings were discussed.

Plate 21 A young visitor answers the question 'What is a mammal?' in the exhibition 'Discovering mammals: a new exhibition for the blind and partially sighted' at the Natural History Museum in 1985. Courtesy the Natural History Museum, London.

Several participants offered case-studies of museum and gallery education work, in England, Sweden and South Africa. Anne Hanson, from the Nordiska Museet in Sweden, described how she had become blind during the course of her work as an education officer. Her ideas were therefore informed from a dual point of view, both professional and personal. She

described how at first she had thought a room set aside for blind people only, either for an exhibition, or for handling, would be helpful, but she was now not enthusiastic about segregation. An approach favouring integration rather than segregation remains a frequent recommendation (Royal Ontario Museum,1980; Museums and Galleries Disability Association 1987).

A second participant described the touch exhibitions that had been held at the National Gallery of South Africa annually from 1967. These were exhibitions of sculpture, including sculptors' tools and materials. Practical art classes taught by specialized and experienced art teachers were held in conjunction with the exhibition for both old and young students, using clay, found objects, string and paper to make sculptures. Carvings were made in soft wax, plaster of paris and soapstone, and large collages were sewn.

A visit to Derby Museum by deaf children was described. The visit involved handling, drawing and trying on costumes. Written work was carried out later at school. The session as usually delivered was modified very slightly for the group. It took place in a reconstructed Victorian parlour lit by an oil lamp, but in this case, concealed electric light was also used to raise the level of illumination so that the children could see the museum education officer's face for lip-reading.

As usual, selected objects were explored to open up areas for discussion; a sewing-machine introduced changes in the manufacture of clothes and in fashion, decorative shell work stimulated talk about the growth of the railways and holidays at the seaside, and so on. This was a second visit, which turned out to be more successful than the first, as the children understood more, having greater familiarity with the teacher and the museum itself. Less emphasis was placed on auditory aspects of the visit than usual; a musical box and a tape-recording were not used. The teacher interpreted with sign language where she thought the children had not understood. Some special vocabulary needed explanation; parlour, sampler, aspidistra, and magic lantern, for example, were all unfamiliar words. The visit included a demonstration of a magic lantern and a handling session. The children then selected an object to draw.

This conference drew together information about the nature of disabilities, the work of local and national organizations and examples of some ways of working with disabled people in museums. As such, it was a seminal occasion.

Touch exhibitions

In 1976 a second seminal event took place. From November to December of that year the Tate Gallery held an exhibition called 'Sculpture for the Blind'. This exhibition of sculpture, some of which was from the collections, and some of which had been specially commissioned, was to prove influential, and the beginning of a trend for touch, and especially sculpture, exhibitions throughout the 1980s.

The exhibition was organized by the Education Department of the Tate Gallery, with the Royal National Institute for the Blind (RNIB) providing a

braille catalogue, braille labels and a tactile map. Large print catalogues and labels were also provided, although tape-guides were rejected as inappropriate. The exhibition was designed for blind and partially sighted visitors, but open to sighted people also. Many special design features were experimented with in the exhibition, most of which have been adopted and further improved in later shows at the Tate and in other museums. One serious mistake was made, in that the light levels were intentionally very low, and this was found to be problematic for people with residual vision. The Tate volunteer guides were an integral part of the exhibition, helping visitors and, where it was appropriate, conducting a touch tour.

The exhibition stimulated many others, including an exhibition at the National Museum of Wales in 1980 (Pearson 1981), at the Ulster Museum in 1981 (Ford-Smith 1988), a further exhibition at the Tate in 1981, two touch exhibitions at the Natural History Museum in 1981 and 1983, and a further two at the British Museum in 1983 and 1986. A detailed evaluation of the first of the British Museum exhibitions, 'Please Touch', commissioned and funded by the Carnegie Committee of Inquiry into the Arts and Disabled People, offers vital advice on the design and operation of touch exhibitions for people with visual impairment (Coles 1984).

The two exhibitions at the British Museum, 'Please Touch' and the later exhibition 'Human Touch', organized by the Education Department, were very carefully researched and evaluated and introduced a number of useful innovations. A handrail was used, rather than matting as at the Tate exhibitions, to make a physical link between the sculptures. Small black and white images of the objects were used on the labels and repeated in the catalogue, to enable those with some sight to obtain a complete view on a small scale of the larger object they were touching. The objects were displayed against coloured backgrounds to produce a clearer silhouette, and a keying into the space around the object. Generous seating was provided in the middle of the room instead of round the walls.

By the end of the 1980s, the 'art and touch scene', had become very vibrant, with over a dozen temporary touch exhibitions staged in museums and galleries in Britain in an eighteen-month period (RNIB 1988:1). The concept of 'touch education' had emerged through the experience of touching sculpture in exhibitions and through practical workshops (RNIB 1988: Hartley n.d.(b); Sullivan 1990).

The Carnegie Reports

During the 1980s significant advances had been made in the development of touch exhibitions. These developments were accompanied and in some cases promoted by other initiatives, including a major project funded and organized by Carnegie United Kingdom Trust. The year 1981 was the International Year of Disabled People (IYDP). Funds were available to museums for building adaptation, and guidance was given on policies for provision for disability (Keen 1981). In 1982 CUKT established the Committee of Inquiry into the Arts and Disabled People.

The aim of this committee was to explore the extent to which existing facilities enabled people with disabilities to involve themselves in the arts, both as participants and spectators, and having done this, to make recommendations to encourage development and improvement. Disability was defined to include partial sight or blindness, partial hearing or deafness, physical handicap, speech impairment, mental handicap or mental illness, and hidden handicaps such as epilepsy and disabilites related to ageing. The definition of the arts included public arts buildings such as cinemas, concert halls, art centres, museums and galleries, and occasional venues such as community centres, and other institutions or centres within which disabled people might live, be educated or spend their leisure time.

In 1985 CUKT published two documents resulting from the two-year study: the Attenborough report (Attenborough 1985) which described some of the findings of the Committee and made extensive recommendations, and 'Arts for Everyone' (Pearson 1985), which is a practical guide for venue managers.

The Attenborough Report suggested that disabled people probably represent between 8 per cent and 12 per cent of the population (Attenborough 1985:3). Estimates vary according to the definition used. Those with hearing impairment may make up as much as one-tenth of the population (6 million people). The section of the report dealing with museums and galleries pointed out that although there were some encouraging signs, much more could be achieved. The well-established programme for mentally handicapped children developed by Glasgow museum education service was remarked upon, as was the increase in tactile exhibitions and discovery rooms, which, having been set up specifically to respond to the needs of visually handicapped people, were increasingly being made available for all (Attenborough 1985:22). The initiatives described were seen to be mainly dependent on the enthusiasm of individuals, rather than part of a planned and organized policy, and recommendations were made that staff should have clear instructions and training on how to help disabled people, including the action to be taken in emergencies (Attenborough 1985:47).

'Arts for everyone' identifies in detail the practical modifications necessary for disabled access to museum buildings and describes some aspects of museum education work that can be particularly appropriate for disabled people (Pearson,1985). Loan service material, for example, was taken from Devizes Museum into a home for elderly people suffering from mental illness. Objects in common use in the early years of the century, along with First World War music, prompted the memories of the old people, and stimulated discussion (Pearson 1985:27). Sign language lectures could be offered for those with hearing impairment. The British Museum, for example, offers sign language lectures on a regular basis, and has worked with groups of deaf children in this way, with the education officer being interpreted by the children's own teacher. Induction loops for people with hearing aids can be fitted in lecture theatres (Pearson 1985: 81).

CUKT established the Carnegie Council as a follow-up to the Committee of Inquiry into the Arts and Disabled People in 1985, with the function of a pressure group to promote and monitor the recommendations of the

Attenborough Committee. In 1988 the Carnegie Council published a review 'After Attenborough', which stated firmly that although some interesting initiatives could be observed, the response of government was disappointing (Carnegie Council 1988:15–27).

In 1986 the Museums and Galleries Disabilities Association (MAGDA) was established to provide a focus for work in relation to provision for disability. Training and discussion seminars have been held, sometimes with other museums and gallery specialist groups such as the Group for Designers and Interpreters in Museums, and the RNIB (RNIB 1988). Towards the end of the 1980s CUKT established the ADAPT fund, supported by the OAL, which is designed to help arts venues and museums provide essential adaptations and facilities which benefit people with disabilities.

In 1989 the Museums and Galleries Commission appointed a Disability Adviser as had been recommended by both the Attenborough Report and the Carnegie Council Review. The aims of this part-time two-year post are to assist museums and galleries in developing better facilities for disabled staff and visitors; to advise professional groups; to act as a catalyst for further action, including training; and to advise the Commission on its future policy. A Disability Code of Practice and Action Plan has been produced for museums and galleries during 1990.

By the end of the 1980s therefore, a considerable amount had been achieved, partly through self-help, but partly also through help from CUKT and MGC. The RNIB had also begun to play a stronger role, with its Art and Leisure Department acting as a catalyst between blind groups and museums. As a result, interest in and provision for visual impairment had, as we have seen, blossomed. Similar growth is required in provision for people with other impairments. At La Villette, the Science Park in Paris, for example, signed tours are offered by a tutor whose first language is sign language. Working with people with disabilities as staff and consultants is a useful model to follow (Pearson 1989:22).

Although in practice it is frequently the staff concerned with education that tend to work with people with disabilities, it cannot be stressed too strongly that this is a cross-museum issue, and of crucial importance to all museum staff, including curators, designers, warding staff and management. Several social and demographic changes have taken place and increased the needs of disabled people. The policy for integration into mainstream schools of those children who would formerly have been studying in special schools means that museum and gallery education staff will be likely to find one or two disabled children in a group of able-bodied children. The current policy of closing mental hospitals and relying on the community to provide care and stimulation offers plenty of opportunities for museums to liaise with social workers. As the percentage of older people in the population increases, so too will their needs relative to the needs of other social groups (Pearson 1989).

The work of the MGC Disability Adviser should be seen in the context of other initiatives in the arts. The Regional Arts Associations have insisted that a disability policy be in place before grants can be awarded, and the Arts Council has published a useful and comprehensive 'Arts and Disability

Checklist' (Arts Council 1989). Many local authorities now have their own equal opportunity policies which must be acknowledged by their museums and galleries. The requirement for all museums and galleries to develop policies in relation to provision for people with disabilities is, therefore, likely to increase.

Ethnic audiences and museum collections

The needs, interests and material culture of various ethnic groups has been a second focus for those museums and galleries concerned with expanding their audiences. This focus has entailed the examination of collections, the appointment of staff (but rarely of staff from ethnic minority groups) to work in the community, and the development of approaches to multicultural education work. In general, however, museums and galleries have been slow to realize the imperative for pluralist perspectives, and, with few African and Asian museum staff, have found the retention of rather narrow views unproblematic.

During the last ten years in Britain, some curators, stimulated by a growing awareness of bias and omission, have begun to consider how their collections and activities relate to audiences from varied ethnic back-grounds (Bourne 1985; Durrans and Katterhorn 1986; Jones 1987). Similar endeavours can be seen in other parts of the world with imperialist histories being rewritten in Barbados (Cannizzo 1987), and institutional ideologies being reoriented in Canada (Janes 1987; Harrison 1987).

Ethnography curators with historic collections which were gathered from many parts of the British Empire have begun to reinterpret the artefacts within today's pluralist society (Pierson-Jones 1985), and where galleries can be redesigned and redisplayed, these historic objects are integrated with contemporary ones. In the new Gallery 33 project at Birmingham Museum, for example, an exhibition called 'A meeting ground of cultures' displays objects from North America, Africa, the Pacific Islands and Australia along with artefacts from contemporary minority and majority cultures in Birmingham.

In some museums, new collections have been assembled that relate to particular ethnic groups within the locality. In Leicester, the Curator for Indian Arts and Crafts collects contemporary material from the Asian shops in Leicester, and has travelled to Gujarat state, the area of India from which most of the Asian population of Leicester originally came, to collect material illustrating themes of the life that had been left behind (Nicholson 1985).

One much-valued aspect of multicultural work in museums has been the opportunity to work more closely with different groups, and to develop links with the local community. Sometimes this has been achieved through making contact with educational or social groups. In Leicester, an exhibition of Indian Wedding Costumes, 'Vivah', in 1983, consisted mainly of material that was lent to the museum by Indian women who had been contacted through an English class. On another occasion, a fashion show that accompanied the display of costumes collected from Gujurat was

completely sold out to local Indian women's groups. Discovering and working alongside existing community networks promotes the development of a network of contacts, which is an essential prerequisite of an approach that acknowledges a multiracial society. Advisory groups drawn from the local communities can help to broaden the perspectives of exhibitions and events, to advise on histories, to suggest artists or performers for gallery events.

Many local communities are made up of a complex variety of different ethnic groups, each with its own cultural history and identity. Sensitivity, and a willingness to learn, to listen and to adapt is essential if museums and galleries want to become relevant to all or any of these groups. Undoubtedly, a first essential is to go out to the community to begin to develop joint working practices (Robinson and Toobey 1989).

There may be tension between the various ethnic communities in any one locality. The Children's Museum in Boston, United States, describes itself as being at the inner-city edge of four ethnic communities, and as being perceived as neutral territory not belonging to any of them. This was found to be a useful feature; too strong a sense of belonging to one group would have prohibited work with another. The Children's Museum works with many groups and aims to share information about and among the different ethnic groups. A small exhibition space, for example, called 'Focus On', offers space to various groups to set up their own shows with no editorial control by the museum. Thus 'Focus on Italians' was developed and mounted by the Italian Advisory Board, who all put their signatures to the exhibition (Gurian 1981: 292).

Multicultural education and school services

Many museum education departments have been working with multi-cultural themes since the early 1970s (Pierson-Jones 1985), but there was an increased thrust in this direction during the 1980s. Many museum teachers, particularly those who work in geographical areas where many different ethnic groups are represented, are skilled at using the apparently most difficult objects to relate to the backgrounds and cultures of their students (Wolfe 1987). In schools in Britain, a focus on multicultural issues was stimulated by the James Report in 1971, the Rampton Inquiry in 1981, and the Swann Report in 1985. An initial slant towards Black Studies, and courses designed for black children only has been superseded by a 'whole-school' approach. It has now been recognized for some years that all children need to know about different cultures and traditions to prepare them for living in a multiracial society, and this is enshrined as a cross-curricular dimension in the National Curriculum.

Museums and galleries can be used for multicultural work in several ways. First the collections themselves are often from distant parts of the world and can open up perspectives on different ways of life, and different solutions to common problems. At Ipswich Museum, children visiting the Yoruba exhibition heard a Nigerian speaker describe his country, and watched him demonstrate traditional Yoruba dance steps (DES 1988c:4). Children fol-

lowing a GCSE course on 'Textiles and Costume' visited the Education Centre at the Horniman Museum where they saw Mexican and Guatemalan garments, West African textiles and costumes from Yugoslavia, China and northern India. A talk from one of the museum education staff was followed by an intensive drawing session. This formed the basis for work carried out in school (Horniman Museum 1987). The richness that a variety of artefacts and experiences like these can offer to children and adults alike is justification in itself for studying objects from different cultures.

The World Box, a loan box prepared by Bedford Museum, is made up of objects that aim to demonstrate the effects of environment on culture, to try to show that different cultures find different ways of meeting needs but often finish up with similar answers. Artefacts from different parts of the world, but all roughly contemporary, enable these points to be discovered by the students as they work out which artefacts might have been produced in which parts of the world, considering weather and vegetation patterns.

Exhibitions on or objects from specific cultures can be used to broaden experience and develop awareness. Leicester's Asian population has already been mentioned. On the whole, the Asian community lives in the city of Leicester, and is unfamiliar to many of the children living in other towns in the county of Leicestershire. The exhibition 'Traditional Arts of Gujarat' was visited by all three classes from a small primary school in one such town in the county, who came to look at the heritage of this part of Leicester's population. The theme of 'India' was explored at school through art and drama based on the story of Rama and Sita, and through other work in geography and religious education (DES 1988c:4).

Museum collections can be used to examine stereotypical images. This was one of the aims of two visits made by a junior school to the Horniman Museum and the Museum of Mankind. Three classes of 7-year-olds each focused on one of the following: Inuits, North American Indians and Australian Aborigines. The group studying the Inuits made a presentation to the whole school and stressed that the name 'Eskimo' is not acceptable to the Inuits, thereby making the point that respect for others includes using appropriate names. The class studying the North American Indian people compared the identity and variety of cultural groups with the stereotypes they had seen in films (DES 1988c).

In 1987 the Museum of Mankind provided a programme for children in which they looked at modern life in different parts of the Arab World to coincide with a BBC schools programme. One of the aims of the project was to address the stereotypes the children may have had about Arab people. This was tackled through practical activities such as sitting in modern and older style homes, wearing clothes of different nationalities, eating food, acting as different members of family groups, being hosts entertaining guests and so on. People and organizations in the Arab community gave money for photographs and lent clothes and objects for wearing and handling (Bateman 1988:13).

One or two museums have begun to reread their collections to show how historic trading and economic links are intimately bound up in how things come to be as they are. At the Rotterdam Historical Museum, for example,

Plate 22 Drama and role-play at the Geffrye Museum: 'The Coming of Light'. The museum worked with the drama group Cultural Exchange Through Theatre in Education (CETTIE). Drama was used to provide an opportunity to address some of the issues relating to the Science Curriculum, AT 11–Electricity. Courtesy the Geffrye Museum.

a tile that appears to be typically Dutch can be reread to show intercultural links. Thus a seventeenth-century blue tile decorated with a tulip is shown to have links with China, whose blue tiles this one imitated; the Mediterranean, where the style of glazing originated; and Turkey, where the tulip bulbs were found (Spruit 1982:67).

The Geffrye Museum in London has produced a report that examines the 'Black contribution to history' (Fraser and Visram 1988). The report makes suggestions about the ways in which the collections and displays can be used to show how links with Africa, Asia and the Caribbean affected British social life, and to point out the presence and contribution of overseas people to Britain.

A schools project demonstrates how the staff have integrated the ideas from the report into their work. 'The coming of light' was a drama project set in the Edwardian period room at the museum which explored the beginnings of electricity, and offered opportunities to work with AT11 in the Science curriculum (Electricity). One of the dramatic presentations explored the history of the invention of the electric light bulb, and showed how Thomas Edison's 'incandescent electric light' lit up but burnt out very quickly. It was commercially useless until the invention of the carbon filament, which allowed the bulb to glow at white heat for several months. This invention was the work of Lewis Howard Latimer, the self-educated son of a former slave (Bastian 1989:14).

Plate 23 Many museums are concerned to work more closely with their local communities. Although this would seem to be more difficult for museums that serve national and international audiences, it is not impossible if this is one of the objectives of the museum. Here a group from the Turkish community dance next to the colonnade of the British Museum as part of the events of the Turkish Day in May 1990, which was organised by the Turkish Parents Association and the British Museum Education service. Other events included talks, slide shows, music, art activities and storytelling. Courtesy the British Museum.

Education staff working with cross-cultural approaches are concerned to avoid presenting 'other' cultures as 'exotic', with European culture an unacknowledged norm. This is not always easy, but can be approached by emphasizing similarities in cultures before differences, or by taking basic human needs, for clothing or homes, for example, as topics for exploration. Many of the collections held by museums and galleries enable this kind of cross-cultural approach in a way that is not possible anywhere else. Museums and galleries also have a unique potential as sites for the display, exploration and celebration of artefacts that celebrate cultural diversity, whether through historical objects or through contemporary works of art or craft.

The development of multicultural work in museums has, perhaps, been most in evidence in those local authority museums which benefited from the appointment of staff funded under Section 11 of the 1966 Local Government Act. The posts were very few, at Bradford, Kirklees, Leicester and Ipswich, and only one of these, at Leicester, was specifically in museum education, but the work carried out by the post-holders succeeded in

raising awareness and in stimulating a range of temporary exhibitions, workshops and activities for schools (DES 1988c). Conferences and seminars have stimulated a general awareness of the nature and value of work across a variety of cultures. All of the post-holders and others who have initiated work in this area have learnt through mistakes and difficulties, and have been willing to discuss these with others (Nicholson 1985; Pierson-Jones 1985; Belgrave 1986; Simpson 1987; Smith forthcoming).

In many museums the first response to multicultural issues was sometimes to 'leave it to the education department' or to 'Section 11 work'. It is now more generally accepted that this is a cross-museum issue, although there is still some way to go. Art galleries, in particular, have not begun to relate their displays to the concerns of a multicultural society, although some excellent educational initiatives can be observed (Mason 1988: Whitechapel 1989). Some museums, however, have clearly stated policies in relation to ethnic and cultural matters, some of which have been stimulated by LEA policy initiatives. Where these policies exist, they have the following aims: to use the collections to encourage understanding of and respect for varied cultures; to reject prejudice and stereotype; to ensure equal access to the museum's collections and services; and to liaise with the local community about participation in the museum's activities (DES 1988c:8). It is incumbent on all museums, art galleries and historic sites to review their temporary and permanent displays, their visitor profiles, their educational programmes and their marketing strategies with a knowledge of the ethnic composition of their local geographical area, and an awareness of the multi-cultural potential of their collections.

Adult and family audiences

Museums and galleries have provided a service for adults for many years. The national museums, in particular, have organized regular lectures, gallery talks, film shows and concerts. In local authority museums and galleries, with fewer resources and access to less of a mass market, lectures and events tend to be limited to provision for special exhibitions. In recent years, a new focus on in-depth work with older adults can be observed, along with a recognition that the family is a unit that repays attention.

Events and activities for adults are sometimes organized as a series in conjunction with university departments of adult education, and/or LEA adult education units. Sometimes single study days are offered in relation either to parts of the collection, or to a special exhibition. Slide lectures and gallery talks are common, but activities are popular when possible. The Geffrye Museum, for example, offered a textile workshop day and a ceramics workshop day to celebrate the refurbishment of their William and Mary Room.

Very few museums in Britain have fully exploited their potential for adult education, and there are few members of staff with this as their sole reponsibilty (DES 1988a). The Royal Ontario Museum (ROM) in Toronto has recently extended their provision for adults and now offers a complex

Plate 24 Young visitors and their families and carers enjoy watching the animals at Norfolk Rural Life Museum. Courtesy Norfolk Museums Service.

and stimulating variety of activities, including 'Connecting', a series of lectures followed by cocktails and a finger buffet for 'working singles'; a cosmopolitan selection of lecture series relating to specific areas of the collections, on cross-departmental themes (such as 'The Goddess'), and 'behind-the-scenes' processes; lunch-time gallery tours (including lunch); multi-arts thematic workshops (traditional life in Mexico with food, music, slides, artefacts); and a vast array of 'creative arts courses' based on the collections, including pottery, drawing, water-colour, Chinese brush paint-ing, and sculpture. In effect, the ROM has become an enormous adult education institute, with a host of different ways of relating to and finding inspiration from the collections. All courses are fee-paying.

Older adults have been targeted as audiences in America for some years (Sunderland 1977; Graetz 1981; Heffernan and Schnee 1980). A variety of programmes has been offered, including practical workshops, and tours. Often run in series, these workshops aim to focus on life-experience, and to proceed at a pace that suits the participants. In Britain very little work has been carried out with the elderly, although one or two museums have worked with day-care centres or nursing homes. Warwick Museum worked with local nursing homes using social history objects as aids to memory and discussion with the work funded through a temporary employment project. Reminiscence activity is a popular method with groups working with the

elderly, such as Age Exchange (Kavanagh 1990:151,170), and one or two museums, such as the People's Story in Edinburgh have been involved in similar projects (Beevers *et al.* 1988; Kavanagh 1990:172).

An increasing attention to provision for families as a unit can be identified. Guided environmental expeditions for families have been provided by the National Museum of Wales for some years (Sharpe and Howe,1982). The Armada exhibition, and the later '*Mutiny on the Bounty*' exhibition at the National Maritime Museum included interactive discovery centres designed for children aged 3–8 and their parents and carers (Anderson 1989a). These events provide opportunities for children and accompanying adults to enjoy themselves, and to learn together.

Other provision for very young children is limited, although one or two museums, such as Bethnal Green Museum and Norwich Castle Museum have organized playgroup sessions (Siliprandi 1987). Bristol Museum recently ran a day for toddlers in conjunction with WHAM (Women's Heritage and Museums) which attracted a significant amount of media publicity. One or two new museums, such as the Manchester Museum of Science and Industry, have included spaces and activities for under-fives and infants in their planning.

It is possible for all museums, galleries and sites to offer valuable and enjoyable learning experiences. All collections and all environments offer many opportunities. Where there are no specialist staff, however, curators are often lacking in both expertise and confidence, and are uncertain how to proceed. The Scottish Museums Council (SMC) evolved a unique and valuable programme to help museums interpret their touring exhibitions (Scottish Museum News 1987; Stewart 1988; 1989). The Leisure Learning Programme (LLP) was made possible through external funding for a three-year post. The task of the LLP co-ordinator was to identify a variety of feasible events and activities for each of the SMC exhibitions, to research these ideas and to draw up a 'menu' to send out to the museums receiving the exhibitions. The 'menu' named possible demonstrators or lecturers, identified costs for each activity, listed likely sources of help and expertise, and pointed out the resources that the museum would need to produce for each activity.

The ideas were original and exciting, and with the help of the LLP co-ordinator, and a grant from SMC for 50 per cent of the costs, museums were able to plan and host programmes for targeted sections of their local communities who were often unaware of their activities. Following the closure of the Scottish Museums Council's touring exhibition service on the recommendation of the Museums and Galleries Commission, the LLP co-ordinator shifted attention to working with museums and their permanent collections. The work of the LLP is recorded in a video, available through HMSO (Stewart 1989). Unfortunately, the programme has now ended with the cessation of the special funding. This represents a tremendous loss to the many museums and galleries that benefited.

The success of the Scottish Museums Council's Leisure Learning Programme demonstrates that all museums and galleries are wonderful potential educational resources, and that, given funding, expertise and staffing,

they could become indispensable community assets for leisure, for learn-ing, for enjoyable discovery and for social occasions. All the events dis-cussed above, in fact, show very clearly where and how new initiatives could be established. Precedents in terms of structure and method have been described, and almost all institutions would benefit from developments in many of the areas outlined. Adult and community work is the least mature of all areas of museum education in Britain, and is perhaps the most vulnerable when resources are limited. However, it is a grave mistake not to develop this area. Museums and galleries, particularly at the local level, are dependent on their local communities. If these communities have no expe-rience of the museum, and no knowledge of their work, how can support be forthcoming? As one woman said in surprise, when visited in her home by a curator from Warwickshire Museums: 'Oh, you're from the museum! You're quite nice really, aren't you?'

14. School services I: in the museum

School visits to museums and galleries

Museums and galleries are visited by schools of all sorts, including primary and secondary schools, state and private schools, and special schools. The variety of teaching styles and approaches that are represented by these schools is large. The children who come to the museum range across every level of ability and may be able-bodied or disabled. Collection and museum-related themes are relevant to most areas of the curriculum, and include language development and social education. This enormous range of factors means that museum teachers need to adopt a very flexible approach to the particular needs of their various users, and need to be imaginative and selective in relating the museum and its collections to these needs. Most museum teachers adapt their approach to fit the needs of each group, as far as possible, although popular themes and topics are often presented for teachers in a 'menu' for selection.

On the whole, museums and galleries are most used by primary schools. In the past, primary school groups have made up approximately two-thirds of all the children provided for by all educational departments. However, this general picture may vary considerably in different museums: the Horniman Museum recorded 217 secondary school groups and 811 primary school groups using the Education Centre in 1986/7; the ILEA survey suggests that twice as many secondary as primary groups visted the Tate Gallery in London in 1988/9; Ironbridge Gorge Museum was used almost exclusively by secondary groups until the appointment in 1988 of two full-time education staff; at Warwick, the vast majority of visits are made by infant and junior schools as secondary schools often need to bring bigger groups than can be accommodated in the space available. Sometimes numbers are affected by events over which the museum has little control: 30,000–40,000 children visited the galleries of the British Museum over six weeks when Egypt was featured on schools television. It is very likely that current patterns of use will vary with the new educational structures, and it is difficult at this stage to predict how matters will develop. Much will relate to the local situation and to the methods of publicity and contact used by education staff.

Not all school visits are organized with the help of museum staff: some teachers prefer to plan visits completely on their own, and in many cases,

the demand is such that only advice can be given. At Warwick in 1989, for example, the total number of all party visitors was 12,237 (412 groups), of which 9,000 (300 groups) took part in museum-structured educational activities (Clarke 1990a). Most of the other group leaders would have been in contact with the education service and received advice and help.

While nearly all institutions now provide something for teachers and children, school services vary in almost every museum. They can include all or any of a range of approaches. In many places face-to-face teaching is the main provision offered, with the National Portrait Gallery, London, the Horniman Museum, London, and Kelvingrove Art Gallery and Museum, Glasgow, as examples. Teaching, by a member of the museum's staff, takes place either in the museum or gallery itself, or in an adjoining room using demonstration and handling material. Where numbers of schools visiting are great, the production of resources for teachers and children is felt to be more useful than direct teaching itself, although in some cases teachers' materials are available to supplement teaching. The British Museum, the Natural History Museum, and the Tower of London and English Heritage provide teachers' packs, worksheets and, increasingly, videos, carefully designed to help teachers use the museum themselves.

Most museums and galleries provide an opportunity for teachers to learn how they may be used. This can take the form of work with initial teacher-training colleges, perhaps by giving a talk at the college, or a demonstration at the museum. Sometimes students are placed in museums or galleries for a short while. Courses for serving teachers are also available.

Active methods of delivery are used. At Aberdeen Maritime Museum, a living history project, 'Cloots, Creels and Claikin' explored the lives of the fisherfolk of the east coast of Scotland one hundred years ago (Keatch 1987). Some museums are able to work with schools on reconstructions: an Iron Age homestead was 'rebuilt' in Leicester. Some museums or galleries assemble museum material into short-term displays which can be used as a resource for a series of sessions for teachers and children; 'Animals and their homes' was a special exhibition for schools prepared by the Leicester teacher-leader for Natural Sciences. Many museums are involved in outreach work including loan services, mobile museums, and the organization of 'artists/craftsmen in schools' programmes. In one or two cases, such as Clarke Hall in Yorkshire, museums exist explicitly as a service to schools.

The learning experiences offered by museums and galleries are designed to be complementary to those offered in the classroom. One of the values of a school visit to a museum is the opportunity for students to be exposed to alternative ways of learning, and to a variety of active ways of working with material evidence. For some children, this enables a chance to demonstrate abilities and skills that are not visible in the more formal environment of the classroom. For all students, going to a new place, meeting new people, experiencing new approaches to gathering information and encountering real things can be very stimulating and motivating, and can put the knowledge that they have gained at school into perspective. As one London teacher commented: 'Museum study visits are essential in order to provide a context and meaning for pupils. In the light of educa-

tional developments regarding experiential learning and active involvement, galleries should be used more' (Adams 1990:16).

One way of providing school services that is often found in museums and galleries is the organization of large-scale events that last for a fairly short time, perhaps a week or a month. Events such as these are designed to relate closely to school-based work, either in the preparation beforehand, or in the follow-up work later. Often a particularly interesting building is used, and a moment in its history is reconstructed. Thus castles and historic houses have been used to develop historical imagination (Fairclough 1980;1982; Fairclough and Redsell 1985) and a large country house was used for language learning in relation to a BBC Schools broacast series 'Look and read' (Winterbotham 1987).

Sometimes museums are able to collaborate to offer different perspectives on a particular theme. Three museums in Brussels, the Children's Museum and the Art and History Museums, worked together to offer teachers three ways of approaching the theme of 'housing'. At the Children's Museum, the topic of 'first shelters' could be tackled, at the Art Museum, some of the paintings depicted both present-day and historic housing, and at the History Museum, objects and furniture were used in reconstructions. The project was unified through the use of topic sheets which were designed both to enable object study in the various museums, and also to relate the objects to familiar themes (Deltour and Gesche-Koning; Unesco survey).

Museums and galleries are often able to offer the chance to participate in or observe specialized activities and demonstrations, either at the museum, or by sending the specialist to the classroom. Clarke Hall uses demonstrators of weaving, corn-dolly making, butter-making and other seventeenth-century domestic crafts in the museum as part of their role-play and living history programmes. The joint museum 'North Shore Maritime Heritage Project' in Salem, Massachusetts enabled teachers to arrange for events and demonstrations ranging from sail-makers, scrimshanders, ropeworkers, woodcarvers and cabinet-makers in their classrooms (Hercher; Unesco survey).

A Brazilian example

The description of a museum project from Brazil demonstrates the way in which experiences can be organized to complement and enhance school education. A project called 'A wedding at the Imperial Court' was set up in 1983 by the Museu Imperial at Petropolis, near Rio de Janeiro (Baretto; Unesco survey). The museum was in fact the old Imperial Summer Palace, a grand but not overwhelmingly large mansion, with a beautiful garden. Over September and October 838 children aged from 8 to 13 participated in the project. The aim of the day was to give the children a concrete experience of an aspect of nineteenth-century life through the preparation and re-enactment of a wedding at the Court. The themes to be explored covered topics in social studies, history, arts and crafts, music and dance.

The children were first cast in the role of apprentices in the preparation

of the things required for the wedding: costumes, swords, military decorations, food, drink, ball-room decorations, musical instruments and so on. Later the same children acted out the roles of the wedding guests: the bridal pair, their parents, relatives and friends, the servants and orchestra. A small exhibition extended and gave basic information about the social, historical and cultural themes which the children had actively encountered: nineteenth-century social life and its hierarchy at the Court, and in relation to upper and middle classes, and artisans; nineteenth-century artefacts, including costumes; music and dance; and the religious ceremony and the marriage contract. The main focus of the exhibition was a painting of the wedding in 1864 of Princess Isabel, the daughter of Peter II, the object upon which the entire project was based.

The children had learnt about the historical period at school. At the museum, they first visited the exhibition with the museum education officer, looked at the painting and were introduced to some of the themes of the project. They were then divided into five groups of ten children each with one tutor, to become involved in one aspect of the preparation for the wedding and ball to be held later in the day. The groups were divided into makers of women's costume, makers of men's costume, cooks, makers of ball-room decorations, and musical instrument makers and players. The day ended with the wedding; playing and listening to music, dancing the waltz, quadrille and polka, wearing the costumes, eating, drinking and role-playing.

The day offered many possibilities for follow-up work for the teachers back at school, as had been intended. The cultural and social themes could be developed in their own right or as aspects of major nineteenth century historical events; the use of paintings and artefacts as historical evidence could be compared with other forms of evidence; creative writing and drama could be used to recall and then analyse parts of the experience; weddings could be compared in the past and the present, at the Imperial Court and in humbler environments, and so on.

The potential for teachers to build on an experience such as this is great. The project was also carried out in conjunction with teachers in other ways. The museum education officer had enlisted the help of four student teachers, who acted as group-leaders, and gained valuable and varied experience. A local TV company which had lent costumes for the group leaders, also made a video-tape which was later used with in-service teacher-training. Visual records enable teachers, museum managers, and potential sponsors to understand the nature and the potential of events such as this very quickly.

Children's levels of achievement

HMI have identified a hierarchy of skills and knowledge that children can achieve when schools have encouraged working with museums and galleries. By the age of 7, pupils are aware that museums exist, and have visited one or more. They have been introduced to handling objects in the class-

room and have talked about or drawn museum objects. Some infant schools have given their young pupils experience of making temporary museums in the classroom with loan services and objects from home. Through writing labels, caring for their own displays, visiting museums and galleries, and talking to staff there, these children have laid valuable foundations in the understanding of the use of museums across the curriculum.

By the age of 11, students have become knowledgeable and discriminating about different types of museums and their varying approaches to display, are accustomed to undertaking sustained observation in museums and galleries and are skilled in a range of recording techniques. A study of Roman Britain for one 8-year-old group included the mounting of a small display, the completion of accession cards, and the use of reference books to research the objects. Some children at this stage have been introduced to the need for restoration of museum collections, and have begun to discuss the concepts of conservation and interpretation.

By the age of 16, students understand what can and cannot be learned from observation in museums and know where to go for further information. The skills of using objects as evidence are well developed, as are appropriate recording skills (Moffat, 1988a).

It is sometimes difficult to know how far museums and galleries are, in fact, used by schools. Although most education services are working to capacity and beyond, many schools visit without using these services, and it is hard to know what percentage of schools in any one area make museum and gallery visits. Most education sections can give detailed figures of the customers worked with as has been pointed out (see Fig. 10.1), but surveys must be carried out in the schools themselves to discover the use of museums in relation to the school population, and to evaluate the level of satisfaction with services. Just such a survey was organized by the ILEA in 1989 (Adams 1990).

The use ILEA schools made of museums

The survey was carried just before the abolition of the Inner London Education Authority, with the aim of discovering how schools in London were using the museums of the capital. As an education authority, ILEA had managed two museums, the Geffrye Museum and the Horniman Museum, had provided a Museum Advisory Service, and had seconded teachers to Dulwich Picture Gallery, the Serpentine Gallery and the Hayward Gallery. A Museum Education Working Party had been established when it became clear that the authority would not survive, with the aim of identifying the level of use of museums by ILEA schools, and with the intention of using this information to support any London-wide initiative that might emerge after abolition. A random sample of 125 primary and 70 secondary schools, 195 schools in all, were sent a one-page questionnaire in the autumn term of 1989, asking for information relating to museum and gallery visits during the previous school year. The form was kept as brief as possible as it was recognized that the many changes in the world of educa-

tion would militate against much time being spent on completion of a long questionnaire. The response rate was good: 80 per cent for primary schools and 59 per cent for secondary schools.

The survey demonstrated conclusively that the vast bulk of London schools were frequent and enthusiastic museum visitors, and that this had become an established tradition during at least the last fifteen years. Of the responding primary schools, 92 per cent had carried out museum visits during the school year 1988–9; of those, 52 per cent had visited between one and five museums, 29 per cent had visited between six and ten museums, and 10 per cent had visited between eleven and fifteen museums. One primary school had visited more than sixteen museums during the year.

All of the responding secondary schools had made museum visits during the year: 39 per cent had visited between one and five museums, 31.7 per cent had visited between six and ten museums, and 29.3 per cent had visited between eleven and fifteen museums. This very high level of museum visiting appears to have remained relatively constant since the last ILEA survey which was carried out for the academic year 1975–6, although visits from primary schools had increased where those made by secondary schools had fallen.

A total of 1,764 visits were made by both primary and secondary schools to London museums. Secondary schools made most visits to the Science Museum (9.8 per cent of all secondary visits) and to the Tate Gallery (8.8 per cent of all secondary visits). Primary schools made most visits to the Science Museum (12.1 per cent of all primary visits), the Natural History Museum (8.9 per cent of all primary visits) and the Horniman Museum (8.6 per cent of all primary visits). Put another way, 59 per cent of primary schools, and 48 per cent of secondary schools that responded to the questionnaire said they had visited the Science Museum; 63 per cent of all secondary schools who responded had visited the Tate Gallery; and the four most visited museums were the Science Museum, the Natural History Museum, the Commonwealth Institute and the Horniman Museum.

Fifty-seven per cent of the secondary schools who responded said that they had used the London museums for GCSE work, although not all of these visits had involved work with museum and gallery education staff. It appears that those museums which charge for entrance are less attractive to schools. The additional expense of the entrance fee means that charging museums tend to be omitted at the outset from teachers' planning. One teacher commented: 'If entrance charges were introduced we would be obliged to cancel the majority of our visits.'

Most of these visits had been organized despite considerable difficulties experienced by teachers. Finding and funding teachers to cover for classes missed during the visit time was one problem. The further costs involved in paying for transport was another. The implications of Circular 2/89 (see page 75) on charging for school visits were often confused and misunderstood. Fears were expressed that in the future finance and staffing problems, and the size of practical classes, would increase the difficulties, or might change the nature of the visit. One effect, for example, might be that local museums were used more than the large central museums (Adams 1990:14). Another might be an increase in individual visits by older students.

Comments from the teachers revealed that they considered museum and gallery visits an integral part of their teaching. A teacher in a secondary school commented: 'Museum and gallery visits are an essential (not optional) part of GCSE and 'A' Level courses. It is a tragedy that these visits have been so hard hit by legislation.' A primary schoolteacher made very similar remarks: 'Local museums. i.e. accessible by public transport, are a vital aspect of any course of study. Obviously necessary to develop the concept of primary/secondary evidence.' Museums were seen as 'invaluable in consolidating work achieved in the classroom—visits give a sense of occasion and the work done in the museum is more likely to be remembered'. Primary schoolteachers felt that museums were essential to help with the delivery of the National Curriculum: 'They are an invaluable resource which we need even more since our own resources are becoming so limited. The N.C. makes demands on us—particularly in science—which we can only meet with the help of such resources'; and 'Move towards Science-based lessons in the new curriculum will require more frequent visits because the average primary school lacks science resources.'

Overall the survey demonstrated that museums and galleries were very much appreciated and used extensively by teachers at all levels and across the curriculum. At the same time the difficulties in using museums were also spelt out and fears were expressed for the future. Problems with school funding, sufficient teaching staff, large class numbers, costs of the visits were all felt to militate against making the number of visits teachers would have liked:

Museum education departments have enormously improved just at a time when transport and other costs make it almost impossible to use them;

We would use the museums and galleries far more if more money was allowed for school visits and time-tabling would enable staff to be freed from classes. The facilties are excellent and in the past we have made considerable use of them. However, finance and staff pressures are making it more and more difficult.

Teachers pointed out how the school visit to a museum or gallery acted not only as a catalyst in the learning process of children, but also as a stimulus for adult visits: 'When museum visits are done to support the curriculum they have tremendous value for taking the children's learning experience forward. Many children revisit, taking their parents with them.'

The survey raises issues about the management of school visits in the future. Difficulties in schools due to new structures and the pace of change, and the levelling of charges for visits at some museums and galleries were found to be major impediments to using museums as teachers would wish. The survey made the following recommendations:

1. that the National Curriculum Council recognize that museum and gallery education is a key learning resource in meeting the demands of the National Curriculum by issuing guidance to teachers;
2. that unambiguous support be provided by all Authorities for museum and other essential study visits, separately defined from other

school trips or outings;
3. that staff cover arrangements are willingly provided for museum programme visits;
4. that museums and galleries are strongly urged to maintain the tradition of free entrance for staff and students on all educational visits (Adams 1990).

Support for teachers

Most museum and galleries provide support for teachers both in giving access and in planning their visits. A case-study from a special exhibition in Edinburgh provides examples of the various forms that this support might take. School visits formed 10 per cent of the visitors to the 'Gold of the Pharoahs' exhibition at the City Art Centre in 1988 (Woodward 1989). This was a very busy exhibition and a number of measures were taken for teachers to maximize their visits, ranging from the very practical, to help with the exhibition content. Much of the help would not have been possible without the input of the LEA, who clearly felt that there was a responsibility to facilitate teachers' visits.

Pre-booked parties were guaranteed entry into the exhibition where the general public sometimes had to queue. Introductory sessions were arranged for some teachers where a video about the exhibition was shown and the arrangements for visiting were explained. Staff were seconded from the LEA (Lothian Regional Council) to help with daily organization. A video and teachers' pack was prepared to give information on the content of the exhibition. The video was available for hire, prior to the visit, at a cost of £5, but the tape-slide presentation on which it was based was also available at the City Art Centre. Three-quarters of the visiting school groups saw the presentation, with the vast majority viewing the tape-slide at the start of the visit rather than hiring the video. About 90 per cent of the teachers felt that the presentation was useful, and those who had seen it at the beginning of the visit were more likely to feel this. The tape-slide contextualized the artefacts and gave an introduction to the exhibition that was an important part of the success of the school visit.

The teachers' pack was distributed free to all primary, secondary and special schools within Lothian Region and was available to private schools and schools outside Lothian at a cost of £2.90. Of those teachers taking a group to the exhibition, 62 per cent had used the pack, most of whom were from primary schools. The pack was used for both preparation and follow-up work, to prepare worksheets, for pupil reference, for language and drama work and in the stimulation of art work. Teachers commented that packs prepared for either primary or secondary groups would have been appreciated.

Many museums are now preparing teachers' packs of various sorts. These can take the form of loose-leaf packs, sometimes with the images on separate sheets which facilitates photocopying; sometimes books are produced. Ironbridge Gorge Museum has begun a very ambitious five-year

Plate 25 Teachers on a training day at the Horniman Museum examine some of the objects that they and their groups will later study. Photo: Keib (sic KEIB) Thomas. Courtesy the Horniman Museum and Public Park Trust.

programme to produce a set of teachers' guidelines, sponsored by BP. These will be written for and by teachers of specific age-groups, including under-fives, infants, juniors, lower-secondary, upper-secondary and post-sixteen. Each booklet is planned to begin with an outline of the principles of educational philosophy appropriate to the age-group of the children concerned, followed by detailed accounts of one or two projects undertaken at the museum, including follow-up work. The Guidelines for the Under-Fives contains a discussion of the pre-school curriculum, and the learning needs of young children in museums, and gives examples of two appropriate themes, 'Homes', and 'Then and now'. Concepts, skills and attitudes are explored, activities for the visit itself and for follow-up work are suggested, and appropriate questions for a qualitative evaluation are proposed (Ironbridge Gorge Museum n.d.).

These guidelines are designed to be of use at Ironbridge Gorge Museum, but also to enable teachers to develop their own approaches to other museums. A similar approach is taken by 'Discovering 19th century fashion', produced in conjunction with the V&A. The writer has used the collections of the costume department of the museum, but has arranged topics and ideas in such a way that they would be relevant in any costume display (Buxton 1989). Sponsorship also enabled the production of this book.

English Heritage have produced an excellent series of teachers' handbooks for use at particular sites, including the Avebury Monument and Tilbury Fort. The ideas and approaches, both to visit management, and to the educational use of objects, buildings, and sites, although specific to the places in question, offer reliable guidelines for visits elswhere.

Museum newsletters are sometimes used to inform teachers about the availability of specific teaching sessions at museums, events, teachers' courses, redisplays, or special exhibitions. Other contents might include details of new staff, projects undertaken, accounts written by teachers of work done, and information about the loan service. In some cases, such as at the National Museum of Film Photography and Television in Bradford, a teachers' section is included in a general museum newsheet. Decisions taken by museum staff on which is the most effective method of publicity need to take account of mailing lists and procedures.

Other written forms of support can include teachers' guides to the collections or to particular frequently used artefacts. Some museums and galleries have produced children's guides, such as 'A young person's guide to the gallery' produced by Leeds City Art Gallery, or the 'Horniman Museum Children's Guide'; and some have collaborated on books that are about children visiting a particular place, like 'Sam goes to the Burrell'.

Some museums have begun to produce videos and slide-packs to help with visit planning. These are sometimes produced for specific events, as in the example quoted above, 'The Gold of the Pharoahs' exhibition in Edinburgh. It is possibly more cost-effective to produce materials for permanent parts of the buildings or collections. The Tower of London have recently produced an excellent introduction to working with the site, 'Castle Clues', which divides a thirty-minute video into three parts on specific themes, each of which could be used by teachers in different ways. This is available for sale, although sometimes videos, or slide-packs are also available for hire. English Heritage, for example, have an extensive collection of excellent videos available on free loan.

Many museums arrange courses for teachers (O'Connell 1987). The idea of working in a planned and organized way with teachers has been established since the 1950s (ICOM Committee for Education 1956), and today some museum education staff regard teachers' courses as one of the most effective ways of delivering a school service. Where numbers are high and it is not possible to teach all school groups face-to-face, it makes sense to train teachers to use the museum on their own. Teachers are often unaware of the vast potential of the use of museums in their teaching. There is not enough information or experience of museum and gallery education given to student teachers although HMI have recommended that the initial training of teachers should ensure that all future teachers are introduced to ways of planning learning in museums and galleries (Moffat 1988a).

Teachers' courses can be approached in a number of different ways, but generally include museum or artefact teaching strategies, and, for serving teachers, often the opportunity to plan a future visit in conjunction with museum staff. The *Journal of Education in Museums* no. 6 deals exclusively

Plate 26 Teachers on a training day at the Horniman Museum try on some of the masks that the museum has selected as appropriate for their groups to study, and robust enough for handling. Photo: Keib Thomas. Courtesy the Horniman Museum and Public Park Trust.

with this issue and includes articles on general advice, accounts of work with science and art teachers, advice of how to use historic buildings, and comparisons with work in the United States with initial teacher-training establishments. Some museums work with teacher-planning groups which can act as supportive for both museum staff and teachers. In Finland, the

Museums Association and the National Board of General Education
have launched a national training programme on museum teaching meth-
ods for teachers, organized on a regional basis (Leimu, Unesco survey). On
the whole, both teachers and museum staff benefit from close and sus-
tained relationships, and wherever possible this should be an important
objective in the delivery of museum school services.

15. *School services 2: outreach*

Loan services

Many museums and galleries organize an outreach programme as part of their provision for schools. This might include a loan service (particularly in local authority museums), a mobile museum, or workshops in schools and community venues. In most cases outreach programmes are closely related to in-house work, although it is comparatively rare in Britain for museum education officers to spend much time working in schools.

Loan services have a long, if rather thin, history in local authority museums in Britain. As one of the first enthusiasms of the Museums Association (Rosse 1963:288), by the end of the nineteenth century a few loan services were established in the north of England (the Ancoats Museum, Manchester, Liverpool Museum and Sheffield Museum), and gradually others emerged across the country, with a boost from CUKT in the 1930s. The educational philosophy that underpinned the establishment of these early services emphasized the value of learning from objects, and in this, the importance of touching: 'Lifting things up and putting them down, stroking with the finger-tips or cupping them in the hands, are most vital processes of learning about things' (Winstanley 1967:57). Added to this was the democratic aim of enabling those people to benefit from contact with objects who, due to undeveloped transport systems, were unable to visit museums in towns and cities. As late as 1963, the Rosse Report recommended, 'that School Museum Services should be established all over the country and *especially that loan services should be established in rural districts*' (Rosse 1963:73; my italics).

Loan services were well established from very early in the century in the United States, with 'lending divisions' offering an important school service which included cased exhibits, charts and illustrative material (Weston 1939:110). The loan collection of the Buffalo Museum of Science, for example, included 79,000 lantern slides, 2,000 micro-slides, 12,000 pictures, and 8,051 units of teaching aids, including charts, cased objects and specimens. The Art Gallery of Toronto had a collection of 2,000 black and white and colour reproductions of paintings, prints, including etchings, lithographs and woodblocks, and reproductions of manuscripts and missals for loan. These well-organized and well-funded services were regarded

enviously by Ruth Weston from Leicester Museum on her CUKT-funded tour of American education sections in the 1930s.

The early loan services in Britain held historical, archaeological and natural history material. Art objects, often valuable, were more problematic, and once acquired, as their value increased, often had to be withdrawn. Before the establishment of Teachers' Centres in the 1960s and 1970s, with resources for teachers in short supply, the loan boxes often contained books, slides, and sometimes teaching notes along with the objects. Later, this extra material was withdrawn.

A variety of systems exists: most of the early loan services were subsections of the museum education service, as was the case in Sheffield, Liverpool and Leicester; in Derbyshire, however, the loan service established in 1936 had no parent museum, but purchased its collections specifically for schools; the loan service at Wakefield is also independent of a museum, contains some 'museum' artefacts, but also performs the function of a large-scale resource centre, with many objects being specially made. Some small museums, such as the museum at King's Lynn in Norfolk and the Acton Scott Working Farm Museum in Shropshire have small collections of museum material for loan by special arrangement. In general, the national museums do not operate loan services at all. The Victoria and Albert Museum large-scale Circulating Department which opened in 1864 to lend material to schools, colleges, and latterly with an emphasis on lending to provincial museums, closed in 1978.

Museum artefacts, models or replicas?

Some loan services contain almost as many models and replicas as genuine 'museum' specimens and artefacts. Where models of, for example, a farm cart, or a Tudor house, have been requested or identified as useful, models will be produced. Some services have plastic parts of the human body for loan, acquired from specialist firms. Some loan services will produce complete sets of, say, flint arrowheads, which are boxed along with one or two of the real thing. The replicas offer the opportunity to see a complete set which would otherwise not be possible. The amount and type of model and replica material will vary from service to service.

Some loan services have budgets for buying their own material, which in many cases will pay for little more than replacing worn-out items, but can sometimes be used to create new loan boxes. Leicester Museum, for example, has recently bought some modern Asian cooking implements to put together to make up a box on the theme of Indian cookery. Small musical instruments representing many cultures have also recently been purchased.

The acquisition of museum objects for loan services is sometimes questionable. What is the relationship of the loan collection to the main museum collections? How should the loan collection be managed? It is common for curators to pass duplicate and unprovenanced material to the loan service. The lack of documentation means that the object can be used only in a relatively limited way, and that its specific history is unknown. This is perhaps less of a problem than being given poor quality material, although

even here, some objects can be useful, and of course, much historic material is likely to be damaged in some way. However, as Howarth said long ago: 'It is a good principle that if you are going to show anything to young persons, a boy or a girl in the school or in a museum, it should be of the best, so that they can learn exactly what it is' (Howarth 1918:8).

Artefacts that are transferred to the loan service should be officially removed from the main collections, and should be listed in a loan service acquisitions register. Most objects that are in use are stored in their transport boxes, on shelving in sections relating to subjects. Transport boxes are designed to be carried by one person; they are strong, with the object firmly fixed inside it; and are marked for identification with a subject and object code. Some boxes are designed to act as display units.

Loan services today

Many loan services were established in the 1960s (Dawson 1981) and were still being established in Britain in the early1970s (DES 1987a: 2), but by this time both the development of transport systems and the costs necessary for large operations made it unlikely that services would be set up on the same scale as the earlier services.

The loan service of the Oxfordshire County Museum Service must have been the last to be established based on older models. It emerged soon after the opening of the main museum, the Oxford City and County Museum at Woodstock in 1966. This museum was unique in being the first public museum in the country to be opened completely equipped and staffed to receive visiting school groups. The loan service, modelled on the Derbyshire and Leicestershire services, was designed for use by both city and county schools (Derbyshire County Council 1967:16). In 1985 the loan service owned some 10,000 objects, grouped together into 1,900 collections: 850 natural history collections; 600 art and craft collections; and 450 collections of historical and archaeological material. The relative size of each category of material reflects the ease of acquisition rather than the importance of the subject (Anderson 1985).

The service has its own specially designed building with storage, workshop and administration space. Staff include two drivers, two cleaners and packers, booking staff and a manager. Each term between 10,000 and 12,000 requests to borrow material are received, of which about 50 per cent can be satisfied. Loans are made on a fortnightly basis, with twelve deliveries each year made by the museum vans. The loans are currently free to state schools, with private schools paying £5 per loan. The main users are primary schools. Although the service is mainly used by schools, collections may also be borrowed by other groups, and loans have been made to day-centres for the elderly for reminiscence work, to the local historical society, to libraries and elsewhere.

In 1982 there were 172 loan services operating in Great Britain (Martin 1982). On the whole, such services are very popular with teachers, and most loan services are unable to meet the demands made on them. Very few loan services use modern technology: the loan service of North Hertfordshire

Museums was one of the first to be computerized (in 1985), with links to the mainframe computer in the District Council's Finance Department. Schools can call up information on the loan service and make their own requests direct from the classroom (Hunter 1986). Oxfordshire and Bradford services are also now working with computers.

The more recently established loan services tend to be on a much smaller scale than the earlier ones, with teachers fetching their own material, and with the officers in charge having this as only one of their responsibilities. Booking forms are not used as is customary in the larger services, with arrangements being made by telephone. This less formal and less elaborate system limits the amount of use made of these services. The earlier, larger-scale operations tend to cater for between one-third and three-quarters of the schools in the LEA area, and other establishments are also served. Catalogues are generally issued to help teachers select material (DES 1987a).

Loan services are one of the oldest, and for many museums and teachers, the most familiar aspects of museum school services (Whincop 1983). There are, however, problems associated with them, including the large resource outlay in terms of buildings, staff, equipment and materials required to provide a well-managed service; the difficulty of deciding whether to supply 'museum objects' or models and replicas for loan; and the problems of educational evaluation.

Loans can, of course, be used in a number of different ways: for art and design, to help with both written and spoken language, to illustrate scientific principles, to prepare for a museum visit, to complement a radio or TV programme (Ball 1990). Many services in England are now reorganizing their loans in relation to the National Curriculum. Relevant Attainment Targets are being identified where possible, although most objects will relate to many areas and targets.

The HMI report emphasized that many teachers would benefit from preparation in the use of artefacts before using loan materials (DES 1987a: 8), and there is no doubt that well-planned courses open up new methods of use (Hennigar-Shuh 1984). In at least one recent venture into the development of loan boxes, teachers are not able to borrow the material until they have attended an in-service training-course.

With current changes in educational structures, the funding and management of museum loan services are being carefully scrutinized, and it is likely that many may be endangered. Theoretically, with LMS, schools should be able to choose to pay to hire a loan, and costs have been calculated at about £10 per loan. In practice the level of funding for schools is unlikely to stretch to this. Loan services as a resource are very labour intensive and costly to maintain, but the abolition of local loan services would be a loss to many schools.

Mobile museums

Mobile museums form a second aspect of school service outreach work. These were not established until the 1970s in Britain (Rees 1981; Porter

1982). Similar initiatives emerged in the United States and India at the same time.

Most of the mobile units were for exhibitions that were taken to fairs, libraries and other public venues in areas where museum provision was limited, and as such performed a general educational service. In 1979 the Merseyside Museums and Walker Art Gallery Mobile Exhibition Project was established as an extension of the education department of both the museum and the art gallery. This unit was to provide a service specifically for inner-city schools, and was funded by a grant from the Urban Aid Programme. During the mid-1980s, a similar service with an inner-city school brief was established by the Museum of Docklands, an outstation of the Museum of London.

Both these latter two mobile units were established specifically to work with schools, and with schools in the deprived inner-city. It is perhaps significant that the earlier service was able to find funding from government money, while the later service is dependent on industrial sponsorship. The philosophy underlying the two services is, however, broadly similar: they are both seen as attempts to alleviate the problems of poor housing, unemployment, and general lack of amenities. Both units are operated by trained teachers. In Merseyside, permanent staff are employed by the museum, working as part of the large permanent education department. In Docklands, project workers are employed on contract through sponsorship monies.

Both units work directly with schools, the mobile unit travelling to the school concerned for a day's work with one or more classes. In general, classes are divided into two, with one group working in the van itself, and the other working on related themes in the classroom with one of the staff from the mobile unit. The methods of work are slightly different, and reflect both the specialist skills of the staff concerned, the collections of the parent museum(s) and the prevailing educational philosophy.

The Merseyside teachers plan, design and mount temporary exhibitions for the interior of the mobile, with themes which relate to either of the parent institutions: 'sculpture' and 'transport' have both been exhibition topics. The exhibition introduces some main topics through simple and eye-catching graphics, photographs, drawings and three-dimensional objects. Each exhibition might look very different from the previous one, depending on the objects and ideas. The exhibition is supported by a video unit. Children can look at the exhibition for a short time and then watch a related video and take part in a discussion. Music or singing is also possible in the mobile unit. In the classroom, there is space for larger-scale activities, which might include artwork, as one of the teachers is a trained art teacher, or the careful study of artefacts from the collection brought especially for handling.

The Museum of Docklands has not, at the time of writing, yet opened, although the mobile museum has been working in the Docklands area for about three years. The staff employed are community artists with skills in drama. Some of the collections of the Docklands Museum are available for use in the mobile unit, being sturdy industrial and social history objects related to the history of this part of London. The exhibition set up in the

van is designed to act as a stimulus for drama work in the van or the classroom. Topics are related specifically to the docklands theme, and have included 'cargo handling', 'divers', and 'the call on'. Preparatory material is available for teachers, with historical and specialized information, excerpts from contemporary documents, and photocopied photographs.

In the United States, mobile museums are far more common (Supplee 1974). In 1974 there were more than forty mobile units, about half of which had been established since the beginning of the 1970s. Science museums in San Francisco, Portland and Seattle operate computer vans. The Seattle mobile museum van, for example, takes two instructors, fifteen Apple computers and various day-long lesson plans to schools, with funding from user fees, and foundation and corporation grants.

In India the mid-1970s was also a time for development. In 1974 the Department of Culture of the Government of India, as part of a programme of the dissemination of culture, launched a mobile museum scheme in conjunction with four major national museums including the National Museum of New Delhi. These museums were designed for the general public as well as for schools. The travelling exhibitions were very different from those established in England. The English vans all depend on the visitor entering the trailer and viewing the exhibition from inside the museum. The Indian vans are arranged so that the exhibition can be viewed from the outside as well as the inside: the walls have glass panels and sections at various heights so that cases and objects can be seen without entering the museum.

Other initiatives are also taking place in India. Science museums and particularly science centres are being established and one of their modes of communication with potential and actual publics will be with mobile museums. In other areas, mobile museums can act to determine the level of potential interest in museums. In the state of Gujarat, a tribal museum sent a bullock cart with exhibits to tribal areas, and on discovering that this was well received, the state museums of the area have launched an ambitious programme of mobile museums (Jain 1990).

American science centres and museums often operate outreach programmes that, in addition to the computer vans mentioned above, send teams of teachers, small exhibits, and hands-on lessons to schools for day programmes. Some, including the North Carolina Museum of Life and Science in Durham, provide classroom-sized inflatable planetaria and accompanying instructors to conduct astronomy lessons that teach children how to use star charts and make their own observations of the night skies. In some instances, even more ambitious projects are arranged. The Centre of Science and Industry in Columbus, Ohio, provides an overnight camp at the museum for 35,000 youngsters and their youth leaders annually. Science activities on topics such as cockroaches, crystals and maths puzzles are enjoyed (Van Dorn, Unesco survey). The Ontario Science Centre in Toronto sends a Science Circus to remote communities and schools in the province for two-week visits. The huge tractor trailer transports 3,000 sq.ft. of exhibits, a theatre, and materials for workshops and demonstrations. After the Science Circus had visited the Science Museum in London, and proved so popular with young visitors, the idea for Launch Pad was born (Gillies 1981).

Artists in schools

Some art galleries have been very successful in organizing artists' residencies in schools. One of these is the Whitechapel Art Gallery in London's East End. Artists are used to lead all the workshops in the gallery itself, and the residencies and related studio visits evolved as a natural extension of this. Artists work in schools, conducting workshops, making art and helping children both to make their own work and to put on exhibitions. One primary schoolteacher commented that the artist 'offered us new and very valuable experiences; her use of materials and ways of working fascinated the children. New vocabulary, sounds and visual experiences were absorbed. Through discussion, she inspired work right across the curriculum' (Whitechapel 1989:17).

Each project is very carefully planned and the artist and the school carefully matched. The artist and some of the children from the school will have met at the gallery, and the school may also have visited the artist's studio. Some short workshops at the school may follow, so that by the time the longer residency begins, everyone feels familiar and comfortable with the situation. The artist generally makes quite an impact right across the school:

> Jefford constructed a vast pair of hands while he was here; we bought the sculpture from him, and it's just about the only thing in the school that has never been vandalized. Now while the finished work is quite strange, quite mysterious, for the kids to see him actually making it was extremely demystifying. (Whitechapel 1989:18)

Artist workshops in schools and the community are also organized by the Tate Gallery Liverpool (Jackson 1989). With a very clearly defined objective to increase audiences and to bring art to new audiences, the education section at the Tate Liverpool has developed a policy and a set of guidelines that promote outreach work. The programme was devised within funding restraints, but has been extremely successful. A project worker was appointed for one year, funded by British Telecom, and a year's programme drawn up, with the overall aim being 'to show, through good practice, the value and potential of an integrated programme of outreach work, with a view to raising the required funding to realize the original plans'.

The Tate aimed to act as a catalyst for a series of arts education and training initiatives, specifically designed for particular groups in the Mersyside community, in order to build a long-term active and committed audience. In-house and outreach work is integrated in imaginative and consistent ways, the gallery creates networks with a wide range of arts, education and community organizations, joint projects are established, and projects interrelate in fruitful ways (Jackson 1989). An ambitious programme was designed with several units, including work with schools, Park Lane Secure Hospital, Africa Arts Collective, WOMAD (World Organization of Music, Art and Dance), the Somali community and many other groups on a local, national and international level.

The future of outreach work in Britain

Many local authority museums in Britain organize a loan service, but very few have established mobile museums, or other forms of school outreach work, although some outreach work is done with other sections of the community. Artist-in-school programmes arranged by museums are relatively rare. National museums have made very little effort in this direction, except for the pioneering work at the Tate Gallery Liverpool. However, although outreach is patchy across the country and across different types of museums, teaching methodologies and structures are in place, and many models of organization exist in Britain and elsewhere which could easily be developed.

It is, in fact, possible that outreach work may soon be given a higher priority. LMS has made funding for some loan services more insecure: one solution, if a service were abolished, is to use some of the collections as handling material for school-based sessions led by the museum education staff who would otherwise have been running the loan service. If educational services as a whole are threatened, it is also possible that classroom-based work may turn out to be one way to maintain a museum school service. It is already the case at Stevenage Museum, for example, where visits to the museum have proved so difficult for schools, for the same reasons as those outlined in the ILEA survey (Adams 1990), that the museum education officer has offered handling and slide sessions in the classroom, with the museum visit set as homework to be carried out in the student's own time. The increase, again identified by the ILEA survey, in sending older students to museums individually, may lead to teachers asking museum education staff to visit the school to speak to a group of older students prior to a museum visit.

There is no doubt that the lead given at the Tate Gallery Liverpool has opened up possibilities of new ways of working for the national museums. On observing the success of the work in Liverpool, the Trustees of the Tate Gallery have now for the first time acknowledged that outreach work is an appropriate educational approach for the Tate. It is likely that this approach will be developed at the Tate in London, especially since the former Director of the Whitechapel has now been appointed as Director. If this is so, other national museums would be influenced. In any case, other national museums, rethinking their educational policies, are also reviewing the potential of outreach work and some would be more than happy to introduce a mobile museum if funding could be found. With the increased emphasis on audience needs and on the sharing and dissemination of resources that is encouraged by government, outreach work may well be seen as an excellent solution.

16. Museums for education

Old and new phenomena

A cluster of phenomena can be identified that could be loosely grouped under the term 'museums for education'. Some of these are relatively recent occurrences and some are nearly as old as the oldest museum. The factor which unites them is a relationship of one sort or another to education and learning. In other words, these museums or subsections of museums, or movements within the museum field, all have the education of either children or the general public or both as their major focus.

Some types of museums can be identified that have been established for explicitly educational purposes. These include 'children's museums', of which there are many in the United States, but none in Britain as yet; and museums of both 'education' and 'childhood'. These two types of museum, are however, fundamentally different in intention. Children's museums aim to relate very closely to children's interests and ways of learning, while museums of education and museums of childhood are concerned with documenting the history of either education or childhood.

One or two museums have been established as 'educational museums'. In Britain both the Clarke Hall Educational Museum in Wakefield and Haggs Castle, in Glasgow fall into this category. They are both museums set up for teaching purposes. Clarke Hall is open only to booked parties of children or adults from educational establishments based within the LEA funding consortium. Haggs Castle is open to the general public but the displays are designed for children.

Some subsections of museums have evolved to exploit discovery and self-directed learning. An example is the Discovery Room in the Royal Museum of Scotland, which was itself based on the well-known and well-documented Discovery Room at the Royal Ontario Museum. The Natural History Centre in the Liverpool Museum, National Museums on Merseyside, can also be grouped with discovery rooms.

The rapid development of Science Centres, and related ideas about interactive exhibits and their teaching potential, can be identified as a movement within the museum field. With financial support from the Sainsbury Foundation, and intellectual sources and models in North America, the idea of the science centre has emerged during the 1980s as

one of the most significant developments in British museums. At the same time, similar movements can be observed in other countries such as India and Japan.

Together these initiatives represent on the one hand a very long tradition of concern both for children and for the educational potential of museums, and on the other hand, a very recent intense focus on ways of making museums both useful and entertaining in a world where technological and scientific literacy are at a premium.

Museums of education and museums of childhood

Since the middle of the nineteenth century, some museums have been established as 'museums of education'. By the beginning of the twentieth century one writer suggested that about a hundred of these museums, specifically relating to schools, or to education as a profession (but not including school museums) could be identified in various parts of the world (Andrews 1908:3). Andrews identifies the first museum of education in the world as the Educational Museum of the Ontario Provincial Education department, established in 1845 by the Provincial Superintendent of Education.

Of the other museums of education world-wide, most at the beginning of the twentieth century were in Germany, although some were also found in Austria, and a few in Brazil, Denmark, France and other countries. On the whole these museums contained collections of material relating to schools and pedagogics, including textbooks, and historic educational material. A museum in Hamburg, for example, illustrated the history of local eduaction, while one in Zurich contained a Pestalozzi memorial room (Andrews 1908:40). A modern equivalent is the Museum of Education in Edinburgh.

Related to this type of museum are museums of childhood. These museums contain collections of toys, games, children's clothes and so on. Their topic is the history of childhood, rather than the history of schooling. Modern examples are the Museum of Childhood in Edinburgh, a lively, well-presented collection of childhood materials, and the Museum of Childhood at Sudbury Hall in Derbyshire. The Bethnal Green Museum, an outstation of the Victoria and Albert Museum, with its collections of dolls and dolls' houses, games, clothes and children's books also comes into this category.

Childrens' museums

Different from both of the above types of museums are children's museums. These museums take children up to the age of 12 or so as their primary audience and the museum is made up of displays to interest and inform this age group. Children's museums also have a long history, particularly in America, where the first children's museums opened: Brooklyn,1898; Boston, 1914; Detroit, 1917; Indianapolis, 1925. There are now about 160 children's museums across the United States.

The philosophy behind children's museums is close to that underlying museum education as a whole. Learning by doing, touching and talking; learning through activity; and child-centred learning that puts the maturation level of the child at the forefront of the learning process were all important notions in the evolution of new ways of making museums. The ideas of Dewey and Montessori were behind the practices of opening the display cases and making the collections accessible that soon developed in the new children's museums. Collecting ceased to be an activity with its own ends, with objects acquired for their intrinsic worth or rarity. Rather, acquisition of objects was undertaken to interpret subjects and ideas (Cleaver 1988: 7). The importance of the collections diminished and the importance of the audience grew, until children's museums had evolved to the point where decisions on what to exhibit, what to collect, what project to carry forward were all made with reference to audience needs rather than to the nature, extent, or availability of collections.

Children's museums aim to explain rather than collect, with exhibits and apparatus as their communicative tools. One of the most unusual features of children's museums is the emphasis on evaluation of displays. Where communication is so important, it is vital that exhibits work as intended, and a large proportion of the display budget is allocated to finding out how the constructed exhibits and apparatus function with large numbers and how they should be modified. This approach is extended to labels and to displays in general.

Perhaps the best-known children's museum is the Children's Museum of Boston. Housed in a large warehouse building on the wharf-side, the museum displays are designed to offer many different entrance points for many different learning styles (Gurian 1981; Feber 1987). Although the primary audience is children, these children come accompanied by group leaders including teachers, parents, grandparents, and other relatives and friends. The potential for adult learning in relation to children is considerable and not ignored. Some labels, for example, are written for adults to read to children.

The museum has created a series of thematic learning environments. Each area is conceptually and thematically distinct and is designed to provide different learning modes. Objects in cases are rarely to be seen, while physical environments, for example, a Japanese house or a tepee, are combined with exhibits that invite activity, such as bones to be dug for by small children, Grandma's attic with dressing-up clothes, drawers to be pulled out, lids to be lifted and so on. The cases that are used tend to be disguised, so that, for example, a suitcase with an open lid disguises a glass-topped secure case, and a Chinese market-stall where children (and adults) can role-play, enlivens the area next to a shop-front displaying Chinese artefacts.

A number of trained interpreters work on the 'shop-floor'. Their role is to facilitate the learning experiences of the visitor in all ways, by giving information about the exhibits when required, joining in the role-play, leading art, craft or music activities related to displays, and by subtle visitor management. When numbers are too great in one area, for example, the

interpreters will suggest other parts of the museum to visit. The interpreters are trained by the museum in the subject-areas which the museum covers, and in how to deal with people and school groups of all kinds.

Museums like the Boston Children's Museum have renegotiated the relationship between museums and learning in a way that has not been seen in Britain. There is no children's museum like this in Britain, although a new institution Eureka! is under construction in Halifax. Some of the original ideas were inspired by American children's museums, but until the new 'museum' opens it is impossible to know how, and indeed if, these ideas have been utilized.

Educational museums: a case-study of Clarke Hall

A unique museum exists in Britain: the Clarke Hall Educational Museum. Clarke Hall is a seventeenth-century house in Wakefield, which, funded by a consortium of LEAs, has been developed solely as a resource for the schools within the consortium. The manor house is furnished with original and replica furniture and artefacts, and is 'lived in' by Benjamin and Priscilla Clarke. The resource, including the house, the grounds, and Benjamin and Priscilla in role, are available to teachers for a day at a time, to use as they wish.

The Director of the museum is a former primary school headteacher who has, over the last fifteen years, built up Clarke Hall in a unique and very effective way (Stevens 1981; 1987). He, as Benjamin, or his part-time assistant, as his wife Priscilla, will introduce children to the manor house, using seventeenth-century language and conventions (Hepler 1978). The spaces, colours, sounds, costumes, textures and so on provide a rich sensual experience at the beginning of the day. Benjamin takes the children into his sitting room to look at his best ceiling: 'what is it made of, do you think', 'look at my fire-place and my fireback'; and then to the music room, where he plays the cornetto and flageolet, and a child explains how the harpsichord works. In the bedroom, a story is told about 'Cousin Martin who came to the house, having skirmished that night with the King's men because he was a Papist'.

Later, the children try weaving, writing, table games, candle-making, or making potions, or butter-making, and prepare and eat a meal. Often the day is interrupted by a visitor, someone wanting help, or to hide as Martin did. The drama and/or the activities of the day can be manipulated according to the wishes of the teacher. The main aim of the visit for many teachers is to spend the day living in the past, experiencing both the everyday activities and some of the dramatic events of the seventeenth century. General educational and social objectives are important, and the day is inevitably cross-curricular (see Fig. 16.1).

Some visits take unusual forms, and exploit the house in new ways. An art teacher, for example, used the resource to give sixth-form students insight into ways in which social and cultural forces shape works of art, and their meanings. Seventeenth-century paintings were studied, using a special exhibition at the National Gallery; students then visited Clarke Hall in the role of painters gathering information for their work. The three-dimen-

Plate 27 A child tries out seventeenth-century writing skills at Clarke Hall. Courtesy Clarke Hall Educational Museum.

History - drama, role play
 - characters, incidents from the 17th century
Language - listening, speaking, writing
Maths - measurement... time, weight, length
 - estimation... money, cost of visits
Science - introduction of concepts,
 e.g. butter making, cooking
Music and Games - singing, appreciation
Home Economics - cooking, cleaning
Environmental work - plants, animals in the grounds and garden,
buildings

The experience of the visit was used to integrate the curriculum in the above
areas over a long period of time

Social - interaction with other children and adults
Emotional - enjoyment, fear, fulfilment, laughter,
 satisfaction
Intellectual - guessing, estimation, language
Physical - crafts, motor skills, manipiulative skills,
 games - effort, co-ordination
Sensory - things to see, touch, hear, smell, taste

The above areas of child development were enabled through the day at
Clarke Hall

Figure 16.1 A primary school teacher analyses the educational value of a visit to
 Clarke Hall, identifying the various subject-areas of the primary
 school curriculum and the areas of child development that were
 improved by the visit

sional 'compositions', using themselves, specially made costumes, light and
artefacts were recorded photographically with advice from the education
officer of the National Museum of Film and Photography, who was with the
group at Clarke Hall. Later, work continued at the Museum of Photography
(Paterson 1989).

One of the most significant aspects of the management of the work at
Clarke Hall, and an important factor in the continued success of the
venture, is the insistence on preparatory visits for teachers. All teachers who
plan to visit the Hall must attend a preparatory course, where every detail of
the intended day is discussed and resolved as far as possible at that stage
(Stevens 1987). Two weeks prior to the visit the teacher is required to
submit plans in writing and confirm them by telephone. Many helpers are
required by the class-teacher during the day at Clarke Hall, and in the past
it has been the teacher's task to prepare the accompanying adults, and
sometimes this has not been fully achieved. Preparation for some parents
and helpers will now take place at the Hall where the adults, in costume,
will experience the flavour of the day, including the role-play and will learn

Plate 28 A student uses a Vermeer painting as source to respond to the ambience and atmosphere of Clark Hall. Courtesy the Education Department of the National Museum of Film, Photography and Television.

how to play their parts. One important aspect is to have the confidence and understanding to allow the children to answer Benjamin's questions, even if at first they do not understand them. The Director, as an experienced teacher, is watching for this and has, in fact, probably deliberately used new vocabulary, which requires an experience of the real thing for understanding: 'Fetch me my crumhorn from yonder corner ... I have two that twist and turn, but the larger makes the better sound.'

Science teachers, together with the staff, have reviewed the possible activities and approaches to Clarke Hall in relation to the Primary Science Programmes of Study and Attainment Targets in the National Curriculum. Thus 'Fabrics' are related to AT1 and AT6, and a related problem-solving activity is suggested:

- what might Mistress Priscilla have used to dye her cloth?
- try: red cabbage, beetroot, onion skins, blackberries, pea pods, dandelion roots, lily-of-the-valley roots.
- which fabric dyes the best?
- does the time in the dye make any diference?
- does the temperature make any difference?
 [Clarke Hall 1989].

Plate 29 'Fetch me my crumhorn from yonder corner...' Courtesy Clarke Hall
Educational Museum.

Other links to the National Curriculum have been made. For example,
the History curriculum HSU3 (History Study Unit 3) at KS2 covers 'Life in
Tudor and Stuart Times', and includes as essential information in eco-
nomic, technological and scientific topics: agriculture; towns, trade and

Plate 30 An adult visitor tries out an early calculator in the Discovery Room in the National Museums of Scotland. Courtesy the National Museums of Scotland.

transport; exploration, Drake and Raleigh; and scientific discovery, Isaac Newton. All of these can be discovered, discussed and explored by children at Clarke Hall.

The educational methods that have been pioneered at Clarke Hall have

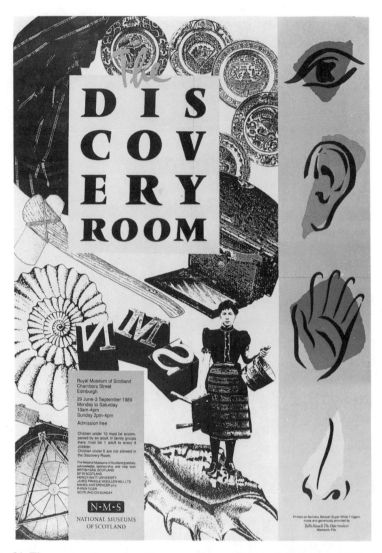

Plate 31 The poster from the Discovery Room, National Museums of Scotland, 1989. Courtesy the National Museums of Scotland.

been influential on a national and an international basis. In Sweden, two sites have now been established based on this model. The quality of the educational experience that is offered to schools is very high indeed, such that when the possibility of closure of the Hall with budget reductions in relation to LMS was raised, a consortium of local headteachers wrote in the strongest terms to both local and national educational decision-makers.

Although some aspects of the methods and approaches employed at

Clarke Hall are to be found elsewhere, in relation to most museum education systems, Clarke Hall is very different. Clarke Hall has a tightly defined function and a restricted audience. The museum is not open to the general public. There is no loan service or other provision of any kind. Most museum education staff have a far greater demand in terms of breadth on their expertise. However, the excellence of the provision for schools at Clarke Hall is such that it makes an excellent example for others to follow.

Discovery centres

Some museums have made major efforts to find new ways to open their collections to their visitors. This is especially felt to be necessary in the older, larger museums where many of the displays are of a fairly traditional nature. It is recognized that as educational methods change, and children become more accustomed to active learning, to reviewing evidence, to using sites and out-of-school resources, and to setting targets and negotiating self-generated learning, so a generation of adults is being trained that will demand more from museums than the possibility of merely looking. A desire has emerged in museums to provide an active, self-directed, multifaceted method of learning. One of the first institutions in Britain to find a way of satisfying this desire was the education department of the National Museums of Scotland.

In the summer of 1987 the Education Centre was transformed for a trial period into a new public 'hands-on' space. The success of the first experiment led to the repetition and development of the project in subsequent years. The Education Centre was divided with inexpensive felt-covered partitions into small individually lit study booths. Each small section contained objects and related materials on one of nine themes: archaeology, ancient Egypt, hats, micromarvels, insects, fossils, body-coverings, colour and domestic technology. Work cards, information sheets, books, photographs, computers, tape recordings, magnifying glasses and a microscope were provided to help investigate the objects.

The aims of the Discovery Room were to build up the confidence of the museum visitors in handling and understanding objects, to enable people to investigate themes from the past, present and future, and to attract people who might not normally visit museums. It was also intended that the objects and themes explored in the Discovery Room would complement the more traditional displays.

As the objects were explored, questions were asked and interest quickened:

> there's a radio over there playing 40s-type music … but that's odd, there's no light on when you turn it on … is it genuine? Look at her—I bet she had one of those scrubbing boards when they were first married … this iron is *so* heavy: how did they manage the ironing then? Can I have a go at the turban? I can't imagine having the time to do this every day—oh, I see, they would keep it ready wound for a week or so.'

Plate 32 The Natural History Centre at Liverpool Museum, Merseyside. Adults,
children and family groups all enjoy handling and investigating the
objects. Trained museum staff are on hand to answer enquiries and to
help when required.

Discoveries were being made about raw materials, textures, design,
weight, function, about people in the recent past, about our ancestors
thousands of years ago, and about the contemporary world (Bryden n.d.).
Hand in hand with the questions and the discoveries went enormous
interest and enjoyment.

Staffing the Discovery Room was carefully considered and it was decided
that instead of using traditional-style warding staff, interpreters should be
employed. It was felt necessary to have two members of staff always on duty
and a team of seven was employed. The initial capital costs of the project
were about £25,000 which covered construction, lighting and so on. It is
estimated that the system should last for about ten years.

The Discovery Room was extremely popular. Queues were to be ob-
served every day in the Education Centre. The success of the first experi-
ment led to a repetition the following summer, and then to the Discovery
Room being taken up to Inverness Museum for a short time in October.
The opening period in Edinburgh was extended from late June into Octo-
ber so that both the general public and schools were able to use the
Discovery Room.

The National Museums on Merseyside have been pioneering various
initiatives in active investigation and discovering learning (Fewster 1990).

These include the Ceramics Study Centre, and the Natural History Centre in the Liverpool Museum (Greenwood *et al.* 1989), where specimens are available for the public to investigate in a very similar way to that of the Discovery Room in Edinburgh; the records centre at the Maritime Museum; and Technology Testbed—the latter two are both part of the National Museums on Merseyside. Interestingly, here the impetus has come from curators and the Director, concerned that reserve collections were being deprived of funds for continued care because, being reserve collections, they were held in store. The numerous solutions devised to provide greater and more active access to collections represents a decade of hard work and imaginative experiment, informed by the view that museums cannot expect support from the public if the public does not know or care about what museums do.

The Discovery Room in the Royal Ontario Museum (ROM) in Toronto has been influential in all of these initiatives. The original room opened in 1977, was operated by the Education Services, and aimed to offer all visitors the chance to have direct access to objects and specimens. A book had been produced to help others, *Hands on: setting up a Discovery Room in your museum or school* (ROM 1979) which discussed the practicalities and possibilties and offered a useful methodology in the process of designing a discovery room. The work continues at the ROM, and both the theoretical and practical aspects of discovery learning are being developed.

A recent evaluation of the ROM centre, now called the Discovery Gallery, offers a series of categories of 'discovery learning' which progresses from a teacher-led to a learner-controlled situation (Freeman 1989). Guided discovery, which is teacher-led, is characterized by convergent thinking. The teacher/instructor devises a series of statements or questions that guide the learner step by step to a predetermined conclusion. In working with a sixteenth-century panel portrait, for example, the teacher might ask questions which would lead from observation of some aspects of the painting to conclusions about the social role of some portraits. 'What is the sitter wearing?' 'What makes you think the clothes might be expensive?' 'Why would anyone want to wear expensive clothes like this?' 'What were some of the functions of portraits in the sixteenth century?' The learner engages in active cognitive inquiry, which may include: recognizing data, analysing, synthesizing, comparing and contrasting, drawing conclusions, hypothesizing, memorizing, inquiring, inventing and discovering. By actively doing and then discovering facts, the learner will understand and therefore remember.

Problem-solving is characterized by divergent thinking. The teacher/instructor poses a problem and the learner engages in active inquiry to discover one or more solutions. The teacher does not provide a step-by-step route to one answer, but encourages active investigation in any direction, which may provide a number of alternative solutions, some of which may be previously unknown. This method promotes individual choice and decision-making on the part of the learner. In relation to the sixteenth-century panel portrait, the problem might be to discover what the picture was painted on and why this material was used. The investigation of the panel

Plate 33 A young visitor with an interactive exhibit at Jodrell Bank learns how white
light is composed of light of seven colours. Courtesy Jodrell Bank.

portrait would need to start by looking closely at the object itself, when the
underlying grain and warp of the wood would become evident, and the
floorboard-like separate panels making up the whole picture would be
seen; then the inquiry would begin into why and how wood was used at this
time in England. Books, catalogues, curators, teachers, videos and slide-
tapes could all be used to take the investigation further. Many topics for
further learning emerge and could be pursued by individual learners:
finding out about trade between England and Europe in the sixteenth

century; making a panel to paint on; discovering what dendrochronology (carbon-dating of the wood) means and can tell us, and so on.

Both guided discovery and problem-solving are possible learning methods for discovery rooms. Guided discovery generally requires help to follow the route laid down; this can be done through interpreters, computer-programmes or prepared work cards, and sometimes by using specific exhibits. Problem-solving requires the statement of a problem and the provision of resources and materials to work through chosen aspects of the problem.

Individual learner-designed programmes are the final and purest form of discovery learning discussed in the ROM study. In this form of learning, the planning, implementation and follow-up phases are controlled exclusively by the learner. This form of discovery learning is not appropriate to discovery rooms as in varying degrees the experiences offered must be structured and controlled by museum staff.

Science centres and interactive exhibits

During the 1980s a new concept has emerged in Britain, that of the 'science centre'. Although the idea had been familiar in North America for a considerable time, and this development had, in fact, been partly inspired by the original Children's Gallery at the Science Museum in the early part of the century, British interest is relatively new. The science centre movement has been based on the ideas of Oppenheimer and Danilov in the United States (Oppenheimer 1973; Danilov 1973; 1982) and represents that area of museums where most research into informal learning has been carried out. The establishment of science centres has been intimately related to the concern for the public understanding of science, and as this has quickened in Britain over the last decade, so science centres have appeared. All kinds of phenomena can be found at Nottingham, Manchester, Glasgow, Bristol, Liverpool, London, and Buxton, for example.

These science centres vary in scale and in management. At Nottingham, Green's Mill is a reconstructed windmill with a very small science centre adjoining. The centre and the windmill are managed by the education department of Nottingham Museums. At the Manchester Museum of Science and Industry, Xperiment! is run by demonstrators, managed by curators (Greene 1989), but much visited by school parties, especially since a Teacher's Pack identified all the Attainment Targets that could be covered with the various exhibits. The result was an increase of 40 per cent in school parties.

Launch Pad, at the Science Museum began as a project of the education department. It opened in 1986 and was described as Britain's first full-scale permanent interactive science centre (Stevenson 1987). The emphasis is on technology rather than pure science, and the experience is designed to be enjoyable. Visitors old and young can build an arch with specially shaped bricks and then walk across it; try their strength on an exercise bike to see if they can produce enough power to light up a column of light bulbs; watch the very young play with sand and water; talk to the interpreters, who are

there to help.

Research in America has shown that visits to science centres are success-ful in changing attitudes and motivation towards learning science (Borun, Unesco survey). Facts can be learnt, but no more is learnt than would be learnt in the classroom; what is of more significance is that during a visit to a science centre children become interested and can begin to see how science might after all have something to say to them. Attitudinal change will then have an effect on learning and remembering. Some doubts about the relationship of fun to the learning of scientific concepts, have however, been raised (Shortland 1987).

The success of the interactive exhibits used in science centres has dem-onstrated that people enjoy active physical involvement, and are enthusias-tic about becoming involved, either singly or in groups, with investigation and experiment. The physical involvement leads easily to an engagement with interpreters or demonstrators, questions begin and conversation flows. Informal and unstructured learning, based on the event of the moment and the visitors' reaction to it, can occur. Curators and educators have been anxious to exploit this in areas other than science, as the initiatives on Merseyside and in Edinburgh demonstrate.

As museums move from a collecting phase into a phase that emphasizes the use of collections and the development of qualitative methods of relating to visitors of all ages and with many different interests, interactive exhibits and methods will spread from the discovery rooms and science centres into the galleries and permanent displays. Museums have the po-tential to offer the unique combination of the study of beautiful artefacts of historical significance with opportunities to engage in active and investiga-tive ways with the ideas represented by these objects. Such a combination is irresistible.

17. Museum and gallery education for the twenty-first century

Whispers from the past

At the end of the century, it is appropriate both to look back on the past and forward to the future. Looking back two hundred years, we see the birth of the public museum (Bazin 1959). In France in 1792, a decision had been taken to open a public museum in the galleries of the old royal palace of the French Kings. The Musée Français, later to become the Louvre, became the depository of the treasures looted from the French aristocracy, the church, and the conquered kingdoms of Europe. The museum represented an opportunity for the masses, who had been excluded from culture and education under the *ancien régime,* to be exposed to beautiful, interesting and illuminating things. The museum formed an integral part of the newly democratic state, and an essential element in governmental efforts to educate the French people as citizens. The educational role of the museum was carried out in different ways: thematic and labelled displays, inexpensive catalogues, and gallery teaching (Hooper-Greenhill 1988a). Students of all sorts visited the museum and, later, its linked institutions (Les Jardins des Plantes, for example). Visitors from overseas poured in. The museum became a place to learn, to browse, to meet friends, to talk, to paint, to enjoy exhibitions and events. This museum demonstrated for the first time both the immense power of museums to appeal to a vast public, and the enormous inherent educational potential.

This educational potential was a driving-force behind the establishment of many museums, particularly, in Britain, the Victoria and Albert Museum. The V&A began as a museum and a school combined, with, in the early days, the art school and the museum occupying the same buildings (Physick 1982). Much was done to make the visits of the general public both profitable and pleasurable, and perhaps most significantly, the public, in all its humdrum reality, was welcomed in. At this time, museums were, without question, institutions for public education. Some institutions performed this function better than others, but a general consensus insisted on this as a primary function.

By the end of the nineteenth century, some aspects of the educational role of museums were becoming formalized. In 1895 in England, through the efforts of Horsfall and the Committee of Manchester Art Gallery, the day school code was modified to allow visits of schoolchildren to museums and galleries to count as valid school attendances (Smythe 1966:11). Loan services were becoming established and links were being made with education committees and teachers. Provision for other visitors was limited, however. As the new century began, the Victorian values that celebrated museums as institutions for educational self-help were already dying, to be replaced by less altruistic attitudes. The self-evident nature of museums for education was being lost as curators struggled to establish museums as places where important objects were collected and cared for. The development of curatorial practices meant that educational work took a second place. The museum preferred to take a position alongside universities as institutions of research, rather than alongside schools as places for education.

As the century progressed, holistic approaches to the museum as educational in its own right were superseded by piecemeal arrangements for different audience segments, with a concentration on school groups. Soon 'museum education' was understood to mean children's activities and provision for schools. The main communicative role of museums was not considered. Museum education became a separate sub-specialization in many museums, with different categories of staff, and different objectives and values from the rest of the institution.

Calls to the future

At the end of the twentieth century, a new approach to museums and galleries repositions museum education in a new way. Over the last twenty years, and particularly over the last five, the communicative roles of museums have been explored. As we have seen, these explorations have encompassed discovery galleries, interactive exhibits, new relationships to publics, and new audiences. This heartfelt concern for audience relevance is experienced in education departments, as one would expect, but also by curators of all disciplines and by museum managers.

The new developments in museum communication have been carried out equally by education and by curatorial staff. However, efforts to find new ways of communicating with publics have often come about because of individual conviction rather than as a result of planned policies and management. Often, too, education and curatorial staff have been pursuing the same goals without working together. A whole museum approach has not been in evidence, except in a very few cases.

The time has now come when all these disparate strands must be drawn together. How can relationships be made between, on the one hand, the schools provision which (in England and Wales) must take account of the National Curriculum and new funding arrangements, and the provision for a more demanding and active public who want to be involved in dynamic

Plate 34 The National Youth Music Theatre performing an extract from 'The Caucasion Chalk Circle' in the entrance foyer of the Chambers Street Museum, National Museums of Scotland in 1989. Courtesy National Museums of Scotland.

experiences in museums and galleries rather than to be passive viewers? How can scarce resources be maximized at a time when new measures of accountability are being developed for museums and galleries, and when demands seem to increase and diversify daily?

At the Museums Association Annual Conference in 1989, a document entitled 'Policy statement on museums—a national resource, a national responsibility' was presented and adopted. This document suggested that museums should be required to draw up an educational policy. As we saw in Chapter 9 (see pages 79–80), a museum education policy is profoundly influenced by the specific circumstances and objectives of the particular institution concerned. A museum or gallery education policy cannot be drawn up in the abstract. The process of arriving at a policy for education entails a serious consideration not only of the audiences for educational work, but also of the general visitor profile; not only the provision for formal education through taught sessions, but also the provision for informal or distance-learning through displays, catalogues, and events; not only the educational work itself, but also the interrelationship of collecting policies and management policies (Zyl 1987a; 1987b; Ontario Ministry of Culture and Communications 1985).

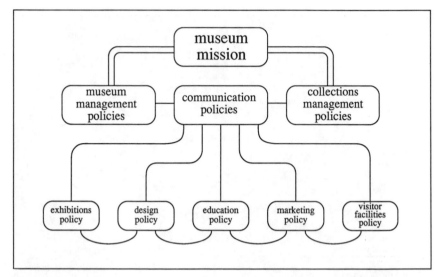

Figure 17.1 A museum education policy is one of the communications policies.

In drawing up a policy for museum education, it will quickly become apparent that a whole museum policy for communication is required (Southern African Museums Association 1989). This policy for museum or gallery communicaton must in turn be informed by the mission statement of the museum (Ames 1988). The mission statement of the museum or gallery will, in fact, guide the formulation of policies in all areas of practice, including communication, collection management and museum management (see Figs. 17.1 and 17.2).

The interfaces and relationships of all these museum activities should be explored and understood. For example, sometimes educational work can generate objects for the collections. In Southampton an adult education group explored museum exhibition processes while planning and setting up an exhibition of their own history. The artefacts for the exhibition were provided from the attics, cellars and living-rooms of the students, and were later donated to the museum (Jones and Major 1986). At the Ulster Folk and Transport Museum, Belfast, a class working with an artist produced a beautiful stitched collage which joined the museum's collection of patchwork quilts and related artefacts.

There are other ways in which curatorial and educational values interact. The concept of the 'audience advocate' has been developed at the National Museum of American History, as part of a more effective system for the management of the development of exhibitions (Hilke 1988). The ideas have been eagerly adopted by museum educators in other countries, and particularly in Australia, where educators are looking for new concepts to help articulate their expanding functions within museums and galleries (Duffy 1989).

The 'audience advocate' has the function both within the institution in

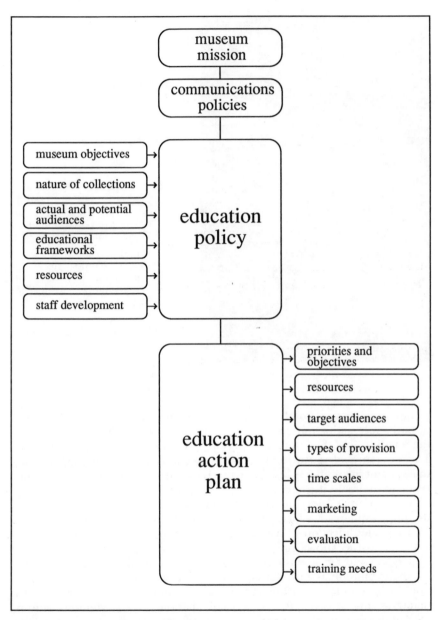

Figure 17.2 The museum education action plan is developed after deciding on the museum education policy.

general, and within the exhibition team in particular, to review events from the point of view of the visitor and potential visitor. The 'audience advocate' helps to improve the general experience of the museum including

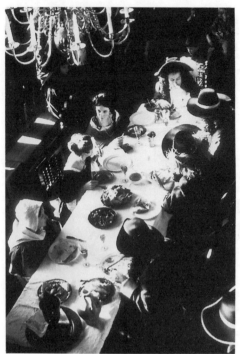

Plate 35 Increasingly drama and 'living history' are used as a means of exploring the past. In the summer of 1990, History Re-enactment Workshop and Kirklees Museum Service worked together at Batley Hall. An elaborate seventeenth - century meal, including fish, rabbits and pigeons, was prepared and eaten, watched by huge crowds of fascinated visitors

facilities for physical comfort; spatial and intellectual orientation; varieties of pace, style and communicative approaches of successive displays within the building; and the interaction between the museum staff and the public. The 'audience advocate' identifies those sections of the potential audience that are not involved because the experience the institution offers does not relate to their specific needs.

The 'audience advocate' is directly involved in exhibition management, the improvement of which should be implemented on three levels: first, with the identification of a target group for specific exhibitions, and research into the knowledge within this target group of the concepts the display will address, and the resulting development of 'teaching objectives' for the exhibition as a whole; second, the variety of modes of communication to be employed within the display, including labels, photographs, diagrams, maps, booklets, audio-visual material, videos, demonstrations, etc.; and third, in the provision of an educational menu of interactive experiences that explores the concepts covered by the display and provides the opportunity to learn more and to experience more deeply.

A further role for the audience advocate is the management of the evaluation of the experiences that museums, galleries and sites can offer. This covers frontal analysis, including audience research, formative evaluation into the effectiveness of communication methods, and summative

research to identify how far the exhibition or event has achieved its goals. As museums are increasingly paying attention to the needs and experiences of visitors, the functions of the 'audience advocate' are gradually evolving, although, at least in Britain, no such unified staff role exists at present. Duffy recommends that museum educators have the training and the skills to adopt this role. Placed within the history of museum and gallery education such a recommendation can be seen to be a reiteration of ideas that have had a very long currency (Miers 1928:42; Wright 1973:42).

The development of a communications policy and a communications strategy (Royal Ontario Museum 1976) will enable the identification and implementation of a comprehensive and coherent approach to the many and varied communicative roles of museums and galleries. Although at the present time there are few museums, at least in Britain, that have adopted these ideas, as the pressure increases for museums to relate more efficiently to their publics it will become necessary to develop new strategies for communication management. The need for coherence across the whole institution in relation to design, marketing, exhibition planning, outreach work, and provision for schools will generate new project management systems, and new understandings of the relationships between these activities. The role that museum education staff will play in these new strategies will vary from institution to institution, depending on the local structures and funding arrangements, the personalities of the individuals concerned, and management approaches. None the less, however the role of museum education staff is defined, it will be essential to understand this role within a framework of museum communication in general.

The future of museum education, then, will be an interesting one. Museums and galleries are moving back to the old nineteenth-century idea of the museum as educational in its own right. Enormous efforts are being made to make valid and lasting links with all kinds of visitors. A vast reservoir of experience gathered over the last hundred years suggests methods and approaches that are being adapted and developed for present-day needs. The educational roles of museums are once again expanding to encompass the whole public face of the museum.

Appendix. List of Unesco survey articles

In 1985 the author was invited by Unesco to write a report as the working document for a conference held in Guadalajara in March 1986. This report was compiled from a synthesis of eighty-eight articles written by museum education staff from across the world. Some of these articles have been used in the writing of *Museum and gallery education*. These are listed below.

Baretto, M. P. Horta. 'A wedding at the Imperial Court' and 'In the time of the sedan-chairs', Museu Imperial, Petropolis, Rio de Janeiro, Brazil.

Borun, M. and Flexer, K. 'The impact of a class visit to a science museum: an experimental study', the Franklin Institute Science Museum, USA.

Deltour, C. and Gesche-Konig, N. 'Discovering museum and learning is fun', Musées Royaux d'Art et d'Histoire, Belgium.

Hercher, G. P. 'The north shore maritime heritage project', Peabody Museum, Salem, USA.

Juel, S. 'Giving history back to its owners', Moto Moto Museum, Mbala, Zambia.

Leimu, Tuula. 'Educational legislation provides for the museum's role in teaching', Suomen Museo Lütto, Suomi, Finland.

Metz, G. 'The case of museums in Africa', National Museum and Art Gallery, Botswana.

Norman, J. and Stahl, S. 'The Islamic Studies project at the Metropolitan Museum of Art', Metropolitan Museum of Art, USA.

Pfenninger, M. 'Teachers of modern art museums', Musée d'Art Moderne, Strasbourg.

Silberstein-Storfer, M. 'The aims, goals and methodology of parent–child workshops at the Metropolitan Museum of Art', Metropolitan Museum of Art, USA.

Van Dorn, B. 'Science museums and science education', Association of Science-Technology Centres, USA.

Bibliography

Adams, G., 1989. *Museums and Galleries: A Teacher's Handbook*. Hutchinson.
—— 1990. *Survey of Museum and Gallery Usage by ILEA Schools 1988–1989*, ILEA.
Airs, J. and Ball, C. 1988. 'Murder or an act of war', *Journal of Education in Museums*, 9, 24.
Allan, D. A., 1949. *Museums and Education*, Royal Society of Arts.
Altick, R.D., 1978. *The Shows of London*. Harvard University Press, Cambridge, Massachusetts.
Ambrose, T. (ed.) 1987. *Education in Museums: Museums in Education*, Scottish Museums Council, HMSO, Edinburgh.
American Association of Museums, 1984. *Museums for a New Century*, American Association of Museums, Washington, DC.
Ames, P., 1988. 'To realize museum's educational potential', *Curator*, 31 (1), 20–5.
Anderson, C., 1985. 'Loan services', unpublished paper presented at the Crafts Council conference on loan services, Birmingham Museum and Art Gallery, 22 May 1985.
Anderson, D., 1989a. 'Learning history in museums', *International Journal of Museum Management and Curatorship*, 8, 357–68.
—— 1989b. 'Museum education, marketing and sponsorship', in Hooper-Greenhill, E. (ed.), *Initiatives in Museum Education*. Department of Museum Studies, University of Leicester, 24–5.
Andrews, B. R., 1908. 'Museums of education', *Teachers College Record (New York)* 9, September, 195–292.
Anon, 1901-2. 'Children and museums', *Museums Journal* (1901–2): 171.
—— 1913. *The Public Utility of Museums*, reprint of letters and leading articles in the Times and other newspapers, and of the official report of the debate in the House of Lords, 29 April 1913.
—— 1915a. 'Discussion on museums in relation to education, at the London Conference,1915', *Museums Journal*, 15 (1915–16), 129–33.
—— 1915b. 'Discussion on museums in relation to education', *Museums Journal*, 15 (1915–16), 138-40.
—— 1916. 'Liverpool Museum and elementary school children', *Museums Journal*,16 (1916–17),143-4.
—— 1919. 'Report of a conference between representatives of the Board of Education and a committee of the Museums Association on the proposed

transfer of museums to the local education authorities', *Museums Journal*, 19 (1919–20),123-9.

—— 1987. 'Meeting the GCSE challenge', *North East Museum Service News*, 16.

Arts Council, 1989. *Arts and Disability Checklist: a Quick Reference Guide for Arts Officers on Arts and Disability Officers*.

Attenborough, R., 1985. *Arts and Disabled People*, Carnegie United Kingdom Trust and Centre of Environment for the Handicapped.

Avery-Gray, A., Ball, M., Daniel, S., Drinkall, P., and Wright, S., 1987. 'Leicester Museum initiatives', *Museums Journal*, 87(1), 41–3.

Ball, M., 1990. '1930-1990: 60 years of museum loans to schools', *Museum Education Newsletter*, 112, Leicestershire Museums, Arts and Records Service, 8–9.

Bartlett, J. E. 1955. 'Museums and the blind', *Museums Journal*, 54, 283–7.

Bastian, S., 1989. 'The coming of light' in Goodhew, E.(ed.), *Museums and primary science*, Area Museum Service for South Eastern England, 14.

Bateman, P., 1988. 'Handling sessions at the Museum of Mankind', in *Talking Touch: Report of a Seminar on the Use of Touch in Museums and Galleries Held at the RNIB on 29th February,1988*, Royal National Institute for the Blind, 10–15.

Baxandall, M., 1985. *Patterns of Intention: On the Historical Explanation of Pictures*. Yale University Press.

Bazin, G., 1959. *The Louvre*. Harry N. Abrahams, New York.

Beevers, L., Moffat, S., Clark, H. and Griffiths, S., 1988. *Memories and Things: Linking Museums and Libraries With Older People*, WEA South East Scottish District.

Belgrave, R., 1986. 'Southampton's Caribbean heritage: an analysis of the oral history project carried out by Southampton Museums 1983–84', *Archaeological 'Objectivity' in Interpretation*, Vol. 3. World Archaeological Congress, 1–7 September, Southampton.

Bell, B., Hitchin, M. and Taylor, C., 1933. 'History teaching in Manchester Museums, and its relationship to school work', *History*, July,131–8.

Bennett, S., 1989. 'Museum education and Information Technology', in Hooper-Greenhill, E. (ed), *Initiatives in Museum Education*, Department of Museum Studies, University of Leicester, 20–1.

Berger, J., 1972. *Ways of Seeing*, British Broadcasting Corporation and Penguin Books.

Board of Education, 1931. 'Museums and the Schools: Memorandum on the possibility of increased co-operation between public museums and public educational institutions', Educational pamphlets, No. 87, HMSO, London.

Booth, J. H. and Krockover, G. H., 1982. *Creative Museum Methods and Educational Techniques*. Charles C. Thomas, Springfield, Illinois.

Bosdet, M. and Durbin, G., 1989. *Museum Education Bibliography 1978–1988*, Group for Education in Museums.

Bourne, R. 1985. 'Are Amazon Indians museum pieces', reprint from *New Society*, 29 September.

Bown, L., 1987. 'New needs in adult and community education', in Ambrose, T. (ed.), *Education in Museums, Museums in Education*, Scottish Museums Council/HMSO.

British Association for the Advancement of Science, 1887. 'Report of the Committee on the provincial museums of the United Kingdom', *Report of the British Association for the Advancement of Science 1887*. 97–130.

—— 1888. 'A further report of the Committee on the provincial museums of the United Kingdom', *Report of the British Association for the Advancement of Science 1888*, 124–32.

——1920. 'Final report of the Committee on museums in relation to education', *Report of the British Association for the Advancement of Science, 1920*. London, 267–80.

Bryant, M. E., 1961. 'The museum and the school', *Teaching of history*, leaflet no. 6 (revised), The Historical Association.

Bryden, M., n.d. 'Interpretation through handling: travels with a Discovery Room', unpublished paper from the National Museums of Scotland.

Busse, F., 1880. 'Object-teaching – principles and methods', *American Journal of Education*, 30, 417–50.

Buxton, A., 1989. *Discovering 19th Century Fashion: A Look at the Changes in Fashion Through the Victoria and Albert Museum's Dress Collection* Hobsons, London.

Calkins, N. A., 1880. 'Object-teaching: its purpose and province', *Education*, 1, 165–72, Boston, Mass.

Canadian Museums Association, 1989. 'Museums and education' *Muse*, 7 (2), summer.

Cannizzo, J., 1987. 'How sweet it is: cultural politics in Barbados', *Muse*, Winter, 22–7.

Carnegie Council, 1988. *After Attenborough: Arts and Disabled People: Carnegie Council Review*, Carnegie United Kingdom Trust.

Carr, J. R., 1986. 'Education everywhere for everyone at Mystic Seaport', *The American Museum Experience: In Search of Excellence*, Scottish Museums Council, Edinburgh, 41–8.

Carter, P. G., 1984. 'Educational Services' , in Thompson, J.(ed.) *Manual of Curatorship*, Butterworth, London, 435–47.

Chadwick, A., 1983. 'Practical aids to nineteenth-century self-help—the museums: private collections into public institutions', in Stephens, M. D. and Roderick, G. W., *Samuel Smiles and Nineteenth-Century Self-Help in Education*. Department of Adult Education, University of Nottingham, 47–69.

Chard, J., 1890. 'On circulating museum cabinets for schools and other educational purposes', *Report of the Proceedings of the First Annual General Meeting of the Museums Association, Liverpool, 17,18, 19, June*, 54–9.

Charlton, J. A., 1933. 'The showing of museums and art galleries to the blind', Museums Journal, 33 (3), 85–99.

Cheetham, F. W. (ed.), 1967. *Museum School Services*, Museums Association, London.

Clarke, P., 1989. '"Julia was sick on the coach and I had peanut butter sandwiches" or how to turn a museum visit into an educational experience', unpublished paper, University of Warwick.

—— 1990a. *Review.* Warwickshire Museum education service.

—— 1990b. 'The evaluation of the teaching programme of Warwickshire Museum Education Service: methods and approaches', unpublished paper, University of Warwick.

Clarke Hall, 1989. *Investigations around Clarke Hall*, Clarke Hall and the Educational Resource Centre, Wakefield.

Cleaver, J., 1988. *Doing Children's Museums: a Guide to 225 Hands-on Museums*, Williamson Publishing, Charlotte, Vermont.

Coles, P., 1984. 'Please Touch: an evaluation of the Please Touch exhibition at the British Museum, 31 March – 18 May, 1983', Committee of Inquiry into the Arts and Disabled people/CUKT.

Collins, Z., 1981. *Museums, Adults and the Humanities*, American Association of Museums, Washington, DC .

Council for Museums and Galleries in Scotland, 1970. *Report on Museums and Education*, Council for Museums and Galleries in Scotland.

—— 1981. *Museum Education Scotland: A Directory*, Scottish Education Department, HMSO, Edinburgh.

Council of the Museums Association, 1945. *Museums and Art Galleries: A National Service; A Post-War Policy.*

Cox, A. and Loftus, J., 1979. 'Teaching through museums', *ILEA Contact*, 11, Inner London Education Authority, 9–10.

Cunningham, H., 1980. *Leisure in the Industrial Revolution*, Croom Helm.

Danilov, V. J. 1973. 'Science/technology museums come of age', *Curator*, 16 (3), 183–217.

—— 1982. *Science and Technology Centres*, MIT press.

Davies, M., 1989. 'Circular arguments', *Museums Journal*, 89 (2), 23–4.

Dawson, A., 1981. 'Museum loan service', *Journal of Education in Museums*, 2, 19–21.

Deas, C., 1913. 'The showing of museums and art galleries to the blind', *Museums Journal*, 13 (3), 85–109.

——, 1927. 'Museums and the blind', *Museums Journal*, 27 (2), 39–40.

Delahaye, M., 1987. 'Can children be taught how to think?', *The Listener*, 22 October, 14.

Department of Education and Science, 1971. *Museums in Education*, Education Survey, 12, HMSO, London.

—— 1985a. 'Report by HM Inspectors on a survey of the use some Hertfordshire schools make of museum services, carried out 1–4 July

1985', HMI report 40/86.

—— 1985b. 'Report by HM Inspectors on a survey of the use of museums made by some schools in the North West, carried out 17–21 June 1985', HMI report 20/87.

—— 1986a. 'Report by HM Inspectors on a survey of the use some schools in six local education authorities make of museum services, carried out June, 1986', HMI report 53/87.

—— 1986b. 'Report by HM Inspectors on a survey of the use some Oxfordshire schools and colleges make of museum services, carried out Sept–Nov 1986', HMI report 312/87.

—— 1987a. 'Report by HM Inspectors on a survey of how some schools in five LEAs made use of museum loan services, carried out Spring,1987', HMI report 290/87.

—— 1987b. 'Report by HM Inspectors on a survey of the use some pupils and students with special education needs make of museums and historic buildings', HMI report 4/88.

—— 1988a. 'A survey of the use of museums in adult and community education', HMI report 7/88.

—— 1988b. 'A survey of the use of museums and galleries in GCSE courses', HMI report 369/88.

—— 1988c. 'A survey of the use schools make of museums for learning about ethnic and cultural diversity', HMI report 163/89.

—— 1989a. 'A survey of the use schools make of museums across the curriculum', HMI report 340/89.

—— 1989b. *National Curriculum: From Policy to Practice*, HMSO.

—— 1989c. *The curriculum from 5 to 16* (second edition, incorporating responses). Curriculum Matters 2, an HMI series. HMSO.

—— and the Office of Arts and Libraries, 1990. *Arts and Schools*, Central Office of Information 5/90.

Derbyshire Education Committee, 1957. *Museum Service: Twenty-One Years 1936–1957*. Derbyshire County Council.

Derbyshire County Council Education Committee, 1967. *Museum Service 1966–1967* Derbyshire County Council.

Divall, P., 1989. 'Museum education—a new ERA?', *Museums Journal*, 89 (2), 23–4.

Drew, Sir A., 1979. *Framework for a System for Museums* (the Drew Report). Standing Commission on Museums and Galleries, HMSO.

Duffy, C., 1989. 'Museum visitors—a suitable case for treatment', paper for the 1989 Museum Education Association of Australia conference.

Durbin, G., 1983. 'A museum in the Great War', *Museums Journal*, 82 (2/3), 168–70.

—— 1984. *The past displayed*, Norfolk Museums Service.

—— 1989. 'Improving worksheets', *Journal of Education in Museums*, 10, 25–30.

—— 1987. 'Practical courses for teachers', *Journal of Education in Museums*, 8, 4–5.

—— Morris, S. and Wilkinson, S., 1990. *A Teacher's Guide to Learning From Objects*. English Heritage.

Durrans, B. and Kattenhorn, P., 1986. 'Representing India: issues in the development of the 1982 Festival of India in Britain', paper for the symposium 'Making exhibitions of ourselves: the limits of objectivity in representations of other cultures', 13–15 February, British Museum.

Eisner, E.W. and Dobbs, S. M., 1986. 'Museum education in twenty American art museums', *Museum News*, 65(2), 42–9.

Elliot, B. J., 1977. 'Museums and history teaching: the early experience', *History of Education Society Bulletin*, 20, 41–5.

Fairclough, J., 1980. 'Heveningham Hall, midsummer 1790: a Suffolk schools project', *Museums Journal*, 80(1), 8–9.

—— 1982. 'Heveningham and after', *Journal of Education in Museums*, 3, 3–4.

—— and Redsell, P., 1985. *Living History: Reconstructing the Past with Children*. English Heritage.

Falk, J., 1985. 'Predicting visitor behaviour', *Curator*, 28(4), 249–57.

—— and Balling, J., 1980. 'The school field trip: where you go makes the difference', *Science and children*, 17 (6), 6–8.

—— Martin, W. and Balling, J., 1978. 'The novel field-trip phenomena: adjustment to novel settings interferes with task learning', *Journal of research in science teaching*, 15 (2), 127–34.

Feber, S., 1987. 'The Boston Children's Museum', *The International Journal of Museum Management and Curatorship*, 6, 63–73.

Feher, E. and Rice, K., 1985. 'Development of scientific concepts through the use of interactive exhibits in a museum', *Curator*, 28 (1), 35–46.

Fewster, C., 1990, 'Beyond the show-case', *Museums Journal*, 90 (6), 24–7.

Ford-Smith, J., 1988. 'Touch facilities', in *Talking Touch: report of a seminar on the use of touch in museums and galleries held at the RNIB on 29th February, 1988*, Royal National Institute for the Blind, 24–6.

Foucault, M., 1970. *The order of things*, Tavistock, London.

Fraser, P. and Visram, R., 1988. *The Black Contribution to History*, Geffrye Museum, London.

Freeman, R., 1989. *The Discovery Gallery: Discovery Learning in the Museum*, Royal Ontario Museum, Toronto.

Frostick, E., 1985. 'Museums in education, a neglected role?', *Museums Journal*, 85 (2), 67–74.

Fry, H., 1987. 'Worksheets as museum learning devices', *Museums Journal*, 86(4), 219–25.

Gillies, P., 1981. *Participatory Science Exhibits in Action: The Evaluation of the Visit of the Ontario 'Science Circus' to the Science Museum, London*, Science Museum.

Glasgow Museums and Art Galleries, 1951. *Educational Experiment 1941–1951*, Corporation of the City of Glasgow.

Goodhew, E. (ed.), n.d. *Museums and the new exams*, Area Museums Service for South Eastern England.

—— (ed.), 1988. *Museums and the curriculum*, Area Museum Service for South Eastern England.

—— (ed.), 1989. *Museums and primary science*, Area Museum Service for South Eastern England.

Gooding, J., 1985. 'How do you begin? Museum work with undergraduates and initial teacher training students in British and American institutions', *Journal of Education in Museums*, 6, 8–10.

Graetz, L., 1981. 'Houston: "a steady hand and a peaceful heart"', *Museum News*, 59(5), 33–5.

Greene, J. P., 1989. 'Xperiment! the role of a hands-on gallery in the Museum of Science and Industry in Manchester', *COPUS*, 11–12.

Greene, M. 1989. 'Doing the business', *Museums Journal* 89 (6), 26–9.

Greenwood, E.F., Phillips, P. W. and Wallace, I. D., 1989. 'The natural history centre at the Liverpool Museum', *The International Journal of Museum Management and Curatorship*, 8, 215–25.

Greenwood, T., 1888. *Museums and art galleries*. Simpkin Marshall, London.

Grinder, A. L. and McCoy, E.S., 1985. *The Good Guide: A Sourcebook for Interpreters, Docents and Tour-Guides*. Ironwood Press, Scotsdale, Arizona.

Gurian, E., 1981. 'Adult learning at Children's Museum of Boston', in Collins, Z. *Museums, Adults and the Humanities*, American Association of Museums, Washington, D. C. 271–96.

Hale, J., 1987. *Museum Professional Training and Career Structure*. Museums and Galleries Commission, HMSO, London.

Hall, C., 1981. *Grandma's Attic or Aladdin's Cave: Museum Education Services for Children*, New Zealand Council for Education Research, Wellington.

Hallet, C., 1913. 'Remarks by Mr. Cecil Hallet, B. A.', in Anon. 1913. *The Public Utility of Museums*, reprint of letters and leading articles in *The Times* and other papers, and of the official report of the debate in the House of Lords, 29 April 1913, 44–5.

Hammitt, W. E., 1981. 'A theoretical foundation for Tilden's interpretive principles', *Journal of Interpretation*, 4(1), 9–12.

Harrison, J., 1987. 'De-colonizing museum classification systems: a case in point—the Metis', *Muse*, Winter, 46–50.

Harrison, M., 1942. 'Thoughts on the function of museums in education', *Museums Journal*, 42(3), 53.

—— 1950. *Museum Adventure: The Story of the Geffrye Museum*, University of London.

—— 1967. *Changing Museums—their Use and Misuse*, Longman, London.

—— 1970. *Learning out of School: a Teacher's Guide to the Educational Use of Museums*, Ward Locke Educational.

—— 1973. *Museums and Galleries*, Routledge and Kegan Paul.

—— 1985. 'Art and Philanthropy: T.C. Horsfall and the Manchester Art

Museum', in Kidd, A.J. (ed.) *City, Class and Culture*, Manchester University Press, 1986, 120–47.

Hartley, E., n.d. *Touch and See: Sculpture by and for the Visually Handicapped in Practice and Theory*, University of Leicester, Department of Adult Education.

—— n.d. *Art and Touch Education for Visually Handicapped People*, University of Leicester, Department of Adult Education.

Harvey, B., 1987. *Visiting the National Portrait Gallery*, HMSO, London.

Haward, L., 'Discussion', in Howarth, E. (ed.), 1918. *Educational Value of Museums and the Formation of Local War Museums*, report of the proceedings of the conference held in Sheffield, October 1917, 33–42.

Heath, A., 1976. 'Civil War co-operation', *ILEA Contact*, 4(32), 16–20.

Hebditch, M., 1990. 'Community concerns', *Museums Journal*, 90(5), 35–7.

Heffernan, I. and Schnee, S., 1980. *Art, the Elderly and a Museum*. The Brooklyn Museum.

Hein, G. E., 1979. 'Evaluation in open classrooms: emergence of a qualitative methodology' in Meisels, S. (ed.) *Special Education and Development*. University Park Press, Baltimore.

—— 1982. 'Evaluation of museum programs and exhibits', in Hansen, T. H. *et al.*, *Museums and Education*, Danish ICOM/CECA, Denmark.

—— (ed.), 1990. *Journal of Museum Education* 15 (1), Museum Education Roundtable, Washington, DC.

Henley Centre for Forecasting, 1986. *Leisure futures*, London.

Hennigar-Shuh, J., n.d. 'Teaching yourself to teach with objects', *Journal of Education*, 7(4), Nova Scotia, Canada, 8–14.

—— 1984. 'Talking with teachers about museums in Nova Scotia', *Museum*, 144, 184–9.

Hepler, S., 1978., 'A Visit to the Seventeenth Century: History as Language Experience', *Language Arts*, 56(2), 126–31.

Hewison, R., 1987. *The Heritage Industry*. Methuen.

Higgins, H., 1890. 'Circulating museums for schools and other educational purposes', Report of the proceedings of the first Annual General Meeting of the Museums Association, Liverpool, 17,18,19 June, 60–4.

Hilke, D. D., 1988. 'What is an audience advocate? A position paper', National Museum of American History.

Hood, M., 1983. 'Staying away—why people choose not to visit museums', *Museum News*, 61(4), 50–7.

Hooper-Greenhill, E., 1980. 'The National Portrait Gallery: a case-study in cultural reproduction', MA thesis, Department of Sociology of Education, Institute of Education, University of London.

—— 1982. 'Some aspects of a sociology of museums', *Museums Journal*, 82(2), 69–70.

—— 1983. 'Some basic principles and issues relating to museum education', *Museums Journal*, 83(2/3), 127–30.

—— 1985a. 'Art gallery audiences and class constraints', *Bullet,* 5–8.

——1985b. 'Museum Training at the University of Leicester', *Journal of Education in Museums,* 6, 1–6.

—— 1985c. 'Museum and education—report prepared for the Unesco conference on "Museum and education"', Guadalajara, Mexico, March 1986.

—— 1987a. 'Museums in education: towards the twenty-first century', in Ambrose, T. (ed.) *Museums in Education: Education in Museums,* Scottish Museums Council, HMSO, Edinburgh, 39–52.

—— 1987b. 'Museum education comes of age', *Journal of Education in Museums,* 8, 6–8.

—— 1987c. 'Knowledge in an open prison', *New Statesman,* 13 February 21–2.

—— 1988a. 'The museum: the socio-historical articulations of knowledge and things', PhD thesis, Department of the Sociology of Education, Institute of Education, University of London.

—— 1988b. 'Counting visitors or visitors who count', in Lumley, R. (ed.) *The Museum Time-Machine.* Methuen/Routledge, 213–32.

—— 1988c. 'The art of memory and learning in the museum: museum education and GCSE', *The International Journal of Museum Management and Curatorship,* 7,129–37.

—— 1988d. 'Museums in education: working with other organisations', in Ambrose, T. (ed.), *Working with Museums,* Scottish Museums Council/ HMSO, Edinburgh, 41–8.

—— 1989a. 'The museum in the disciplinary society', in Pearce, S. (ed.), *Museum Studies in Material Culture,* Leicester University Press.

—— (ed.), 1989b. *Initiatives in Museum Education.* Department of Museum Studies, University of Leicester.

—— 1990. 'The space of the museum', *Continuum: an Australian journal of the media,* 3 (1), Murdoch University, 56–69.

—— (forthcoming) 'A new communications model for museums', in Kavanagh, G. (ed.), *Museum Languages: Objects and Texts,* Leicester University Press.

—— (forthcoming). 'Museum education', in J. M. A. Thompson (ed.), *Manual of Curatorship* (3rd edition), Butterworth, London.

—— (forthcoming). *Museums and the Shaping of Knowledge,* Routledge.

—— (in preparation). *Approaches to Museum Communication,* Routledge.

—— (in preparation). *A handbook for Museum Communication,* Routledge.

Horne, D., 1984. *The Great Museum.* Pluto Press, London and Sidney.

Horniman Museum, 1987. 'Horniman Museum education centre: report of term time activities, September 1986–August 1987', unpublished report.

Howarth, E., 1913–14. 'Presidential Address', *Museums Journal,* 13 (1913– 14), 42.

—— 1914. 'The museum and the school', *Museums Journal,* 14 (1914–15), 282.

—— (ed), 1918. *Educational Value of Museums and the Formation of Local War*

Museums, report of the proceedings of the conference held in Sheffield, October, 1917.

Hudson, K., 1975. *A Social History of Museums*, Macmillan.

—— 1987. *Museums of Influence*, Cambridge University Press.

—— 1990. *1992—prayer or promise?* Museums and Galleries Commission, London, HMSO.

Hunter, E., 1986., *Golden Jubilee of the Museum School Service: 1936–1986*.North Hertfordshire Museums.

ICOM Committee for Education, 1956. *Museums and Teachers*, International Council of Museums, Paris.

Ironbridge Gorge Museum, 1987. *The GCSE and Museums: A Handbook for Teachers*.

—— n.d. *Under-Fives and Museums: Guidelines for Teachers*.

Jackson, T., 1989. 'Reaching the community: modern art and the new audience' in Hooper-Greenhill, E. (ed.), *Initiatives in Museum Education* Department of Museum Studies, University of Leicester, 16–18.

Jain, S., 1990. 'Mobile exhibitions in India with special reference to the National Museum, New Delhi', unpublished paper. Department of Museum Studies, University of Leicester.

Janes, R. R., 1987. 'Museum ideology and practice in Canada's Third World', *Muse*, Winter, 33–40.

John, D. D., 1950. *The Museums School Service*, National Museum of Wales, Cardiff.

Jones, D. 1987. 'Exhibition review: "Hidden Peoples of the Amazon"', *Museum Ethnographers Newsletter*, 20, 103–110.

Jones, S. and Major, C., 1986. 'Reaching the public: oral history as a survival strategy for museums', *Oral History Journal*,14(2), 31–8.

Kavanagh, G., 1988. 'The first world war and its implications for education in British museums', *History of Education*, 17(2), 163–76.

—— 1990. *History Curatorship*. Leicester University Press.

Keatch, S., 1987. '"Cloots, creels and claikin"—drama on display', in Ambrose. T. (ed.) *Education in Museums, Museums in Education*. Scottish Museums Council, 77–84.

Keen, C., 1981. 'Everyone should have one—a policy for the disabled visitor' *Museums Bulletin*, 20 (10), 177–8.

Kelly, T., 1970. *A History of Adult Education in Great Britain*. Liverpool University Press.

Knell, S. and Taylor, M. T., 1989. *Geology and the Local Museum: Making the Most of Your Geological Collection*, Area Museums Service for South Eastern England, Area Museum Council for the South West, HMSO.

Kusamitsu, T., 1980. 'Great exhibitions before 1851', *History Workshop Journal*, 9, 70–85.

Kushner, S., 1989. *A for Arts: Evaluation, Education and Arts Centres*. Arts Development Association and Centre for Applied Research in Education.

Lawson, I., 1987. 'Standard grade and Scottish museums', *Museums Journal*, 87(2), 110–12.

Lawson, J. and Silver, H., 1973. *A Social History of Education in England*, Methuen, London.

Lewis, G., 1989. *For Instruction and Recreation: a Centenary History of the Museums Association*. Quiller Press, London.

Locke, S., 1984. 'Relations between educational, curatorial, and administrative staff', in Thompson, J. (ed.) *Manual of Curatorship*, Butterworth, London, 482–8.

Lowe, E. E., 1928. *A Report on American Museum Work*. Carnegie United Kingdom Trust.

Luce, R., 1988. Parliamentary reply to a question from Mr Tony Baldry on the future of museum training following the Hale Report, 17 March, Office of Arts and Libraries press release 4047/107.

MacDonald, S., 1986. 'For "Swine of discretion": design for living 1884', *Museums Journal*, 86(3), 123–30.

Marcousé, R., 1961. *The Listening Eye—Teaching in an Art Museum*. Victoria and Albert Museum.

Markham, S. F., 1938. *A Report on the Museums and Art Galleries of the British Isles*. Carnegie United Kingdom Trust, Dunfermline.

Marr, A., 1988. 'Museums and galleries face hiving off plan', *The Independent*, 15 March.

Martin, L., 1982. 'Educational and children's activities in museums', Museums Association datasheet, no.7.

Martin, R. F., 1918. 'Report on school picture collections in Aberdeen', in Howarth, E. (ed.), *Educational Value of Museums and the Formation of Local War Museums*, report of the proceedings of the conference held in Sheffield, October 1917.

Mason, R., 1988. *Art Education in a Multi-Cultural Society*, Croom Helm.

Matthews, M. R., 1980. *The Marxist Theory of Schooling: a Study of Epistemology and Education*, Harvester Press.

Mattingley, J., 1984. *Volunteers in Museums and Galleries*. The Volunteer Centre.

McNamara, P. A., 1990. 'Trying it out: what research says about learning in science museums', *Journal of Museum Education*, 15(1) 20–1.

Meewezen, J., 1989. 'Art reaches out to give the mentally ill a new freedom', *Sunday Times*, 21 May.

Mellors, M., 1982. 'Horniman Museum and Primary Schools', *Journal of Education in Museums*, 3, 19.

Middleton, J., 1990. 'Education', *Museums Journal*, 90(4), 15.

Miers, Sir H. A.,1928. *A Report on the Public Museums of the British Isles*, Carnegie United Kingdom Trust, Edinburgh.

—— 1929. *Museums and Education*, Royal Society of Arts.

Miles, H., 1986. *Museums in Scotland*. Museums and Galleries Commission,

HMSO, London.

Miles, R., 1982. *The Design of Educational Exhibits*, Allen and Unwin.

Millar, S.,1987. 'An opportunity to be grasped', *Museums Journal*, 87(2), 104–107.

—— 1989. 'Pre-vocational education and museums', in Hooper-Greenhill, E. (ed.), *Initiatives in Museum Education*, Department of Museum Studies, University of Leicester, 14–15.

Miller, E., 1973. *That Noble Cabinet*. André Deutsch.

Minihan, J., 1977. *The Nationalization of Culture*. Hamish Hamilton.

Moffat, H., 1985. 'A joint enterprise', *Journal of Education in Museums*, 6, 20–3.

—— 1988a. 'Museums and schools', *Museums Bulletin*, 28(3), 97–8.

—— 1988b, 'The educational use of museums: an English case-study', *The History and Social Science Teacher*, 23 (3), 127–31, Grolier Limited, Toronto, Ontario.

—— 1989. 'Museums and the Education Reform Act', *Museums Journal*, 89 (2), 23–4.

Moore, D., 1973. 'Children in a museum', *Amgueddfa, Bulletin of the National Museum of Wales*, 13 (reprint).

Morris, S., 1985. ' "Museum Studies"—a mode three CSE course at the National Portrait Gallery', *Journal of Education in Museums*, 6, 37–40.

—— 1989. *A Teacher's Guide to Using Portraits*, English Heritage.

Mullen, B. H., 1918, 'Scheme for scholars visiting the Salford museums', in Howarth, E. (ed.), *Educational Value of Museums and the Formation of Local War Museums*, report of the proceedings of the conference held in Sheffield, October 1917.

Munley, M. E., 1986. 'Asking the right questions: evaluation and the museum mission', Museum News, 64(3), 18–23.

Museums Association, 1987. 'GCSE and Museums', *Museums Journal*, 87(1) (whole volume).

Museums and Galleries Disability Association, 1987. *Museums—Opening the Door to Disabled People* report of a seminar held at the Merseyside Maritime Museum.

National Museum of American History, n.d. *Docent Handbook*, National Museum of American History, Smithsonian Institution, Washington, DC.

Newbery, E., 1987. 'Something for all the family', *Journal of Education in Museums*, 8, 9–10.

Newsom, B. Y. and Silver, A. Z., 1978. *The Art Museum as Educator*. Council on museums and education in the visual arts, University of California Press.

Nichols, S. K. (ed.), 1984. *Museum Education Anthology:1973-1983; Perspectives on Informal Learning, a Decade of Roundtable Reports*, American Association of Museums, Washington.

Nicholson, J., 1985. 'The museum and the Indian community: findings and orientation of the Leicestershire Museums Service', *Museum Ethnographers*

Newsletter, 19, 3–14.

O'Connell, P., 1987., 'How to develop effective teacher workshops', *History News,* 42 (3), 19–34.

——. and Alexander, M., 1979. 'Reaching the high school audience', *Museum News,* 58 (2), 50–6.

Ogilvie, F. G., 1919. *Report on the Sheffield City Museums,* Educational Pamphlet no. 34.

O'Neill, M., 1987. 'Quantity vs quality or what is a community museum anyway', *Scottish Museum News,* Spring, 5–7.

Ontario Ministry of Culture and Communications, 1985. *Ontario Museum Notes—Practical Information on Operating a Community Museum: number 11; Developing an Interpretation and Education Policy for the Museum,* Rev 4/88, Heritage Branch, Ministry of Citizenship and Culture.

Oppenheimer, F., 1973., 'Teaching and learning', *American Journal of Physics,* 41, 1310–13.

Otto, J., 1979. 'Learning about "neat stuff": one approach to evaluation', *Museum News,* 58(2), 38–45.

Paine, S., 1985. 'The art classroom in the training of art and design teachers', *Journal of Education in Museums,* 6, 15–19.

—— 1989. 'Museums as resources in the education and training of teachers', in Hooper-Greenhill, E. (ed.), *Initiatives in Museum Education,* Department of Museum Studies, University of Leicester, 28–9.

Park, G.S., 1989. 'The employment of education officers in New Zealand museums: a report on progress', *Agmanz Journal,* 20(3), 6–8, 30.

Paterson, I., 1987. 'Approaches for implementing change', *Journal of Education in Museums,* 8, 30–2.

—— 1989. 'Museum education and liaison with local education authorities', in Hooper-Greenhill, E. (ed.), *Initiatives in Museum Education,* Department of Museum Studies, University of Leicester, 5–7.

Patten, L. H., 1982/3. 'Education by design', *ICOM Education,* 10, 6–7.

Pearson, A., 1985. *Arts for Everyone,* Carnegie United Kingdom Trust and Centre for Environment for the Handicapped.

—— 1989. 'Museum education and disability', in Hooper-Greenhill, E. (ed.), *Initiatives in museum education,* Department of Museum Studies, University of Leicester, 22–3.

Pearson, F., 1981. 'Sculpture for the blind: National Museum of Wales', *Museums Journal,* 81 (1) 35–7.

Physick, J., 1982. *The Victoria and Albert Museum—the History of Its Building.* Victoria and Albert Museum, London.

Pierson-Jones, J., 1985. 'Responding to a multi-cultural society: which Africa? which Arts?', *Museum Ethnographers Group Newsletter,* 19, 15–25.

Pitt, M., 1989. ' "The Royal Society" in action at Clarke Hall', in Goodhew, E. (ed.), *Museums and Primary Science.* Area Museum Service for South Eastern England, 9.

Pond, M., 1983. 'School history visits and Piagetian theory', *Teaching History*, 37, 3–6.

—— 1984. 'Recreating a trip to York in Victorian times', *Teaching History*, 39, 12–16.

—— 1985. 'The usefulness of school visits—a study', *Journal of Education in Museums*, 6, 32–6.

Porter, J., 1982. 'Mobile exhibition services in Great Britain: a survey of their practice and potential', *Museums Journal*, 82(3),135–8.

Prince, D. R. and Higgins-McLoughlin, B., 1987. *Museums UK: The Findings of the Museums' Data-Base Project*, Museums Association, London.

Rees, P., 1981. 'A mobile for the teacher', *Journal of Education in Museums*, 2, 26–9.

Reeve, J., 1983. 'Museum materials for teachers', in Hall, N. (ed.) *Writing and Designing Interpretive Materials for Teachers*. Conference papers, Manchester Polytechnic, October.

—— 1987. 'Multi-cultural work at the British Museum', *Journal of Education in Museums* 7, 27–32.

—— 1988. 'The British Museum', in Stephens, M.D., *Culture, Education and the State*. Routledge.

Rich, E. M., 1936. *Survey of Museums and Galleries in London*, London County Council, publication number 3172.

Riksutstallningar, 1976. *Going to Exhibitions*. Swedish Travelling Exhibitions, Sweden.

Robinson, A. and Toobey, M., 1989. 'Reflections to the future', *Museums Journal*, 89 (7), 27–9.

Rodger, L., 1987. 'Museums in education: seizing the market opportunities', in Ambrose, T. (ed.) *Education in Museums, Museums in Education*. Scottish Museums Council, Edinburgh, 27–38.

Rosse, Earl of, 1963. *Survey of Provincial Museums and Galleries*. Standing Commission on Museums and Galleries, HMSO, London.

Royal National Institute for the Blind, 1988. *Talking Touch: Report of a Seminar on the Use of Touch in Museums and Galleries Held at the RNIB on 29th February, 1988*.

Royal Ontario Museum, 1976. *Communicating With the Museum Visitor: Guidelines for Planning*.

—— 1979. *Hands On: Setting up a Discovery Room in Your Museum or School*

—— 1980. *The Museum and the Visually Impaired*.

Sadler, T. and Morris, B. (eds), 1989. *Museum Educators Think Aloud on Educational Philosphy*. Quoll Enterprises, South Australia.

Scadding, N., 1990. 'Why bother to have a museum education policy; with special reference to the Royal Naval Museum, Portsmouth', unpublished paper, University of Leicester, Department of Museum Studies.

Schools Council, 1972. *Pterodactyls and Old Lace: Museums in Education*. Evans/Methuen Educational.

Scottish Museums Council, 1985. *Museums are for People*. Scottish Museums Council, HMSO, Edinburgh.

—— 1986. *In Search of Excellence: the American Museum Experience*. Scottish Museums Council, HMSO, Edinburgh.

Scottish Museum News, 1987. 'Leisure learning programme gets under way', Scottish Museum News, Autumn, 17.

Screven, C. G., 1986. 'Exhibitions and information centres: some principles and approaches', *Curator*, 29(2), 109–37.

Seling, H., 1967. 'The genesis of the museum', *Architectural Review*, 141, 103–14.

Sharpe, T. and Howe, S. R., 1982. 'Family expeditions—the museum outdoors', *Museums Journal*, 82(3), 143–7.

Shorland-Ball, R., 1989. 'Managing museums for learning', in Hooper-Greenhill, E. (ed.), *Initiatives in Museum Education*, Department of Museum Studies, University of Leicester, 26–7.

Shortland, M., 1987. 'No business like show business', *Nature*, 328, 16 July.

Siliprandi, K., 1987. 'Playgroups and museums', *Journal of Education in Museums*. 8, 13–14.

—— 1990. 'Museum education—the state of pay', *Museums Journal*, 90 (3), 14.

Simcock, A. V., 1984. *The Ashmolean Museum and Oxford science*. Museum of the History of Science, Oxford.

Simpson, M., 1987. 'Multi-cultural education and the role of the museum', *Journal of Education in Museums*, 7, 1–6.

—— 1989. 'Visions of other cultures, current practices in Dutch museum education', *Journal of Education in Museums* 10, 31–6.

Smith, N., forthcoming. 'Museum images of a multi-cultural society', in Kavanagh, G. (ed.) *Museum Languages: Objects and Texts*. Leicester University Press.

Smythe, J. E., 1966. 'The educational role of the museums and field centres in England from 1884', MA thesis, Sheffield University.

Sorrell, D. (ed.), 1975. *Museums and the Handicapped*. Group for Educational Services in Museums, Departments of Museum Studies and Adult Education, University of Leicester

Southern African Museums Association, 1989. *Museum Education and Communication: Guidelines for Policy and Practice*. the Albany Museum for the Southern African Museums Association.

Spiller, E. M., 1917. 'The children's holidays at the Victoria and Albert Museum, 1917-18', *Museums Journal*, 17 (1917–18), 177–80.

Spruit, R., 1982. 'Ethnic minorities in a museum', *Museums and Education* Danish ICOM/CECA, 65–8.

Stake, R. E., 1979. 'Naturalistic study of such things as science teaching', paper delivered at the meeting on 17 May of the North Carolina Association for Research in Education.

Standing Committee for Museum Services in Hertfordshire, 1987. *Museum Education in Hertfordshire: A Development Plan*. Hertfordshire Museums.

Stephens, M. D. and Roderick, G. W., 1983. 'Middle-class Nineteenth-century self-help—the Literary and Philosophical Societies', in Stephens, M. D. and Roderick, G. W., *Samuel Smiles and Nineteenth-Century Self-Help in Education*. Department of Adult Education, University of Nottingham, 16–46.

Stevens, F., 1919. *Some Account of the Educational Work at the Salisbury Museum, 1916–1919*. Salisbury Museum.

Stevens, T., 1981. 'Dramatic approaches to museum education', *Journal of Education in Museums*, 2, 30–3.

—— 1987. 'Change: a constant theme', *Journal of Education in Museums*, 8, 15–17.

Stevenson, J., 1987. 'The philosophy behind Launchpad', *Journal of Education in Museums*, 8, 18–20.

Stewart, D., 1988. 'Leisure learning programme—update', *Scottish Museum News*, Summer, 2–3.

—— 1989. *Building New Audiences for Museums*. Scottish Museums Council/HMSO, Edinburgh.

Sudely, Lord, 1912. 'The public utility of museums', *Museums Journal*, 11, (1911–1912), 271.

—— 1913. 'The public utility of museums', *The Nineteenth Century*, LXXIV, 1219.

Sullivan, R., 1990. *Sculpture for Visually Impaired People: The Art and the Craft* Centre for Disability and the Arts, University of Leicester.

Sunderland, J. T., 1977. 'Museums and older Americans', *Museum News*, 55 (3), 21–3.

Supplee, C., 1974., 'Museums on wheels', *Museum News*, 53(2), 27–35.

Sutton, R., 1989. 'Marketing new education programmes—the Ferrymead experience', *Agmanz Journal*, 20 (3), 9–10.

Swanton, E. W., 1947. *A Country Museum; the Rise and Progress of Sir Jonathon Hutchinson's Museum at Haslemere*. Educational Museum, Haslemere.

Tanner, K., 1987. 'Cookworthy museum and GCSE—a case-study', *Museums Journal*, 87 (2), 107–9.

Thomas, G. (ed.), 1989. 'Museums and education', *Agmanz Journal*, 20 (3), quarterly of the art galleries and museums association of New Zealand.

Thorpe, S., 1987. 'Physical access', in Museums and Galleries Disability Association *Museums—Opening the Door to Disabled People*, report of a seminar held at the Merseyside Maritime Museum, 7–13.

Tilden, F., 1957. *Interpreting Our Heritage*. University of North Carolina Press

Uldall, J. T., 1982. 'Museums collections used in a learning-by-doing project', *Museums and Education*, Danish ICOM/CECA.

Weston, R., 1939. *American Museums and the Child*, reprinted from the *Museums Journal*, 39 (2), 93–116.

Whincop, A., 1983. 'Loan services in Great Britain—a historical and philosophical account', unpublished paper, Department of Museum Studies, University of Leicester.

—— 1987. 'GCSE for curators', *Museums Journal*, 87 (1), 3–5.

Whitechapel Art Gallery, 1989. *Artists and Schools: the Whitechapel's Education Programme with East London Schools.*

Whittaker, J. H. McD., 1966. 'Geology for the blind', *Museums Journal*, 68 (4), 298–9.

Williams, A., 1981. *A Heritage for Scotland—Scotland's National Museums and Galleries: the Next 25 years.* HMSO, Glasgow.

Winterbotham, N., 1987. 'The dark towers of Newstead Abbey', *Journal of Education in Museums* 7, 7–9.

Winstanley, B., 1967. *Children and Museums.* Blackwell, London.

Wolfe, G., 1987. 'Multi-cultural work in a mono-cultural resource', *Journal of Education in Museums*, 7, 20–3.

Woodward, S., 1989. 'School visits to "Gold of the Pharaohs"', *Scottish Museum News*, Autumn, 3–5.

Wright, C. W., 1973. *Provincial Museums and Galleries.* Department of Education and Science, HMSO, London.

Zyl, S. van, 1987a. 'A policy for museum education', *SAMAB*, Southern African Museums Association Bulletin, 17(5), 193–9.

—— 1987b. 'Setting standards for museum education: developing a policy', *SAMAB*, Southern African Museums Association Bulletin, 17(6), 270–7.

Index